"I am impressed to the point of awe by the author's reconstruction of the subjects' thought patterns which make the book a remarkable *tour de force*. It is a most unusual book that conveys the images of the people discussed in remarkably clear ways."
　　—Sidney A. Burrell,
　　　　Professor and Chairman Emeritus, Boston University

"Cantor evokes the ambiances of each of the various epochs, and he enables us to enter sympathetically into the intense idealism of the people concerned even as we become aware of their limitations."
　　—*Kirkus Reviews*

"Lively and engaging portraits of five men and three women whose idealism exerted great influence during the medieval era. . . . his reconstructions rest on solid research and result in compelling depictions of important medieval thinkers, including Hildegard of Bingen, Alcuin of York and Eleanor of Aquitaine."
　　—*Publishers Weekly*

"Eileen Power's *Medieval People*, a brilliantly written collection of brief biographies of six ordinary people, remains a classic introduction to that period. . . . Cantor's purpose in *Medieval Lives* is not to write another standard history . . . but to stir the imagination and whet the appetite. And he does that as well as Eileen Power did."
　　—*Boston Globe*

Medieval Lives

Eight Charismatic Men and Women of the Middle Ages

Norman F. Cantor

HarperPerennial

A Division of HarperCollins*Publishers*

Designed by Janet Tingey

The Library of Congress has catalogued the hardcover edition as follows:

Cantor, Norman F.
 Medieval lives : eight charismatic men and women of the Middle Ages / Norman F. Cantor. — 1st ed.
 p. cm.
 Includes bibliographical references and index.
 ISBN 0-06-016989-3
 1. Biography—Middle Ages, 500-1500. 2. Civilization, Medieval. 3. Middle Ages—History. I. Title.
CT114.C36 1994
940.1'092'2—dc20 93-37051

ISBN 0-06-092579-5 (pbk.)
 98 99 ❖/RRD 10 9 8 7 6

To Mindy

CREDO

We can look forward ... as youths, to being grown up ... to reaching our prime, and in our prime, to growing old. ... Whether this will happen is uncertain; but there is always something to look forward to.

AUGUSTINE OF HIPPO, ALGERIA,
FIFTH CENTURY (TRANS. PETER BROWN)

I, flaming Life of the divine substance, flare up above the beauty of the plains, I shine in the waters and blaze in the sun, the moon, and the stars, and with an airy wind, as if by an invisible life which sustains the whole, I arouse all things to life. ... And so I, the fiery power, lie hidden in these things, and they themselves burn by me, as the breath unceasingly moves the man, like windy flames in a fire ... I am Life whole and entire; ... all that is living is rooted in me. For Reason is the root and in it blossoms the resounding Word.

HILDEGARD OF BINGEN, GERMANY,
TWELFTH CENTURY (TRANS. KENT KRAFT)

CONTENTS

PREFACE

Almost seven decades have passed since a brilliant young don at Girton College, Cambridge, Eileen Power, published *Medieval People*, a collection of biographies of six medieval men and women. Their lives fell within the time span from the ninth to fifteenth centuries. Power's biographies were short and beautifully written, and were intended for the general reader and the student.

Power's book is still in print, having gone through innumerable printings. Its current American publisher, HarperCollins, invited me to try my hand at writing a book similar to Power's in scope and format, and this book is the result.

I have written herein about eight medieval men and women. The time span covered is between the fourth and fifteenth centuries. The biographies are short and the book is addressed to the lay reader and the college student.

Otherwise Power's classic work and this book are different in important ways. Power was a social and economic historian; my interest is primarily in cultural and intellectual history. Power's book is marked by a wonderful freshness and naivete, an irresistible British 1920s medievalist enthusiasm that I cannot quite share. My Middle Ages are both a more complex and sadder place than Power's. It is not entirely to my advantage that I take cognizance of the vast amount of research and publication on the Middle Ages during the past seven decades. Of the forty-five works listed in my bibliography (a highly selective listing), only one would have been available to

Power. It is astonishing and to her great credit as a scholar and writer that a set of medieval biographies written before the mass of modern scholarship on the Middle Ages was published should still be compelling and very much worth reading. On the other hand, in the light of all this learning about the Middle Ages, mine is inevitably a different perception of the medieval world from hers in some significant ways.

These differences can be summed up by saying that Power's medieval people seem a generally contented lot, usually happy with themselves and not oppressed by their environment. My eight people are normally anxious, conflicted, and under stress. That I have chosen to write about people from the elite—charismatic personalities among the ruling class—who were therefore burdened by the cares of leadership, whereas Power's people were more middle and working class, partly accounts for this difference, but not completely.

I also think that the messages of modern psychotherapy have affected me in perceiving my people as placed in critical junctures and facing hard decisions. Power was a marvelously insightful person, but the worlds of Cambridge in the early 1920s and New York in the 1990s are very different ambiences, and these differences are reflected in our perceptions of how people think and behave, in the Middle Ages as well as today.

Power was a forerunner of the "social history" focus that rose with the French Annales school in the 1930s and 1940s and reached its zenith among many American medievalists in the 1970s and 1980s. My book has the character of a countercyclical enterprise. I appreciate what Power, the Annalists, and their successors have done to explore the dimensions of medieval society, and I have learned much from them that I have used in this book, particularly with regard to scene-setting. But I also believe that the great issues and themes of the medieval world still lie within the parameters of church and state, as did so many historians who wrote during the classical era of medievalist scholarship between 1895 and 1965. This conviction shapes this book as it did my recent works, *The Civilization of the Middle Ages* (HarperCollins, 1993) and *Inventing the Middle Ages* (Morrow, 1991; Lutterworth, 1992; Quill, 1993).

A generation of American medieval historians became committed to the social history approach they learned from the Parisian Annal-

ists and which Eileen Power can be said to have anticipated in her classic book on *Medieval People* of 1924. Partly for ideological reasons, the social historians gained hegemony in the academic profession, but there was always a systemic weakness in what they were doing, aside from fundamental interpretive flaws with respect to understanding the central issues of medieval civilization. The social history approach was difficult to communicate in undergraduate classes and to structure a college course around, and beyond a certain superficial level that Power's book already attained, it was almost impossible to communicate to the lay reader.

In the past four decades research has greatly deepened understanding of the Middle Ages. A task that needs to be more artfully and strenuously pursued is the communication of the result of that research to the literate public, among whom a sustaining fascination with the medieval world exists. *Inventing the Middle Ages* pursued this end historiographically and via the sociology of knowledge. *The Civilization of the Middle Ages* attempted a comprehensive narrative history. This book employs the medium of biography to make medieval culture and society meaningful.

Herein, then, are portrayals of the life experiences of eight important medieval people and evocation of the issues that affected them as mature adults, the conflicts they endured, and the hard choices that they made. I have not tried to write psychobiography because we do not know enough, or virtually anything, in most instances about the early childhood of these people. But I have tried to suggest the psychic as well as social and cultural forces that functioned to affect their lives.

There are connecting themes that run through this book, but each biography stands by itself as an exploration of the contours of an individual life irrespective of the roles that each of these eight individuals played in the developing structure of medieval civilization, which are indicated. Each one of these five men and three women were fascinating personalities and I have tried to reveal their distinctive characters. Even if the material, cultural, and social contexts of medieval lives were quite different from our own, these lives can still engage our attention, inspire our empathy, and refine our humanity.

For sake of comprehension, succinctness, and readability I have employed some transposition of the medieval way of talking into

late-twentieth-century discourse and have used some dramatic constructions. This modest exercise of historical imagination preserves, however, medieval sense and sensibility that academic research has revealed. The innovation, if it may be called that, is in the way the narrative is told.

The relationship between narrative history, of which the biographical genre is a subset, and imaginative literature has been much discussed in the past decade, at considerable length and with insight by Hayden White and Simon Schama. Distinguished historians divide on this subject. What was intended as hostile opinion was rendered a decade ago by Gordon S. Wood: "Narrative history cannot be scientific; it is simply story telling, not essentially different from fiction" (*New York Review of Books*, August 12, 1982). A positive view has been expressed in hortatory manner recently by Barbara Hanawalt: "Historians should boldly move beyond current conventions of historical expository writing and explore all avenues for presenting the story" (*American Historical Review*, February 1993). Wood and Hanawalt do not differ so much on the nature of narrative history as on the abstruse question of wherein lie the permissible parameters of the historian's craft.

Without getting involved in the philosophical issues, which are beyond my ken, I have done what I thought would make a difficult subject not only accessible but exciting to the general reader. I think it is the reader's response that finally determines the canonical character of historical writing.

N. F. C.
Sag Harbor, Long Island

ACKNOWLEDGMENTS

To Hugh Van Dusen, my editor at HarperCollins, who commissioned this book and whose critiques of my drafts substantially improved the book and made it more accessible to the reader, I want to express my warmest appreciation. It is very rare in the world of trade publishing to find a senior editor who is a gentleman or a scholar. Hugh Van Dusen is both a scholar and a gentleman, perhaps the last of a splendid breed in the New York publishing world.

I also want to thank my friends Margaret Jennings and Patrick Kilcoyne for reading an earlier draft and making valuable suggestions for improving the book.

Karl Morrison and Mary Alberi, who did not read the manuscript, responded readily to my inquiries on difficult points of research.

Without the ministrations of my literary agent Alexander Hoyt, my secretary Nelly Fontanez, and my wife Mindy Cantor, I could not have written this book. I am very grateful for their constant encouragement and assistance.

Secretarial and other technical support that was funded by the Office of the Dean of Faculty of Arts and Science at New York University significantly facilitated the completion of this book. I want to thank Dean C. Duncan Rice, Dean Ann Burton, and Ms. Elizabeth Robinson.

Some of the themes in the book were tried out at a public lecture at Skidmore College in October 1992. I want to thank the chair of

the Skidmore History Department, Patricia Ann Lee, for giving me this opportunity.

I want to thank the dozens of people, nonacademics as well as academics, who spontaneously gave me positive feedback on *Inventing the Middle Ages*. This showed that there is a wide audience for readable and innovative books about the Middle Ages and that the audience thirsting for good medieval books has not entirely been shunted aside by the intellectual conservatives in the Medieval Academy of America. I also want to thank Ms. Dawn Schaefer, a doctoral student in medieval history at New York University, for bringing to my attention the illumination that has been used on the cover of this book.

In Chapter Five, on Hildegard of Bingen, five sentences put in the mouth of the indomitable abbess follow closely translations from the writings of Hildegard made by Peter Dronke in his *Women Writers of the Middle Ages*, New York, 1984.

In Chapter Six, on Eleanor of Aquitaine, one sentence attributed to the court poetess Marie de France follows closely a translation from one of Marie's poems by Joan Ferrante and Robert Hanning, *The Lais of Marie de France*, New York, 1978.

MEDIEVAL LIVES

CHAPTER ONE
THE ADVENT OF THE MIDDLE AGES

HELENA AUGUSTA

"The old Jewish whore is coming down the road with the bishop of Caesarea and the rest of her entourage," said Spero, the innkeeper, to Petra, the head of his assembled staff of six people. "They will be here very soon and they will be thirsty, hungry, tired, and dirty from the dusty road. They have been on the road from Caesarea since early this morning. Remember she wants to be treated like an empress and the Emperor Constantine expects us to treat his mother Helena as an Augusta, an empress. Remember there is good money for all of us if we please old Helena the Jewish bitch."

It was late in the afternoon of a hot September day in the year 326, at a crossroads a mile east of the Palestinian coast halfway between Caesarea in the north and Jaffa in the south.

As the cloud of dust signaling that the Augusta's party was approaching increased in size, Spero became more nervous and fussy. He turned to the stable boy and made sure there was enough hay for the horses in the Augusta's entourage.

"Remember, Petra," Spero said to the young woman whose special responsibility it was to supervise the dining room, "the meals must be not only well prepared but elegantly served and only our best vintages from the Golan Heights will do."

Spero came from one of the Greek pagan families that the imperial government had settled in ancient Judea after Roman arms

crushed the last Jewish revolt and the province's name was changed to Palestine.

The Romans had treated the Jews generously and the imperial government's reward for this generous treatment had been two fierce revolts within sixty years by the Jewish freedom fighters. After revolts were suppressed and the Jewish Temple destroyed, the Jews were expelled from Jerusalem and coastal plain where Caesarea was located and they were confined to the Galilee and the Golan Heights in the north of the country.

From the eastern Mediterranean the imperial government brought in Greek-speaking Gentile immigrants of various ethnic backgrounds to replace the exiled Jews. Fourth-century Palestine was still a rich agricultural land. It still as in biblical time provided bounteous crops. It was not yet desiccated by millennia of mining the soil, back to the time of the Canaanites, and perhaps a deterioration of the climate through a radical drop in rainfall that occurred under Arab rule.

After the Jews were expelled from southern Palestine, it became a quiet land. No more the clogging of the roads with families headed up to Jerusalem to pray and offer sacrifices at the Temple. No more rabbinical schools where bearded young men shook themselves while they studied, syllable by syllable, the sacred text of the Torah. No more the litigants assembled before rabbis, awaiting their judicial decisions. No more the crowds gathered around prophets declaiming the Word of God on hilltops and in market squares. No more the lineups at the ritual slaughterhouses awaiting precious supplies of kosher meat. Southern Palestine was a quiet land now, like Poland in the late 1940s after the Jews were dead.

The villa, the gymnasium, and the amphitheater were now the prominent features of the Palestinian landscape, signaling the triumph of Greek culture in the Holy Land. Paganism prevailed in the land of the prophets.

Like so many Greeks in Palestine, Spero hated the displaced Jews, just as the Israelis now detest the displaced Palestinians.

"Spero, why do you call Empress Helena a Jewish whore?" said Petra. "I know you don't like the Emperor Constantine and his family because they are Christians and you have stayed passionately loyal

to the old gods. I know that you are disappointed that for the first time a Christian has become emperor. But why do you call Helena a Jewish whore?"

Spero came originally from Alexandria in Egypt. He was a product of that mercantile middle class in the cities of the eastern Mediterranean upon whom both the economic and intellectual vitality of the Roman Empire heavily depended. He had attended the schools of Greek philosophy there, where traditional Graeco-Roman polytheism had been refined through the prism of Platonic philosophy and Middle Eastern mysticism. In Alexandria, Spero had also imbibed the intense anti-Semitism that had developed among the pagan intellectuals as the conflict endured between the Greek-speaking majority and the large Jewish minority in the Egyptian metropolis. Like so many scholars and intellectuals in the later Roman Empire, especially those who remained loyal to the old religion and did not join the Christian Church and become bishops and priests, Spero could not make a living as a scholar and philosopher. He had to find a trade. He migrated to Palestine, where the Roman government had welcomed pagan immigrants, and became an innkeeper.

Spero drew Petra aside, out of the earshot of the rest of his staff.

"Because that is how Helena started out—a half century ago in a small city in Bythinia, in Asia Minor, among the proletarian Jewish masses in those stinking cities there. She was a barmaid and a stable girl, and one day a Roman officer named Constantius took her as his concubine and Constantine our emperor was the product of that union of these two pathetically obscure people—the soldier and the barmaid—in a provincial town. But then Constantius showed his political mettle and rose in the ranks, and his Jewish barmaid concubine became an obstacle to his advancement. So he abandoned her and took a proper wife, and you know the end of the story—Constantius got to be the assistant emperor in the north, in Britain, and Constantine his son inherited his army and marched on Rome and gained the imperial purple."

"Where was Helena all that time?" asked an intrigued, wide-eyed Petra.

"Who knows? Probably back in that town in Bythinia—today

absurdly called Helenopolis—serving wine, cleaning the stables, and putting out for the soldiers. This is our great imperial family. May the gods preserve us."

"But Constantine didn't forget his momma, did he? That says something for the Christian emperor you don't like," said Petra.

"Yes, give Constantine credit for that, if raising whore mothers to the imperial purple is a good thing—Constantine deserves the credit," said Spero.

The Augusta's entourage turned off the main road and wound up the path to the inn. Four soldiers in heavy armor rode at the front, followed by the empress' litter, its sides covered in heavy brocade and the monogram of Christ, Chi Rho, rising in a gold ornament from the top of the litter, which was carried by four huge swarthy slaves. Behind the litter rode the elegantly dressed bishop, Eusebius of Caesarea, the senior ecclesiastic of all Palestine, and chief court propagandist and confidant of the emperor. A dozen servants and six more soldiers on foot shuffled on behind the bishop.

When the Augusta's litter reached the front of the inn, Spero and Petra and the rest of the staff were stiffly assembled to greet Helena and the bishop. Helena opened the side of the litter and looked cautiously at Spero and his group. With the help of a personal maidservant who had emerged from the crowd that had followed the empress and the bishop, Helena got out of the litter and stood erect and looked around. She was an old woman of seventy-six years, but still handsome, vigorous, and dignified. She had white hair, bright brown eyes, and a large Semitic nose. Spero prostrated himself facedown on the ground at Helena's feet until she motioned to him to get up.

Spero rose and quickly dusted himself off.

"How great an honor it is that the Helena Augusta, mother of the most exalted Emperor Constantine, should stay at our humble inn, Supreme Majesty. We shall do everything to make you and his grace, the bishop of Caesarea, the famous theologian and historian Eusebius, and all your soldiers and servants in Your Excellency's entourage welcome and comfortable for tonight."

Helena ignored Spero and motioned to Petra.

"Young woman," said Helena in a loud and firm voice. "I call upon you to help me. I am tired and thirsty from the trip to Caesarea. We

have a long way to go before we reach our destination in Jerusalem. You can show me to my room."

Petra led the way into the inn and upstairs to its best room. A silent Eusebius, a tall, thin figure with a dour face, a silver cross dangling from his neck, followed Spero to the room assigned to him.

Spero's inn lay at the busiest crossroads in Palestine, where the road eastward to Jerusalem intersected with the coastal road between Caesarea and Jaffa. This intersection is still one of the busiest in Israel, the site today of lengthy traffic jams. The intersection lies about 20 miles south of Caesarea, the leading city in Roman Palestine at this time, while Jerusalem still lay devastated from the Jewish wars against Rome and the failure of the great Jewish rebellions against imperial power.

Caesarea on the Mediterranean was renowned for its beautiful villas and a splendid open-air theater. Today villas of prominent Israeli politicians and businessmen, including the private home of the current president of Israel, Ezer Weizman, are located in Caesarea. The amphitheater facing the sea has been restored by the Israelis and is heavily used in summer for concerts. Lifestyle in the Holy Land has not changed much since the time of Constantine—only the ethnicity of the master race.

Today at the crossroads where Spero's inn was located there is a large gas station, within a wing of which is discreetly located one of the best (and cheapest) Arab restaurants in Israel.

After Helena had bathed with the aid of her personal maid, she dismissed the servant, and dressed only in a simple linen chemise laid down in the bed that Petra had prepared for her. Petra had gone down to the wine cellar while the empress was in her bath and now she held on a tray a beaker of white wine and a blue metal goblet, the best that this roadside inn had to offer.

"Your Majesty," said Petra, "may I offer you some of our best white wine. It is from the Golan Heights in the far north, where we get all our wine, and the Jewish rabbi who personally supplies us from his vineyard on the cool mountains in the Golan made a delivery just this morning. It is a new cask we have tapped to make sure the wine would be at its best for you."

Helena took the wine, drained the goblet in one swallow, motioned for a refill, and downed that too. Petra filled the goblet a

third time. Helena set it on the table next to her bed. "Petra," said the Augusta, "come and sit beside me on the bed. You are a pretty young woman. You remind me of the woman I once was long ago in Bythinia, when I too worked in an inn and capably served the guests as you are doing. I think you must be about the same age I was when I gave birth to my son Constantine. I was then twenty-four."

"I am a little older than that, Your Highness," said Petra.

"And what is your race, Petra? Tell me about yourself."

"Your Majesty, I told Spero when I came to work here last year I was a Palestinian, but I cannot lie to you. I am Jewish. Jews are not supposed to live in this part of the country, I know, ever since the great revolts against Rome. The Jews were exiled from Jerusalem and from the coastal plain here and confined to Galilee and the Golan in the north. But some Jews have come back here quietly to seek employment among the Romans, Greeks, and Palestinians. And if we are quiet, no one bothers us, especially the women among us. The Jewish men cannot easily disguise their race because they pray so much and they are circumcised, but it is easy for an unmarried Jewish woman to pretend she is a Gentile and to get employment in an inn. I needed the work. There was little for me to do up north, except to get married to a pious man and produce many children. The atmosphere up there in the Galilee and Golan among the Jews is oppressive, with all those devout rabbis, who consider women inferior and imprison us in their rules and large families. So that is why I came down here and I told Spero I was a Palestinian. I hope, exalted Augusta, you will keep my little secret and not give me away."

"Of course, I won't," said Helena. "I am a Jewish woman myself in origin, and I know how hard it is for a Jewish girl, and how oppressive the rabbis are. I told my son about how I suffered as a young vivacious woman who liked sex and drinking, how the rabbis persecuted me for this, and maybe that is why the Emperor Constantine hates the Jews so much. Constantine won't even let the Church celebrate Easter at its proper time—at Passover. He and the bishops invented an alternative date. I thought that was funny."

There was a warm feeling between the two Jewish women, separated by a half century in age, but with something in common—their careers as barmaids and their need to make their own way in

the world, with little help from their original families and hostility from the rabbis because of their proclivity to sex and drink.

"Empress Augusta," said Petra boldly, "I have heard so much about your many charities to the poor and the sick, how you free slaves and rescue convicts. But why at your age are your embarked on this tiresome journey to Jerusalem? Most of the old city still lies wasted, from the Jewish wars against Rome and the Romans' savage destruction of the city, and you have three more days of travel from here, having already spent a day en route from Caesarea. And you know, it is a difficult journey, first having to cross the hot central plains of the country and then, in the last leg of the journey, having a long climb up a steep hill—Jerusalem is very high up."

"I know that," said Augusta. "It is indeed a difficult journey for someone of my advanced age. But I am in good health and it isn't that I have to walk there or even go on horseback. In any case, I am compelled to go, both by my son the emperor and by my Christian God. I go there to do penance and make restitution for my family. Have you not heard of the tragedy that has struck the imperial family?"

"No, I have not," said Petra.

"The secret has been well kept. Not many people know. The public is ignorant. To speak frankly, three months ago Constantine suddenly ordered the deaths of his eldest son, my beloved grandson, Crispus, a brilliant young man, and also the death of Constantine's then current wife Fausta. The death sentences were carried out very quietly—Crispus died from poisoning, Fausta was killed in a steam bath, to make it look like an accident. The deaths were justified, but Constantine's terrible anger is now stilled and he is remorseful for killing his favorite son and his son's stepmother."

"Why were these killings justified, Your Majesty?" said Petra cautiously.

"Crispus and Fausta were almost of the same age—Crispus was the son of a concubine, as you know Constantine was himself, and I was that concubine who was Constantine's mother. Crispus and Fausta were found to have had a sexual relationship. By Roman law, Constantine was justified in ordering their deaths. Perhaps he was compelled to do so. But now he is remorseful, and to appease the Christian God that he now worships—as I do, because he insists I

do so—he has gone on an orgy of church building all over the empire. He especially wants to honor Jesus Christ, to whom he prayed before his most crucial battles and always received Christ's support. Constantine has already ordered the bishop of Jerusalem to make preparations for building a great church over Christ's tomb, if it can be found. I am going to Jerusalem to find this tomb and to direct the building of the Church of the Holy Sepulchre over it. Constantine thinks that the building of this church in Jerusalem will cause Christ to forgive him for the deaths of Crispus and Fausta, if Christ puts any blame on the emperor."

"I was in Jerusalem a year ago," said Petra, "and the Temple Mount is in ruins and covered with debris. I hope you can find Jesus' tomb."

"I have no doubt that I will," said Helena, "but that is not all. While I am in Jerusalem I will search for relics of the True Cross on which the Savior was crucified. I had a dream last month that I would find the True Cross and bring it back to Constantinople, to Constantine's capital, where it will be the center of Christian worship and adoration. I have already once in my life been the instrument of God's providence for changing the course of history. I was the mother of Constantine, the first Christian emperor. I do not know why God chose me for this divine purpose. But He did. Now I feel He has chosen me to find the Holy Sepulchre and the True Cross which will confirm millions in their faith and, I hope, bring millions more into the Church. All this for a poor Jewish girl in Bythinia, who became the lover and concubine of a minor officer in the Roman army there. Even though Constantius had to abandon me when he rose to eminence in the empire, I had my son to comfort me and my belief that somehow my life would turn out alright. And it has—much better than I expected. If God has been good to me up to now, His favor will continue to shine upon me and I will find the Holy Sepulchre and the True Cross in Jerusalem."

Petra, who had by now downed a couple of glasses of wine herself, became bold in what she said.

"I wish you good luck in your quest for the tomb of Jesus and for the True Cross. I admire the Christian faith, and certainly there is nothing very attractive in what the crabbed old Jewish rabbis teach in their synagogues in the Galilee and the Golan. I was glad to get

away from those bearded, mean men crouched over their Torah scrolls. But the Christian faith disappoints me in two ways, Your Majesty. I want to tell you frankly."

"And which are those?" said Helena, now sitting up in her bed and looking a bit sternly at Petra.

"First," said Petra, "I am disappointed in the way the Church is organized. Only men can become priests. Women are given a subordinate role. It is not different in that respect from the Jews. I blame mean old St. Paul, who was—as he said—a Pharisee of the Pharisees and he took over from his rabbinical faith the conviction that women should keep quiet in the church, should sit in the back, and never assume positions of leadership."

"I am a little disappointed myself," said Helena, "that the Church does not give religious equality to women. But you have to understand that it is a Roman Church, after all, and Roman law gives an inferior status to women even in noble families. In Roman law, the family is rigidly patriarchal. Women are subordinated to the father or eldest son. This discrimination has been carried over into the Roman Church. It isn't all St. Paul's fault. Perhaps in time women will gain equality in the Church. In the meantime, I think women should do whatever they can to serve Christ and the Church and to demonstrate that depth of their spiritual commitment. That is what I am doing on this pilgrimage to Jerusalem and I hope that all wealthy Christian women will emulate me. The more women who go on pilgrimages and distribute charity—along with those who remain virgins and become nuns, which is also important—the more likely it is that the bishops will throw off the discrimination against women they got from St. Paul and from Roman law and give women full equality in the Church. I will not live to see this change, Petra, and my son the Roman soldier who thinks women only good for sex and piety is dead set against such a change, but perhaps you will see the time, Petra, when women are given their due in the Church and allowed to become priests and bishops."

"I doubt that I will see that in my lifetime," said Petra. "The bishops like your friend Eusebius give no indication of recognizing women's equality in the Church."

"We can only do our best and hope that God will change their attitudes toward women," said Helena. "Now tell me Petra, you said

there were two things you held against the Catholic Church, its sexism being one. What is the other?"

There was a pause as Petra seemed to be collecting her thoughts, trying to decide whether she should risk responding to this query. After a few moments of silence, she responded.

"The Catholic faith does not explain the existence of evil in the world. The Jews couldn't explain it; neither can the Christians. How can a good and omnipotent God allow so much cruelty and unhappiness, so much terror and oppression, so much poverty and sickness in the world? It seems to me to make more sense to believe as the Gnostics and Manichees do, that there are two gods, the God of Light and the God of Darkness, and the God of Darkness creates the evil in the world. That is what I believe."

"I do not object to the doctrines of the Gnostics and the Manichees," said Helena. "But do not let Bishop Eusebius hear you talk like that. The bishops are intent on rooting out the vestiges of this dualist faith and now they have the power of the Roman state behind them. My son the emperor will exercise his authority against any Gnostic or Manichee he can find. He believes that anyone who envisages two gods could also imagine two emperors. The Roman faith is now ordained to be a political monotheism—one God in heaven and one emperor on earth, who is God's representative in the world and rules by divine power. Anyone who follows the Gnostics and Manichees in claiming there are two gods is now considered a danger to the Roman state."

"That is the way it is," said Petra. "First the rabbis drove the Gnostics underground and now the Christians want to kill them. How cruel and false is the world of powerful and selfish men."

The former barmaid and the current one looked at each other in sympathetic silence. Then Spero entered and prostrated himself again before the empress.

"Augusta," he said, "it is the dinner hour. Bishop Eusebius has chosen to go down to the private dining room. The other members of your entourage have already eaten in the public dining room. Will you join Eusebius downstairs, or shall Petra bring your dinner up here?"

"I will go downstairs," said Helena. "I have not talked with Euse-

bius since we left Caesarea early this morning. He will begin to think I am angry at him. He is very sensitive and insecure."

When the three of them—Helena, Spero, and Petra—descended to the dining room there was a heated exchange already under way between Eusebius and Rabbi Simon, who earlier that day had delivered the wine from his vineyard on the Golan. Rabbi Simon was a stocky middle-aged man with a short gray beard and black knitted skull cap.

Mean epithets such as "disgusting Jew" and "nefarious Christian" were being hurled between the bishop and the rabbi.

"Rabbi Simon," said Spero nervously, "I am surprised you are still here. I paid for the casks of wine you delivered and I thought you would be on the road by now, leading your camel train back to the Golan."

"Before I leave, Spero," said the rabbi, "you always give me a meal. Of course I cannot eat your meat, but you always let me have some humus with bread and olives and fruit to prepare me for the long journey back to the Golan."

"But I told you," said a near hysterical Spero, "that the Empress Helena and Bishop Eusebius are staying here tonight on their way to Jerusalem and you could not take a meal in the dining room tonight. I shall get the cook to prepare you something to eat on the road."

"Let him be," said Helena imperiously. "I am no admirer of rabbis but I have never found them to hurt anyone. Let the rabbi stay and take some refreshment with us before he leaves."

Eusebius looked as though he was about to say something, then thought better of it and was silent.

So they sat down to an elaborate Middle Eastern meal, which Petra served. Afterward Eusebius addressed Spero and Rabbi Simon jointly.

"In a few years there will be no adherents of the old Roman gods, and no Jews outside the Church either. Christ was born in the reign of Augustus Caesar and died and was resurrected in the reign of Tiberius Caesar. This was a sign that empire and Church were destined to unite. Now God's providence is fulfilled and history reaches its final era. When Constantine the follower of the Cross took Rome, that was God's doing and His sign that henceforth the des-

tiny of Rome and the Church were identical for all time. There is no place for either pagans or Jews in the Christian Empire. You innkeeper Spero, and you Rabbi Simon, should accept the true faith and join the Church peacefully now and you will be amply rewarded for your conversion or in time you will be forced to do so."

Rabbi Simon spread some humus on pita bread and ate it and said nothing. He tried to avoid looking at the bishop as well as at the roasted pig and lamb on the table.

Spero looked at the empress and her expression, he thought, encouraged a response to the bishop. So he spoke.

"When Constantine gained the throne in Rome, fourteen years ago, he issued an edict of toleration. Although he professed to be a Christian, much to everyone's surprise, since the Church had just gone through a period of intense persecution by the Roman state, Constantine said he would tolerate all faiths in the empire, as long as loyalty to the state and imperial majesty was professed. Although Constantine lavished wealth and privileges on the Church and elevated the bishops to the rank of the highest nobility, he still employed members of the old faith—whom you insultingly call pagans, meaning country hicks—in his government. And he embossed his coins not only with Christian symbols but also with a pagan symbol, the emblem of the Unconquered Sun. Constantine is a great ruler, wise and beneficent. But apparently you do not agree with his policy of toleration, Eusebius. You threaten oppression of pagans and Jews, just as the Christians were—wrongly I think—persecuted by the Roman state before Constantine gained the throne."

"When Constantine gained the throne of the Western Empire fourteen years ago," replied Eusebius, "Christians were not more than a quarter of the Latin-speaking population. He vanquished his co-emperor, his pagan brother-in-law, only two years ago, as you know, and only then also became ruler here in the Eastern, Greek-speaking empire, where Christians were more numerous, but still less than half of the population. Therefore Constantine has had to be tolerant of the polytheists like you, Spero. But in time Constantine or his Christian successors, as Christians become the majority of the imperial population, will close the pagan temples and force conversion upon the pagans. You pagans have always believed in Fortune and you considered the triumphs of the Roman state as a sign

that the divine forces in the universe favored the arms and symbols of imperial power. Now the Roman state remains strong and united but under a Christian ruler. So has Fortune decreed for the Roman state. The bishops are replacing the governors as the leaders of local society, by decision of the emperor. Every day thousands of people, including members of the old Roman aristocracy, newly accept the authority of the bishops and join the Church. Those who were last have now become first. You should accept this destiny now, Spero— and you too, Petra, whom I presume is also a pagan—and enter the Christian community now."

Petra looked at Helena, who remained expressionless and did not betray the young woman. Spero had become agitated and responded in a loud voice.

"So this is the glorious dawn, Bishop Eusebius, that was promised the population of this empire. We were promised a multicultural state and now it is to be an intolerant Christian state that uses imperial power on behalf of the Church. This was not the Roman way. The old emperors allowed everyone to worship in their own manner as long as they gave vague recognition to the imperial cult and were loyal to the emperor. Rome prospered under this tolerant regime, and the population of this vast Mediterranean world, comprising so many diverse races and religions, lived in peace with one another."

"They made a desert and they called it peace," said Eusebius. "That is what the old aristocrat Tacitus thought of the Roman order you esteem so highly. The savage persecution of Christians and their martyrdom at the hands of government officials only a quarter of a century ago, before Constantine, this cannot be forgotten. What men prize more than anything, their freedom, Rome took away."

Rabbi Simon, the humus dripping down his beard as he ate it spread on his pita bread, looked up.

"Well spoken, Bishop," said Simon. "We Jews can testify to that. We did not want to be part of the Roman order. We wanted our independence. But the emperors would not allow it. They sacked Jerusalem and burned down the Temple of the Lord."

Spero had become very annoyed.

"You Jews were ingrates. You had everything going for you in the Roman Empire. Not only was Jerusalem a large and beautiful city on a hill but Jews spread everywhere in the empire and multiplied and

prospered. In every large city here in the eastern Mediterranean, and in many ports on the western shores of the Great Sea, there are large Jewish communities. The emperors gave you special privileges. You alone, among all groups in the empire, did not have to worship occasionally at the imperial shrines. And still you would not accept Roman rule. And still you rebelled."

"Because we wanted our freedom. It was precious to us. We recognized only one Lord, Yahweh, not an earthly ruler," said Simon.

Helena could not let this rabbinical pronouncement go by.

"The rabbis like yourself, Simon, are a narrow group of selfish men. They talk of freedom but they repressed their women and kept them at the back of the synagogue and in the kitchen and nursery. The freedom they demanded from Rome they would not give to their own wives and daughters. I say that belonging to the empire was good for the daughters of Israel. They could get out from under the harsh rule of their fathers and husbands, and the tyranny of the rabbis, and find jobs and lives for themselves in the great society of the Mediterranean world."

Rabbi Simon gulped a beaker of his own wine and looked sharply at the empress. He seemed ready to say something—the freedom to be a whore like yourself, Augusta—but he remembered where he was and whom he faced. His lips moved but he said nothing. He was used to keeping silent in the presence of the mighty. That was the rabbinical temperament. That is how the rabbis had survived since the great rebellion against Rome and the destruction of the Temple. He would wait for the Messiah. He had no relish for this own martyrdom.

In the ensuing silence, Spero returned to his debate with Eusebius.

"Bishop Eusebius, you are renowned for your learning. But you seem to have little knowledge of what you call paganism. The old religion has evolved and has become modern. It is as spiritual and philosophic as Christianity. We were shown the way by the great philosopher Plotinus and his disciples in Alexandria. Behind the many images and forms of the gods, there is one great spirit in the universe, one ultimate deity that is the fountain of life. All the gods of Greece and Rome are merely emanations from the one ultimate

Spirit of the universe. That is what I believe, as do all educated poly-
theists today."

Bishop Eusebius was familiar with this argument among the more
intellectual pagans and he responded with alacrity.

"If you truly believe that, Spero," said Eusebius, "you will have no
trouble going all the way and converting to Christianity. The side of
the Christian faith that you miss is the Incarnation—God does not
remain a pure spirit removed from mankind but God so loves
mankind that He became man, He became one of us. That was
inconceivable to Plotinus and the Alexandrian philosophers. The old
Greek and Roman religion made the gods like men and women,
with all the human foibles of lust and treachery. The Alexandrian
form of paganism removed divinity from mankind—God is pure
spirit, raised above mankind. Only the Christian faith bridges God
and man through the doctrine of the Incarnation."

"Such a subtle doctrine you have Bishop Eusebius," said Spero
sardonically, "that you priests fell into confusion recently trying to
define the nature of Christ and the persons of the Trinity, and Con-
stantine had to summon a great council of bishops at Nicea to ham-
mer out a creed."

"But Constantine was able to do that, that is the important point,"
said Helena, "and now the Church can move forward united. I was
never more proud of my son the emperor than when he sat on a
golden chair at Nicea and presided over a council of three hundred
bishops and got them to agree on a common trinitarian creed for the
whole Church everywhere. Then I realized that God had sowed and
perfumed my womb with Constantius' seed so that I might give
birth not only to the restorer of the Roman glory but also to the sav-
ior of the Church's unity. I was amazed that Constantine mastered
that theological stuff at Nicea. You know, homousian this and that.
What hairs those bishops could split about God the Father and God
the Son! Of course Constantine got some important help from
Bishop Eusebius."

Eusebius smiled for the first time. "Just a little bit of help, Your
Majesty," he said beaming. He was actually the principal author of
the Nicene Creed, still used today in the Roman Catholic, Greek
Orthodox, and Anglican churches and still mysteriously ambiguous

about the nature of Christ and his relationship to God the Father. Its ambiguity explains its durability.

Now encouraged by Helena, Eusebius was not finished with his defense of Christianity and his onslaught on paganism.

"I want to put the argument against the old religion, Spero, in more human terms. Let us leave aside theology for a moment. You speak of toleration under the old emperors and an evolving spirituality within pagan culture. But that is a falsification of history and denial of social reality. I refer to the violence and savagery that paganism allowed—the viciousness of the games in the circus that were publicly supported (and still are), in which the population was provided with endless spectacles of torture and death. I speak especially of the persecution of Christians and the torture and savage executions visited upon Christian martyrs, including young women. But even aside from that, the old religion tolerated constant spectacles of torture and violent death. The historical record does not speak well for the old religion and pagan culture. It was sadistic, cruel, savage, barbaric. It provided for legitimation and expressions of the worst aspects of humanity. And paganism also tolerated every kind of sexual deviation—sodomy, prostitution, transvestism, bestiality, sadomasochism. It allowed any kind of disgusting sexual behavior. Nothing was outlawed. With all the plague spreading through the empire these days, I am sure this unrestrained and perverse sexuality has something to do with the epidemics that afflict us. Paganism was—and is—a sex-drenched culture, without ethical limitations, without prudent restraint, and without remorse."

"Yes, yes," said Rabbi Simon excitedly. "That is why we had no respect for Greek culture. That is why we regarded it as evil. It is evil."

Eusebius was annoyed with the rabbi's interruption.

"Yet you selfishly, Rabbi, wanted to keep the new faith, the truly spiritual witness against Roman terror and Greek sexuality, for yourselves. It was only the Church that has opened up for the Gentiles the new witness to a higher spirituality."

"That is not true," said the rabbi. "As the prophet Isaiah said, the word of God shall go forth from Jerusalem to all peoples."

"But the Gentiles were to stay outside of the Jewish community," said Helena. "They were to be at best second-class citizens. Only

those who observed the Law were to be capable of the highest spiri-
tuality. Gentiles without, women within, they were to take second
place to the arrogant, circumcised, learned Jewish males."

Again Rabbi Simon wanted to respond but he knew his place and
was silent.

Spero had been collecting his thoughts and now he spoke again.

"Yes, there was cruelty in Roman culture. The games are not
something we can be proud of. There was the public display of cru-
elty and torture. Deviant sexual behavior was allowed. And the per-
secution of the Christians was wrong and unnecessary. The Jews
were allowed to avoid the imperial cult; perhaps the Christians
should have had the same privilege—although in time the Chris-
tians became such a large minority that is was not easy to conceive of
them enjoying the status of a legitimate, privileged minority without
dissolving the political as well as religious unity of the empire. But
let me say this: cruelty and terror, sexuality and aggression, they are
part of human nature. Man is a beast as well as a god. He stands
halfway in the great chain of being. The old religion allowed for
exercise of the ambivalent, dual nature of man. It was realistic. It
gave an outlet for human aggression, sexuality, and violence, but
within a safe, controlled environment, in specific locales—the circus,
the baths, the gymnasium, the whorehouse. I don't know whether
free exercise of sexuality is morally reprehensible. But even if that
were true, it is a side of human nature that must be exercised in ways
that do not disturb society. Repressing sexuality can be dangerous to
personal health. Christianity is unrealistic. It takes too elevated and
one-sided a view of human nature. It wants to turn everyone into
spiritual beings. And it won't work. You will have to make allowance
for cruelty and sexuality, deviance, and aggression in human life.
Christianity is unnatural. Restraining personal preference in sexual-
ity will produce some saints. It will also produce emotionally dis-
turbed people."

"I used to believe the same thing, Spero," said Helena, "but I have
learned better, under the tutelage of Bishop Eusebius and other reli-
gious teachers that my son the emperor provided for me after he
brought me to Rome fourteen years ago. Previous to that I was your
typical middle-class Jewish matron. What I believed in was a pas-
tiche of Judaism and paganism. Sex and Sabbath were my delights.

But I have come to see the significance of the Incarnation is that with Christ's intervention we can *transcend* the limits of human nature and partake of the supernatural. The Christian way is a life of spirituality and purity, overcoming the demands of sexuality, aggression, and sadism that pressed upon us from our physical being. That is what I have learned. Christianity means the triumph of the supernatural over the natural. The dominance of the Christian Church and state opens a new era in human feeling and behavior."

"Indeed, Empress," said Spero, "and how is this transcendence of our ambivalent human nature to be accomplished?"

"First of all," interrupted Eusebius," through the sacraments, the traditions, the teachings, and communal discipline of the Church, now confirmed by imperial authority."

"But there is something more involved," said Helena. "There are some special connections with divinity, some magical conjunctures with Christ that give additional assistance in gaining a life of supernatural purity. These are the relics of saints—physical properties that have a magical quality of joining us with the Lord and freeing us from the downward cast of our physical nature. These relics, such as the sacred bones of saints, provide us with magical power. That is why I am going up to Jerusalem to find the True Cross on which the Savior sacrificed Himself as the suffering servant, for all mankind. No relic could surpass the magical qualities of the True Cross. I know I will find it, or at least fragments of it. I have had a vision I would do so if I went to Jerusalem. Amid the rubble of the city I will find the True Cross. Christ has told me to go and recover the cross on which He died for mankind and bring it back to Constantinople so that all members of the Catholic community may enjoy its magical powers."

Rabbi Simon could no longer restrain himself.

"This is paganism, pure and simple," he muttered softly.

"I cannot see, Empress," said Spero, "how this magic of yours is different from the therapy of soothsayers and holy men and faith healers all over the Mediterranean who for centuries have been offering some kind of healing and safety through the touching of a material object."

"Because," said the Augusta, "this is white magic, not black magic. It is the same as the difference between the absolute rule of my son,

Constantine, the glorious savior emperor, called from the distant climes of Britain by God to save the Roman state, and all those pagan emperors who went before him—some were bad and some better, but none reached his level of exalted glory and capability of protecting the people of the Roman world that Constantine has provided. Similarly, pagan magic is nothing—or perhaps evil, an instrument of Satan—compared to the miraculous outcome of touching a piece of the True Cross."

Eusebius, Spero, and Simon all started talking at once but Helena cut off their babble.

"Sirs, it is late, and I must retire so that I, an old woman, can resume the rigors of my pilgrimage to Jerusalem tomorrow. Come, Petra, you may accompany me to my room, and hold my hand until I fall asleep. Now gentlemen, good night."

Helena Augusta died in 329. She supervised the building of the Church of the Holy Sepulchre in Jerusalem. It was torn down by the Moslem Arabs when they conquered Jerusalem in the seventh century, but was rebuilt by the French Crusaders in the early twelfth century. Today the Church of the Holy Sepulchre is jointly occupied by Greek, Roman Catholic, Coptic, and Armenian clergy.

Medieval people believed that Helena also found the True Cross, or large fragments thereof, in Jerusalem. Modern scholars are skeptical, pointing out that the story of Helena's finding of the Cross dates at the earliest from a half a century after her death. Nevertheless pieces of the alleged True Cross became the most precious relics in the churches of the Middle Ages and were spread over Europe as well as Byzantium. Helena to this day is revered as a prominent saint in the Greek Church and many Eastern churches are dedicated to her.

CHAPTER TWO
AFRICAN HORIZONS

AUGUSTINE OF HIPPO

✠

"I knew you a long time ago," said Vincent to Augustine, "when we were boys growing up in that pleasant little city of Thagaste near Carthage, under the North African sun. Remember all that fuss when you were a little boy and you crept into someone's orchard and stole some pears. I read your *Confessions* a few years ago and I was amused that you used this innocent juvenile happening to illustrate the doctrine of original sin. I just think we were children having a good time. Also, I remember when you were—what?—around twenty and you professed to having become a Manichee and your mother, a devout Christian lady if there ever was one, locked you out of the house."

Vincent laughed heartily but only a quick smile passed Bishop Augustine's thin lips. "Yes, that is true. My mother the blessed Monica of sainted memory indeed locked me out of the house. My father was a pagan and couldn't understand what all the fuss was about. He thought the lockout looked bad in front of the neighbors and with our declining circumstances my sad, class-conscious father thought we appeared shameful already. But my dear mother didn't keep me out of the house for long. She had a vision in which Christ told her that before long I would abandon the Manichees and become a baptized Christian, which was for so many years her heart's desire. And so it happened. But in my case I was never more than on the fringes of the Manichee community. I was never taken in by all that astrol-

ogy and faith healing they went in for. I always suspected that their leaders, the Perfects, who made such a show of piety, beyond their pure exteriors weren't so perfect. I noticed more than one of them late in the evening walking down the street in the company of a prostitute. I was a Manichee for a while because I was obsessed with the problem of evil and the Manichees had a simple, although of course false, solution to the problem of evil. I kept wondering that if God is good and omnipotent, why is there evil in the world? The Manichees had an obvious rude answer: there are two gods, the God of Light and the God of Darkness, and the God of Darkness creates the evil in the world."

Vincent saw an opportunity to make a critical remark about Augustine's interpretations of Christian doctrine.

"I suppose, Augustine, you know that some of your Christian critics say you are really still a Manichee, that their dualism is still prevalent in your teaching and preaching, lying just beneath a thin surface veneer and still shaping your mentality. It is said that you are still obsessed with the problem of evil. While you later came up with an explanation for the existence of evil derived from the Neoplatonists—evil is a falling away from the good that God creates, a perversion of the good creation—they say at heart you are still inclined like the Manichees to divide mankind into two absolutely separate communities, the Heavenly City and the Earthly City. What's the difference between that and the idea of the Children of Light and the Children of Darkness? It is said that you have the hateful disposition of a Manichee, that you are a great hater, Augustine, that you are deficient in Christian charity which finds good in every human being as God's creature. They say you are always disposed early on in any debate to divide humanity up into the good and the bad and consign the bad to darkness like the Manichees."

Augustine wiped the sweat from his face. He was fifty-seven years old and had been bishop of Hippo for two decades. He was a thin, short, wiry man, with swarthy, almost black complexion, and a scraggly beard and thinning gray hair. It was a blazing hot August day in the year 415. Augustine and Vincent were sitting in Bishop Augustine's cluttered little study next to the run-down, ramshackle cathedral in the provincial port city of Hippo, in what is today Algeria, near the present Tunisian border.

Vincent was blond and fair-skinned. He was a Latin, the descendent of Roman colonists who had come to North Africa two centuries earlier and had prospered there, contributing to making the coastal region of what is today Tunisia and northern Algeria one of the richest parts of the Roman Empire. Here great cities had risen, pressed against the inland mountains and the desert on the horizon. Here around 200 A.D. arose a fierce kind of Latin Christianity—puritanical, demanding, pessimistic.

The native Berber population—people today vaguely called Arab from their language—had taken to the new religion and particularly to the more intellectual Pauline strand within it. They had embraced its fiery zeal, as in later centuries and today they were to espouse Moslem fundamentalism. Augustine was a Berber.

Yet these North African Christians were not fundamentalists in today's meaning of the term—devout believers who stand upon the literal text of Holy Scriptures. The Berbers also absorbed the Latin language and the Graeco-Roman heritage and its complex, especially Platonic, traditions. Out of these diverse sources, not least of which was their own non-Latin ethnicity, they created in the hot sun and in the face of the powerful winds blowing down from the mountains and along the harbor basins like Hippo, a fused, integrated kind of militant Catholicism that through Augustine principally but not exclusively would have a profound impact on the ethos of the early Middle Ages.

The last thing we would want to believe if we were searching for the cultural forces shaping the sensibility of the European Middle Ages is that the Church in North Africa was marginal or idiosyncratic. It was in fact mainstream. It was the cultural crucible of Latin Christianity.

Augustine had closed the shutters against the fierce afternoon African sun. He had been impatient to get rid of his visitor and get back to work on the treatise he was writing, at the urging of many other Catholic bishops. This book was supposed to explain the theological and moral significance of the sack of Rome by the Visigoths five years earlier. It was supposed to respond to the claims of aristocratic pagans that Rome, far from being rewarded—as the Christian bishops had exultantly predicted—for becoming a Christian state

and for dismantling the altars to the old polytheistic gods, had fallen to German invaders in Christian days.

Less than 10 percent of the population of the Roman Empire in the early fifth century was still pagan, but the old polytheism had eloquent spokesmen among some of the aristocratic families in Italy. They taunted the Christians that Rome had fallen in the Christian era and the bishops were embarrassed by this claim. Although the Visigoths had withdrawn from Rome after a few days, the shock to Christian morale remained.

The bishops expected Augustine, their most renowned theorist, to respond to the pagan taunts and explain the Visigothic disaster and the steady political decline of the empire in terms of a Christian philosophy of history that would make the members of the Church still feel good about this painful development. It was not an easy task that Augustine had undertaken.

The lengthy manuscript Augustine was composing lay open before him at his desk and once in a while, as Vincent talked, he would take a furtive glance at the page open before him. Augustine was used to writing long and complex theoretical works in the midst of the hard labor and constant pressure of being a Catholic bishop in a provincial North African town. He engaged constantly in the resolution of judicial disputes in and among Christian families, which alone took up many hours each week, on top of preparing and delivering sermons, for which he was famous throughout the Latin-speaking world; gave counsel to troubled members of his community, and trouble was escalating rapidly as Roman Africa's economic and political structure deteriorated; and kept up a stream of correspondence with bishops all over the Mediterranean on a host of issues. Augustine was very much a hands-on bishop. He had very little assistance beyond an overworked secretary.

Augustine offered Vincent a glass of tepid water, took a sip himself, and then moved his chair closer to that of his visitor. Until Vincent's last accusing remark that Augustine was a crypto-Manichee, or suggestions to that effect, he had been emotionally uninvolved in the conversation with this fellow North African priest whom he hadn't seen for more than three decades. Now suddenly his eyes glistened and his mouth was set with determination.

Augustine chose his words carefully and he switched from the Punic vernacular in which the conversation had begun to ecclesiastical Latin, a language in which he felt more comfortable engaging in intellectual debate.

"Malicious or stupid people attribute things to me I never said. Because my teaching envisages two communities among mankind and so do the Manichees, that doesn't make me a Manichee. I never divided mankind into two absolute, inflexible communities, as the Manichees have done. I said that *mystically* there were Two Cities, the Heavenly and the Earthly. But their membership lists are not engraved forever in stone. Membership can shift from day to day, hour to hour. When we get up in the morning we may feel we are in one of the Two Cities but by nightfall we may feel we are really in the other. From day to day, moment to moment, individuals switch from one to the other. I hate members of the Earthly City but I don't know who specifically they are, although granted, in a few instances I have a strong suspicion about that. Only God knows who belongs to each of the Two Cities and only at the end of time at the Last Judgment will the membership lists be revealed. The Manichees, on the other hand, are convinced they know who are the Children of Light—they are—and the Children of Darkness—everyone else—and they act accordingly. This is indeed a false and hateful religion. It is not my belief. Tell me, Vincent, do you think I am a Manichee?"

"No, I do not," said Vincent. "But I have read some of your books and I can see how others have come to that erroneous conclusion. What concerns me about your theology and moral teachings is not that they are Manichean. They are not. Obviously you do not, like the vile Manichees, believe in the existence of two gods. What concerns me is the constant theme in your writings of man's depravity, of the determining stamp of Adam and Eve's rebellion against God—the original sin—upon human nature and the absolute conviction you have of man's incapacity to do right and live decently and respectfully without divine intervention. This isn't Manichean dualism, of course. But your gloomy predestinarian doctrine and incessant stress upon human depravity signifies a hostile, extremely pessimistic view of human nature that practically is almost as hostile to humanity as the Manichean view. I cannot understand why human nature seems so bad to you, why human reason seems so incapaci-

tated, why human sexuality signifies only corruption and irrationality and evil, why the human body is such a thoroughly rotten vessel in your eyes. I find most people quite decent and well intentioned. I find human reason able to address itself to a lot of valuable undertakings. I find human sexuality an expression of love as well as lust. Given the guidance of the Christian faith and the counsel of our priests and bishops, I don't see what there is to be so worried about with regard to the prospects for morality and the meriting of God's love and achieving of the immortality He offers through the Son and Holy Spirit. I find Christianity a pretty cheerful religion. I can't understand all this gloom and doom you are endlessly involved in."

Augustine's eyes flashed with anger. He raised his voice and almost shouted across the little room.

"Well, Vincent, you sound like that dreadful, silly, ignorant British priest Pelagius with his persiflage about freedom of the will and easy attainment of the good life and heavenly reward—a religion for middle-class matrons and recently converted pagan lords. I can't abide it. I know that many bishops subscribe to Pelagianism and preach it in their churches. But it is not the true Christian faith. St. Paul taught that by our own efforts we cannot merit God's love. We can only be sanctified, made whole and holy, by faith. But it is the faith that God gives to some and not to others. *We can't love God unless He loves us first.* And every day I see practical confirmation of Paul's teaching. Just look at the rottenness and depravity, the violence and terror, the corruption and devastation all around us. As for sexuality, I have found that it extinguishes reason and allows the sloppy, stinking, ever deteriorating body to absorb and corrupt the mind. Sexuality is human depravity and the impotence of reason carried to their extremes. Sexuality signifies the nightmare sleep of reason, the loss of control over our lives. So this is why you are here, Vincent? To join the other bishops in throwing the simple-minded propositions of that abominable British priest Pelagius in my face? Why did you bother to make the trip from your town? Why not send me a mean and supercilious letter like all the other magnates and millionaires who have rushed to support Pelagius, as well they might, because he has promised them the keys of the kingdom of heaven in exchange for a little bit of charity and church attendance and the utterance of pieties on appropriate occasions."

Vincent regretted arousing Augustine in this manner.

"As you have just acknowledged, Pelagius' doctrine of freedom of the will and attaining of heaven and God's love through human merit—this doctrine is widely held by the bishops. It is sad to see that you, Augustine, the Church's greatest theorist and most eloquent writer, puts himself at the marginal extreme and propounds a view of human nature in which many hear overtones of the Manichean hatred for mankind."

Augustine spoke more calmly now.

"Some people, Vincent, talk as though I invented the problem of predestination and free will, as though I concocted this theological conundrum for my intellectual delectation as some sort of game. But it is right there in the Hebrew Bible, the Old Testament that is supposed to be the foundation of our faith. The old Hebrews speak of God's omnipotence and his determination of events in human life. At the same time the Bible says we must do good, we have the freedom to do good, and if we do not we will be punished. The Hebrews thus spoke of *both* predestination and freedom of the will. This left it to St. Paul, and me, to resolve the conflict and we have done so. That it doesn't please the episcopal lounge lizards—that's not my fault. I am convinced of this: we are responsible for our own damnation but God is responsible for our salvation. That is the essence of the Christian faith. If you don't believe that, you are not a Christian. I didn't make this up. That is the message of the Old and New Testament."

Vincent took a deep breath and looked directly at the severe little man with the dark face. "Augustine, I haven't come here after a three-day trip to either denounce you as Manichee or defend Pelagius. I apologize for having raised these matters. What I am here for is to represent the Donatists. You may have heard that I am a bishop in the Donatist Church. Thanks partly to your attacks upon us we are in decline, but there are still millions of Donatists in Roman Africa. I have come to beg that you leave us in peace and especially that you cease calling upon the Roman governor to persecute us and force us to convert to the Catholic Church. Whatever you think of us, it seems strange that a thinker of your stature should advocate the use of force to alter religious beliefs."

"There is nothing strange about the matter," said Augustine.

He had for several minutes already suspected from the conversation that Vincent was a Donatist. Many advocates of Pelagianism were also adherents of this heretical North African church. Augustine recalled that for several years he had heard that an important leader of the heretical North African Donatist Church was named Vincent but he had not associated the name with the boyhood companion he had long ago lost contact with.

Now that Vincent had revealed the real purpose of his visit, Augustine was eager to confront the issue that Vincent had raised. Augustine had gone over it on paper and orally hundreds of times. He had spent more time in debate with and about the Donatists than any other matter in the two decades he had been bishop of Hippo. When Augustine started as bishop in 395, the Donatists in Hippo actually outnumbered the Catholics and the Donatists included some rich and prominent people in their membership, although the majority of the Donatists were ordinary farmers from the grain-growing country that lay between Hippo on the Mediterranean coast and the menacing mountains of the Magreb in the interior.

Nowadays, the Donatist community in Hippo was a small one, due to Augustine's incessant forays against them and the help of the Roman authorities that he recruited. But elsewhere in Roman Africa there were still substantial Donatist groups. Indeed the Donatists would not entirely disappear until the Moslem conquest of North Africa in the seventh century inundated orthodox and heretical Christianity alike in what is today Tunisia and Algeria.

Almost by rote, Augustine summed up to Vincent his objections to Donatism, which took its name from one of the founders of this sectarian North African movement in the early fourth century.

"The Donatists are the enemies of the idea of a Catholic Church, of a universal Christian community. A Catholic Church comprises *both* saints and sinners, those already called by God and those who are slaves of the devil, as well as those whose destiny is not yet determined. The Church embraces in its membership both good and bad people and, perhaps more important, weak people who have repented many times. The Church incorporates the whole human race so that the means of grace, the means of salvation that God in His love and wisdom offered to all humanity through a believing

community, through the sacrifice of His Son and sacraments of the Catholic Church, should be made accessible to all. This makes for a messy church but a necessary one, a church that fulfills the purpose of the Incarnation of Christ in a human being. Remember the Church is not the Holy Spirit. It is not a pure thing. It is a mixed thing. The Church is only the earthly reflection of the Holy Spirit, like the shadows on the wall of Plato's famous cave that only very crudely and in distant outline reflect the transcendent ideas. It is the Eternal Word become flesh and again becoming flesh in each successive generation."

"I agree with the last sentence you have just propounded" interrupted Vincent. "That shows there is no sharp divide between us."

"But you Donatists," responded Augustine, "want the Church *at this very moment* to become purely the Holy Spirit. You want it immediately to consist only of saints, and only sparkling clean ones among those! That is a sectarian, not a Catholic Church. Blasphemously assuming God's providential role in history, which postpones the separation of saints and sinners until the Last Judgment, you want *now*, this very moment, to create a church of saints alone. This kind of sectarian church would have small membership and modest resources. It would be feeble. It would have little power in society. It could not effectively carry out its missionary work, all the more important now that Germans, who must be converted as soon as possible, are in our midst. Since a small, sectarian church of saints alone could not offer the means of grace to all mankind, and since it would lack the personnel and funds to convert the Germans, the Donatists are recklessly selfish people. They want a church that is their own little club. They want to keep the Good News about salvation through Christ Jesus to themselves. We Catholics, following St. Paul, want to open the Church's doors to everyone: Jew or Gentile, slave or free, Roman or German."

"Of course so do we of the Donatist Church," said Vincent. "All are welcome as long as they have already received God's grace and are pure in spirit."

Augustine took a sip of tepid water and glowered at Vincent.

"That isn't what St. Paul meant. He was creating a church, not an exclusive country club. I also oppose the Donatists because they have a false position on the nature of the priesthood and the sacraments.

We Catholics believe that the sacraments—like baptism and the Eucharist—are always effective means of grace if the priest has been legally ordained, irrespective of the priest's personal life. Of course we want all priests to be saints, but we know human nature being what it is, many of the clergy will fall well short of perfection in their personal behavior. That doesn't bother us very much because we know that it is the priest's ordained role, not his personal character, that makes the sacrament work, to make real what it signifies. The priest is Christ's surrogate when he offers the sacraments to the laity. You Donatists, however, insist that the ministration of the sacrament by a personally unworthy priest is invalid. If the priest isn't pure and holy then the wine and bread in the Eucharist, in the Mass, don't mean anything, you claim. No transformation into Christ's blood and body has occurred. That view is a misunderstanding of the nature of the sacraments, which are Christ's, not the priest's. The latter is merely representing Christ. Your view of sacraments and priesthood leads to chaos—the incessant scrutiny of a priest's character and behavior by his parishioners, so he cannot get his work done."

"It is true," said Vincent, "that we Donatists demand very high standards of behavior and character from the clergy. They are supposed to be ministers of Christ. If the priests are not visibly spiritual people, the laity, the ordinary members of the Christian community, will become confused and demoralized."

Augustine was becoming angry and impatient with Vincent.

"That attitude may be suitable for a monastery, Vincent, but not for the Church's functioning in the world. Your view doubts the power of a loving God to communicate to all sorts of people, to realize His love for us through the Word becomes weak, frail, at times sinful flesh—not disembodied spirit. The idea of a Catholic Church is the operation of God's love and majesty in and through the ugliness, the violence, the disorder of actual human life."

"We want," said Vincent, "to separate the Church from the turmoil of society."

"On the contrary," responded Augustine, gesticulating with his right hand, " Donatism threatens constant turmoil in the Church. It will involve the purging of the priesthood and its reduction to a much smaller group. That means that the Church will lack the req-

uisite number of priests to carry out its mission—God's mission of nourishing and forgiving, a power to forgive you somehow seem to limit. If the Donatists had their way, there would be chaos. Laymen would shop around incessantly, looking for a saintly priest. Holy men who prefer to withdraw from the world to communicate with Christ would have to be summoned back from the desert or be dragged out of caves and monasteries to serve as priests because there would be a terrible shortage of saintly clergy. Everything about Donatism, whether viewed theoretically or practically, is wrong. That is why I oppose the Donatists so strenuously, even though personally they are good people whom I love. They threaten the stability of the Church and erode its capacity to play the transforming role in history and society that God has assigned it."

Vincent was taken aback by Augustine's onslaught. He had read some of Augustine's polemics against Donatism and he was familiar with the arguments. But hearing them in person and presented in such a vehement and unqualified manner made Vincent feel weak and inadequate.

"You and I have very different views of what the Christian Church should be, Augustine. Yours is a church of power and majesty; ours a church of piety and devotion. Yours is a universalist conception of the Church; ours is a sectarian one. Let us leave that issue aside. What I am here to protest is that you won't leave us alone, even though in Roman Africa the Catholics now have a substantial majority of the people and the membership of the Donatist Church is fast declining. Yet you seek to obliterate us entirely by bringing in the state to impose forced conversion upon us. Consider the implications of what you are doing. You want to incorporate millions of people into the Catholic Church who don't want to be there. How will that contribute to the stability of the Church you value so highly? What kind of Catholic Church will it be with so many unwilling members? Secondly, think of the long-term implications of your persecuting policy for relations between church and state. You are setting a precedent for the state to intervene in the Church's affairs. You are giving emperors and governors a thirst for power over the minds of men and women. Remember how before the first Christian Emperor Constantine there was persecution of the Christian Church in many places, including here in Africa. Remember

how aggrieved we were when the Church was persecuted by Roman power, when the bishops were called upon to hand over the Holy Scriptures to Roman soldiers. Now you are summoning the state back into matters of belief. Isn't it much wiser to keep the state out of the Church's affairs? What puzzles me also, Augustine, is your soft line on the Jews as compared to the Donatists. You have expressed the view that force should not be used to convert the Jews. You let these Christ-killers off the hook, but you want to use political force against the Donatists who are, like you, devout Christians of a high moral character."

"The Jews are a different case," said Augustine. "Jesus was born and died a Jew. St. Paul was a Pharisee and a rabbi. I do not love the Jews. I hold them in contempt and hatred because they were offered the way of salvation and they rejected it. Yes, I have said: leave the Jews alone. The Lord Himself will reckon with them. He alone will decide on their punishment. The Jews should not be allowed to prosper at Christian expense. But force should not be used to convert them. They had their chance to receive God's Word and they refused. Now they will exist as a cursed race on the margin of society until the Last Judgment: that is my view. The Donatists, however, are the immediate responsibility of the Catholic Church here in North Africa. They are separatists and heretics who sow confusion and impede the Church's mission in society. They are Christian heretics and it is very much within the power of the Church to deal with them. The Lord said to His disciples: 'Compel them to come in.' We are doing what the Lord told His disciples to do. Nor have we come to this decision precipitously. We have contended against the Donatists for three generations. Now to prevail the Catholic Church must use the state's resources. Your generation is already lost. I think not so much of your generation. But I think of the children of the Donatists. They must be rescued from sectarian error."

"And who are you rescuing today, Augustine?" said a woman's voice with a jocular lilt from the doorway of the bishop's study. Vincent turned to find a woman, dressed as a nun, whose dark facial features closely resembled Augustine's.

"This is my sister Placida," said Augustine impatiently. "She is the head of the convent attached to the cathedral. And this man, Placida, is Vincent, a boyhood friend, who is now unfortunately a

Donatist bishop. He has come here to urge me to desist from requests to the state to help us against the Donatists."

"You have to understand my brother, Bishop Vincent," said Placida, with just a faint note of mockery in her voice. "He is a man of absolute rectitude. He is an idealist in the Platonic sense. He believes that ideas exist to be realized on earth. He is a theorist who seeks the fulfillment of theory in practice. He does not compromise. He adheres to what he thinks is the right course, even if there are side effects involved that are worrisome and painful. I assure you that he is not prejudiced personally against the Donatists. He treats you the same way he treats everyone—severely. I, Augustine's own sister, have suffered from his rectitude. One of his principles is not to build new and elaborate ecclesiastical buildings. So he has done nothing to improve the cathedral of Hippo in the twenty years he has been here. While many other African bishops have raised the money to erect magnificent new cathedrals, the building here is the same run-down, shabby structure he found when he arrived here. His idea of improving the cathedral is to put up paper posters on the walls, enjoining people to do this or that, making the interior look even more shabby. He has refused to do anything for me and the nuns by way of improving our domicile. It is old and dilapidated, overcrowded and uncomfortable."

Augustine looked annoyed with his sister. He and she had been having some bitter discussions recently about his parsimonious treatment of the nuns, and here she was raising the matter of the nuns' quarters again, and in the presence of a comparative stranger, who was furthermore a Donatist bishop. This could set tongues wagging all the way to Carthage. But he was not willing to make any concession to Placida.

"I am not a brick and mortar bishop," he said quietly. "I do not hold in high esteem my colleagues here in Roman Africa who make the raising of money by flattering the rich and the erecting of impressive buildings with these funds the main point of their episcopates. As long as we have here a decent enough building in which to hold our services, that is cathedral enough for me. We must have our minds on more important things. You and your nuns have a place to live. That is enough."

Placida was now quite angry.

"I think, my dear brother," she said, "that you get your inflexible rectitude from our mother Monica. You, the eldest of her three children, were her favorite. She thought from very early on that you were a genius and would rise to high preferment in the empire. She spoiled you and allowed you to feel that any idea that came into your head was a good one. This led to a near disaster, when you foolishly joined up with the abominable Manichees."

"Well, we recovered from that soon enough," responded Augustine, a smile now on his lips. "Monica was a wonderful woman. I was fortunate to have such a good mother. I never thought much of my father—a pagan who was a business failure, a bad combination. Vincent, after I was in Italy for a few years, I lost my way. I was confused and depressed. My mother knew something was wrong and crossed over from Africa to Italy. She took care of me, my soul as well as my body. She caressed me and comforted me and showed me what I must do. Join the Church, go into a retreat in a villa in one of the Alpine passes and study to become learned in Christian theology and the Bible, just as I had previously mastered the Latin classics. Then she persuaded me to become a priest and go back to Africa and enter into clerical office. All this she guided me to do. She was coming back to Africa with me but she died in an Italian port as we were about to take ship across the Mediterranean. That was the saddest moment of my life. How happy she would have been to see me become a bishop. She was the best person I have ever known. Monica showed me that there is only one kind of life to live, a life of commitment to highest principles and service."

Vincent found himself in the middle of expression of a long-standing sibling rivalry with deep overtones of psychological tension.

"I cannot share," said Placida, "my brother's feelings about our mother. May she rest in peace but she was no saint. I found her a cold, calculating, distant woman. Remember, Augustine, how when she came to Italy she found you were living with a concubine and the son you had by that woman? Monica made you send them both away so she could get you affianced to a rich young woman of good family, a union, if you had gone through with it, that was intended to advance your career?"

"Yes," said Augustine, somewhat defensively. "It happened as you said, Placida. But disposing of one's concubine in order to enter an

advantageous marriage—that was commonly done. It was very much a Roman, if not a Christian, thing to do. You may remember that Constantius, the father of the Emperor Constantine of blessed memory, abandoned St. Helena, Constantine's mother and his concubine from the lower classes, in order to make a politically advantageous marriage. I am not proud of doing the same thing but Monica interfered to help me, after all. I never saw the woman again by whom I had a son but I kept in touch with Adeodatus, the boy, for many years. He was a brilliant lad but he died when he was seventeen. Maybe it was cruel of Monica to send away my little family and weak of me to comply with her wishes in this matter. But there are things in life that are more important than domestic cares and private feelings, and my mother taught me to rise above such cares and feelings, and I have done so. It is to my mother I owe the realization that it is God's calling and the destiny of the Church that matters over personal involvements and private hopes. I have dedicated my episcopal career to my mother's memory. No day goes by when I fail to think of her. But now in my old age I wish I also had a son. I loved that boy deeply. I miss him more than ever now that I am old."

Augustine's and Placida's family rivalry and autobiographical comments had stimulated Vincent's memory and inspired his imagination. He thought he saw a way to lead the conversation in such a direction that he could appeal to Augustine's recollection of his youth on behalf of the Donatist position.

"I remember, Augustine, when we in our early twenties and students together in Carthage, you and me and other members of our group—Alypius, now back in his African hometown of Thagaste as bishop, and Paulinus, now a bishop in Italy—we all made a vow together to live lives of the highest idealism and fullest rectitude. We regarded ourselves as the vanguard of a movement to reform corrupt and cruel Roman society and impose piety and justice upon the world. We would be a group of New Age activists who would change everything for the better. We would reject materialism and power and devote ourselves to purity and moral regeneration."

"Yes, I remember that," said Augustine, glad to have the conversation drift away from his sister's spiteful remarks about their mother.

"I wonder now if you think it was all worth it, Augustine," Vincent continued, "this commitment to a life of piety and justice. After

you went to Italy, you were very successful there as a student and you were hailed as master of Latin rhetoric—so Alypius has told me—a new Cicero. You had a professorship in Milan, which was the road to high office in the imperial government and to a career in the law courts. You were affianced to a woman of prominent family. Everything was set up for you to become one of the top people in the empire. Yet you suddenly gave it all up to become a Christian theorist, a priest, and finally a bishop. Was it worth it, Augustine, now that you look back? Was this the best road taken—best for yourself, your family, and for the Church and the empire?"

"I have thought about that occasionally, more now that I am getting older and know I don't have that many years left and I can look back and see my whole life laid out!"

Placida intervened. She was relentless in raising Augustine's relationship with the mother she hated.

"It was our mother who made you give it all up and become a priest. After she made you abandon your concubine and your son, and got you engaged to that high-born lady, she became jealous of your fiancee. She thought she was going to lose you. It was Monica who persuaded you to give up the position and honor and marriage prospects you had worked so hard and brilliantly to gain."

"No, it wasn't as simple as that," said Augustine impatiently. "You weren't there, Placida. How would you know? That's just family gossip you are repeating again. Yes, mother helped me make difficult decisions, but the initial break with my imperial career—that was already under way before she got to Italy. What happened, I think, was a very deep conflict between the unworldly ideals that our little group had been committed to back in Carthage—Vincent, that New Age activism you called it—and the way of life as a rhetorician and mover and shaker in imperial circles I had become involved in. I was very unhappy in the midst of my success as a professor, and rubbing shoulders with the imperial big shots and attending dinners at the home of my upscale fiancee. I didn't feel good about it. I knew this was not what I wanted in life. In my depressed and anxious condition, I sought the help of the great Ambrose, bishop of Milan, who was not only the leader of the Church in northern Italy—he himself had come from the highest ranks of the Roman aristocracy. He had been imperial governor of Milan before becoming archbishop. I had

attended some of his sermons and I had been impressed by the vigor of his thought, his high idealism, and especially by his splendid command of the Latin language. He was the first person I had known who could silently read Latin without moving his lips. I went to see Bishop Ambrose in his study and told him about my inner conflict. He didn't tell me what to do, what road to take, but he helped put my feelings in a broader historical and theoretical context."

"Ambrose was a remarkable person," said Vincent. "He combined the deepest spirituality with profound knowledge of the Roman traditions of law and government. He is a model for all bishops."

Augustine ignored this pious interruption. He was not inclined to go back to the issue of the nature of leadership in the Church. He was caught up in the excitement of telling again his conversion experience. He had written a whole book, *The Confessions,* on the subject but he never tired of pulling this experience out of his preconsciousness and examining once again its significance. He could never exhaust for himself exploring the memory of this cardinal event in his life. He was in a kind of reverie now.

It was blazing hot in the little study. Vincent sipped the tepid water and felt faint. Beneath her nun's robes Placida was also perspiring freely in the furnace of an African afternoon. Sweat poured down Augustine's face. His shirt was drenched. But he was oblivious to it all. He imagined once again that incomparable moment he had thrown off wealth, power, and sex and put himself into Christ, the defining moment of his life that shaped and energized and made meaningful everything also he ever experienced and thought.

"I saw myself at that time as a symbolic figure caught up in the struggle between heavenly and earthly communities. I saw myself standing at not just a personal but at a social and cultural crossroads. I saw the decision I was making was a decision not just for myself, but for the reform movement, the New Age movement we had started back in Carthage, a decision for a whole generation of intellectuals and scholars. You see, when Emperor Constantine became a Christian early in the century, Bishop Eusebius of Caesarea, the historian of the early Church and Constantine's court theorist, proclaimed the unity of the destinies of the empire and the Church. He said their destinies would be integrated to the end of time and that God would reward the empire for becoming Christian. He said there

would be a golden age of wealth and power and the Church should enjoy its imperial triumph. As time passed, many bishops became magnates, built huge churches and splendid houses for themselves, and traveled with entourages in fancy carriages like proud lords. I felt I had to reject this Christian triumphalism for two reasons. One, it was morally wrong. This was not the way Christ wanted His disciples to live. A bishop was a shepherd and he was supposed to carry out Jesus' command to His disciples: 'Feed my sheep.' Gaining imperial wealth and power was not the way to do this. I felt I was going down the road to grandeur and secular power and it was the wrong way to go."

"You see, Augustine," interjected Vincent, "I told you there is no big difference between you and the Donatists. We too stress the dangers of wealth and power to the spiritual life."

Augustine paid no attention to Vincent's bromide, but continued his excited soliloquy on the significance of his conversion experience.

"Secondly—and this is what Ambrose especially helped me to see—the destinies of empire and Church were not necessarily united to the end of time, as Eusebius had claimed. Three decades ago, when all this happened in my life, the empire was already in trouble. Already the government was in fiscal chaos. Already there weren't enough soldiers for the army. Already trade in the Mediterranean was declining and beautiful cities along the coastline were getting poorer. I knew I had to break away from the Roman destiny. I realized that our little group back in Carthage had the right idea. I had to reject the selfish, decadent life of a professor, lawyer, and government bigwig and dedicate myself to the Church and its people. And of course to do this I had to be celibate. I couldn't have a wife and family. I had to escape from the burden of the body—for sexual satisfaction, for physical comfort. I had to live an ascetic life of service to the Church. That was the great upheaval I experienced; that was the great decision I made. I haven't regretted it. I think I took the right road. Anyway, God called me to this life. I was destined by God to be what I am. At a certain moment of extreme crisis and utter despair in my life I heard the angelic voice of a child tell me to open the Bible and read, and there I found an injunction from St. Paul to throw off the demonical constraints of physical life and be born again as a follower of Christ. That voice was God's gift to me,

and my conversion, my rebirth as a Christian, was God's doing. I am convinced of that, just as the whole history of mankind is foreordained by Divine Providence. Perhaps there was something in my conversion that was essentially anthropological, that was rooted in human nature. I turned to God in my moment of desperation and anguish just as mankind always turns toward its Maker when it needs comfort and strength. I was Everyman. Yet what happened to me was deeply personal as well. I can't explain it further than that."

Augustine had become agitated. His eyes were moist and spittle was coming from the corner of his mouth. He leaned back in his chair, exhausted for the moment, as though some great force had issued from his mouth. Placida looked at him sympathetically, as if she knew how painful and strenuous it was for Augustine to get these words out.

Vincent saw his opening, the way the conversation might be directed back to the Donatist issue.

"Did Ambrose help you get started on your mission?" he said.

"I cannot recall that he did. He was too far above me and the little group around, men like Alypius and Paulinus. We went off entirely on our own. For a year or two we lived together in a sort of commune, a sort of monastery, along with my mother in a small villa on the shore of a beautiful mountain lake in the north of Italy. We studied and discussed, and mastered Christian doctrine and the Bible, and then we came down and began our careers in the Church. But we started at the bottom, in the Church hierarchy, as simple priests. Nobody welcomed us particularly. Nobody praised us. We each individually undertook a life of service and piety."

"Augustine," said Vincent with an edge in his voice, "that is just what the Donatists want—a life of service and piety. We just want to be left alone to form our own churches and dedicate ourselves to the Christian life. And yet you won't leave us alone. You want to bring in the Roman state, from which you yourself separated, whose majesty and wealth you personally disavowed, to persecute us. It doesn't make sense."

"Yes, it does make sense," said Augustine calmly, "because our little group did not separate itself from the Church. Our life of service and piety was carried out within the context of the Latin Church. In a way, we disavowed the institution of the empire but all the more we

were dedicated to the institution of the Church. The Christian life is a personal thing but it is also a communal thing. It has to be lived within the community that Christ established for mankind and brings His sacramental grace to everyone. I have never questioned the personal piety of the Donatists. Indeed I regret their piety is not at the service of the Church now. That is one reason why I want to get them back by every means possible. But the Christian life is more than personal piety. It is the fulfillment of the Church's teachings, it is reception of the Church's sacraments, it is observing the discipline and good order that the Church demands. Even hermits and monks and saints—called as they are individually by God—they are still subject to the community of the Church and must still therefore obey their bishops."

There was a look of despair on Vincent's face. He knew that he would never persuade Augustine to leave the Donatists in peace. He admired this man but he was at the same time exasperated and angered by him. He seemed such a bundle of contradictions, but contradictions that Augustine had somehow resolved in his own mind so that he had an answer for everything.

"I came here today Augustine," said Placida seeing Vincent had fallen silent, "to discuss with you that book you recommended, *The Seven Books Against the Pagans,* by that Spanish priest Orosius, a work that he dedicated to you. He exults over the decline of Rome; he separates completely the destiny of the empire and the Church; he celebrates the fall of Rome to the barbarians. In view of what you have been just saying about how and why you rejected an imperial career, I assume, Augustine, that you agree with Orosius' antiimperial view of history."

Augustine responded without hesitation.

"I applaud Orosius' book, but I do not entirely agree with him. I am convinced that the sack of Rome five years ago by the Visigoths, even though they withdrew after a few days, was a signpost to the future. Rome is going down; its era is ending before the end of time, contrary to what Eusebius said. The Church must go on alone to continue its pilgrimage. Of that I am convinced and so far I fully agree with Orosius. Yet I am more ambivalent than he is about Rome itself. I do not cheer its demise as he does. Even though I am a native African and not a Latin, even though in my own life at a

critical juncture, I rejected a life of imperial service and preferment, I am more ambivalent about Rome than Orosius is—and many of the others of his younger generation are. I will miss the Roman Empire if I live to see its fall."

"I am surprised at you, Augustine," said Placida, smiling. "You used to thunder against the Romans. Are you getting soft and nostalgic in your old age? When you go for your evening walk along the harbor nowadays do you recite to yourself the love song in Virgil's *Aeneid* about Aneas and Dido, the African princess, and dream of the glory days of old Rome?"

She was teasing her brother now. Augustine flushed and tried to avoid Vincent's puzzled look at him.

"I will admit when I walk along the harbor nowadays and look out upon the great sea, I wonder how long it will be as peaceful as it is today, what terror may be visited upon us soon from invaders crossing the Mediterranean, and how much only a few years from now we may wish that Roman power was still invincible."

"Donatists," said Vincent smugly "will never forgive the Romans for their persecution and martyring of Christians."

There was a wistful, sad tone to Augustine's speech now.

"The Romans were never as noble as they claimed to be. Even the virtues of the Roman aristocracy, we might say, were only splendid vices. But splendid they were. I wouldn't portray all the emperors as monsters and terrorists the way Orosius does. When Rome goes down we shall miss its power and law, we shall hanker after the Roman order, which provided the earthly peace which is needed for the pilgrimage of the City of God to go on. God knows when we shall be able to teach the wild German kings to provide a Roman kind of law and order. It may take a long time. We shall also miss Roman learning, its wonderful language, its literature and philosophy. When I preach in the cathedral on Sundays, and when I speak in Latin rather than in the Punic vernacular, even though the hundreds of farmers standing there shoulder to shoulder, with their families, probably can't understand more than half of what I am saying in Latin, I know they feel inspired by the sheer beauty and force of the language. There is nothing like it in the world. As time goes on I think I agree more and more with Jerome, whose new translation of the Bible into Latin I once condemned as a waste of his time. I now

see the need to rescue Latin language and some parts of the Latin pagan heritage if the empire goes down. I now agree with Jerome that ours is a *Latin* church and it must cultivate its Latinity if it is to function effectively. Whatever else happens, we need to continue to master the Latin language, much of the classical tradition, and the Roman law. We must save the best of Roman culture and put it to our uses in the Church if and when the Roman state is no more. Piety and service aren't enough. We need the tools of Roman civilization to do the work of the Church in society. We must be like the ancient Israelites who took what they needed from the Egyptians as they set out into the desert toward the Holy Land. We too must spoil the Egyptians, take from the pagan Romans what we need for the Church's work."

"Well my dear, brilliant, difficult brother," said Placida, "your own book on the meaning of the fall of Rome that you are writing—*The City of God* I think you said you are calling it—will it then be different in argument from Orosius' book even though he fancies himself your disciple?"

"Orosius' theory of history is really much like Eusebius'. Eusebius said the Romans were good and deserved to triumph; Orosius says that the Romans were bad and deserved to perish. I think no state in itself, and no group of rulers, is either good or bad. When you take justice away from the state—and this quality of justice is only derived from political service to the Church—what is the state but a band of robbers? By that I mean that in and of itself the state is just the pragmatic exercise of sovereign force in society. Whether it is Babylon, or Rome, or the Goths, the state in itself is neither good nor bad. It is just a fact of nature, just an instrument for earthly peace, for law and order. I neither bewail nor exult in the fall of Rome. It isn't important in the long run. The only important thing in history is the pilgrimage of the City of God and that is a history no historian can write because the City of God is a *mystical* community whose members are known only to God. Yet in spite of all this, I will miss the Roman Empire, perhaps for old time's sake, because I was a dark African colonial and yet the Romans always treated me well. Perhaps Virgil said something important. He said Rome's destiny was to lift up the humble and crush the proud. As a dark man from Africa, I was one of the humble."

In the summer of 429, the Vandals, a new Germanic people, much more fierce and primitive than the Goths, burst across the Straits of Gibraltar from Spain and rapidly conquered Roman Africa. The loss of Africa's grain and the passing of command over the sea within the western Mediterranean to the Vandals spelled final doom for the Roman Empire. Disintegration of the Latin-speaking half of the empire followed quickly.

In the autumn of 429 and the winter of 430, Bishop Augustine witnessed the sufferings of his people as impoverished and terrorized refugees crowded into Hippo. He insisted that no bishop in North Africa should leave his church and seek refuge elsewhere but that all bishops must stay with their communities, come what may, and give comfort and guidance to them. He did so until his death at Hippo in August of 430, as the Vandals were besieging the city.

In what was probably the last sermon he ever gave in Hippo's rickety, dusty old cathedral, Augustine offered this advice to his community (in Peter Brown's translation):

Whoever does not want to fear, let him probe his inmost self. Do not just touch the surface; go down into yourself; reach into the farthest corner of your heart. . . . Only then can you dare to announce that you are pure and crystal clear, when you have sifted everything in the deepest recesses of your being.

A medieval monk remarked that no matter how long a scholar lived and how assiduously he studied St. Augustine's voluminous writings, he could not hope to get to the end of them.

At the end of the twentieth century Augustine of Hippo remains the most influential, ambivalent, and controversial of Christian thinkers.

CHAPTER THREE
Northerners

ALCUIN OF YORK

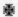

In the early Middle Ages, between the fifth century and the end of the first Christian millennium, kings in Germanic Western Europe normally did not designate a capital city, a single permanent location for the center of royal government. Government and administration were highly personal, depending on the king's presence, image, and energy. The Germanic kings were restless and often violent and impetuous people. They were nearly always greedy for war and the hunt, for booty, land, and women, and moved around from one wooden stockade, with its single high-ceilinged feasting hall and rude satellite houses, to another. Kings also sojourned a while in prized hunting lodges and in encampments on the perpetually roiling frontiers.

Early medieval royal government was a spatially movable feast, a traveling circus of power, ritual, turmoil, and self-indulgence.

The most admired and celebrated of early medieval kings, the awesome and fabled Charlemagne, king of the Franks and Lombards, who in around 800 A.D. ruled what is today France, much of western Germany, and loosely also northern Italy and a thin slice of northern Spain, was a little different from the other Germanic rulers with respect to having a fixed capital. True he too was restless and highly mobile, incessantly in search of booty and concubines and land. But he designated Aachen in the Meuse Valley, not far from the Rhine, as his principal residence, if not quite the permanent cap-

ital of his government, possibly because Charlemagne was in competition with the Byzantine emperor, who was ensconced immobile and decadently in his metropolis of Constantinople (today Istanbul in Turkey) on the Hellespont.

To the Greeks' indignation Charlemagne was also called emperor of the Romans and he erected a permanent stone enclave in Aachen. The church he built there survives—a peculiar, small, octagonal structure approximately resembling a military tent, and heavily decorated inside in the Byzantine manner with multicolored marble and gilded pictures—not a church for elaborate liturgies inspiring huge crowds like the later Gothic cathedral, but a private chapel for the king-emperor and his large family and fluctuating entourage.

To Aachen this colossal personage of the mighty Carolingian dynasty came from time to time, to rest up between military campaigns, to take council with his dukes, counts, and bishops and then issue laws for the reform and recovery of the civil arts, and to engage in clumsy playful dialogue with his court scribes and propagandists who hailed the warrior lord as King David revived.

King David was the biblical prototype of the anointed king. Charlemagne, like his father, was anointed with holy oil at his coronation. Therefore King David was an appropriate name for him. No one who flattered Charlemagne by calling him King David probably had in mind that both the Frankish and the biblical king were famous for their retinue of concubines. Charlemagne was literate—he could read but not write, a common condition of an early medieval literate layman, writing being then a professional skill of scribes and scholars. At Aachen, Charlemagne and his clerical companions played word games, jested about Roman things, and at night after a barbecued red meat dinner the emperor reposed in bed with a copy of Augustine's *City of God* and quickly fell asleep, to dream again of fighting heathen Saxons and scurvy Lombards and perfidious Moors on the frontiers.

Attached to the church at Aachen—in a space today occupied by a small public park—was Charlemagne's Palace School. The school comprised the scribes, teachers, scholars, and manuscript illuminators the emperor had recruited from the four corners of his empire to be a thriving center of book production and instruction. The Palace School more than lived up to its imperial patron's demands of it.

Nearly all of the earliest copy of the Latin classics we have today were the product of its *scriptorium*, its manuscript copying center, or satellite and affiliated book production centers in the great monasteries of the Frankish Empire. No library or publishing house or instructional institution has ever rivaled the Carolingian Palace School in its positive impact on the preservation and dissemination of the texts comprising the foundation of literate culture as it was constituted well into the twentieth century.

Like other castle and cathedral towns of the early Middle Ages in northern Europe, Aachen featured a church and a fortress, their contours scarcely distinguishable from each other at a distance. Around the central buildings were a warren of narrow crooked cobblestoned streets with two-story stone and wooden houses hunched together. Twenty yards in front of the church was a congested open-air market, and around the whole urban complex, comprising a thousand people including the royal soldiers, was a thick stone wall.

The feeling in the town and especially in the church and the school attached to it was one of enclosure and defensiveness against the vast expanse of meadow and woodland that lay beyond the town wall. This kind of circumscribed urban architecture and culture encouraged a longitudinal perception, a looking forward to and back into history, a temporal plane of thinking because the horizontal and spatial dimension was one of deadlocked duel between urban center and mostly uncharted countryside. History and tradition, the remembered past and eschatological vision of the future meant a lot to these people because the contemporary environment was so awesome and discomfiting.

Civilization represented by the town was an entirely artificial construct devoid of natural contours. The rural world was open and primitive and very little touched by human will and sensibility. The confining ambience of the early medieval church and fortress town fostered a mentality of anxious fixation upon the stark polarity between congested urban structure and untamed rural expanse.

A place like Carolingian Aachen was as self-contained and claustrophobic as a space ship plummeted down upon the wasteland of an alien planet. The inhabitants of this space ship, especially the literate and reflective scholars, perpetually felt concern for survival and endurance in the silent alien environment. They believed that relax-

ation of vigilance and departure form commitment and intense labor threatened the sudden implosion of their artfully plotted and strenuously maintained space station. The warriors and lords occasionally got out of the fortress and clerical enclave, traveled the vast extent of almost empty countryside, and became aware of its peaceful and accommodating as well as violent and destructive character. But the lower-ranking clerics saw little of the ambivalent beauty of the natural world of forest, sea, and river, and remained perpetually anxious and on guard.

In the bleakness of the damp northern clime, through the freezing cold of long dark winter days warmed only by fickle and uneven rays from a wood-burning fireplace, the monks in their heavy cowls and wooden clogs, and other clerical scribes who were not members of a monastic order but were similarly garbed, sat on long wooden benches and inscribed Latin while the texts were read to them. Or they painstakingly and expensively illuminated initial letters and whole pages on parchment made from bleached and stretched sheepskin and calfskin, paper supply long ago having been cut off from its Egyptian source by the turning of the Mediterranean into a Moslem lake.

Their eyes red and throats parched from the smoke of candles, the scholars and scribes pursued their assigned tasks of writing and reading under the shrewd leadership and stern discipline of the head of the Palace School, the Englishman Alcuin. Charlemagne had chanced to meet Alcuin of York in Italy in 780, where Alcuin had gone on an embassy to Rome, and immediately recruited him to head the school and be in charge of instruction, publication, and propaganda for the whole realm.

Alcuin was known in the north country as Albinus, "whitey," perhaps from the familiar pale skin, blue-gray eyes, and bleached blond hair of the Anglo-Saxon peoples. Charlemagne, whom Alcuin called David in play moments, addressed this resolute, quiet Englishman from York in the north as Flaccus, the family name of the Latin poet Horace. Indeed Alcuin, with all his other tasks, composed reams of Latin verse, most of it unreadable today because of its wooly didacticism, but some it surprisingly distinguished by crystalline lyricism. Alcuin also wrote orations and little treatises on the glory of the Carolingian Christian Empire, called by God to unite, reform, and edu-

cate the Germanic peoples of the rough, rude, incomplete, and rising northern world.

The northerners, white heroes and hunters, came two millennia before Christ out of the bogs and forests of Scandinavia and reached the Rhine and Danube where the Roman army held them back for a while. But the Romans ran short of soldiers and had to let some of the Germans cross the Rhine and join the Roman army. In the fifth century the effete empire fell apart and the blond German warriors surged across the Rhine en masse, and Gaul became Frankland.

The new northern kings fought and slaughtered each other and there was chaos and enfeeblement of government and civil order. The rich, cool Gallo-Roman lords retired to their walled villas and tried to ignore the German kings. But the latter pursued the Romans into their aristocratic enclaves and married their scions and created a new nobility of the north from the forced unions.

In the late seventh century, the Moslems conquered the Mediterranean and the center of European life shifted northward, to the fertile valleys of the Seine and Loire. Here a fierce and fecund family, the Arnulfings, trained a cohort of armored knights on horseback. The oat crops grew tall in the northern river valleys and the ripe grain fed the heavy head-high horses the Frankish armored soldiers needed to carry themselves to battle.

Frankish calvary stopped the Arab invasion of France in 732 and then this upstart family seized the crown from the old Frankish ruling family and got the pope's blessing for it. An English missionary, St. Boniface, arranged this legalized usurpation of the Frankish crown and he poured holy oil on the head of the leader of the great family, and said it was God's will the new family of the north should rule and conquer.

The great Arnulfing family became known as the Carolingians and its hero Charlemagne ruled and fought for a long time. In his shadow arose a new civilization, the First Europe, beyond the effective limit of the old Roman Empire. But the Carolingians wanted to be seen in succession to the Roman emperors and Alcuin helped them in this glamorous transition game.

On an April day in the year 796, the head of the Palace School, Alcuin of York, was sitting by himself in the main chapel of the small but ornate church at Aachen. He had left the busy scriptorium (writ-

ing office) of the Palace School with its dozens of monastic scribes taking dictation and setting up a clatter from the scraping of pens on parchment and shuffling of chairs and clog shoes on the wooden floors.

Alcuin was sixty-four, old by medieval standards, and his health was deteriorating from recurring bouts with malaria. He wanted to retire from his onerous job as chief educationalist and publisher of the Carolingian Empire and the daily managerial pressures of running the Palace School and the huge publishing operation attached to it. He had sent a letter to Charlemagne, who was fighting in Saxony again in northern Germany, asking to be relieved of his duties in Aachen. Formally, Alcuin requested retirement to his homeland in York but informally he let it be known to Charlemagne that he would like the privileged position of abbot of the old monastic community of St. Martin of Tours in central France.

He felt he could live out his declining years comfortably at Tours, a large and very wealthy abbey. As the top scholar, poet, and teacher in the empire, Alcuin felt eminently qualified for this position. It is true that he had never chosen to be ordained a priest; he was only a deacon in the church. But this did not disqualify him from becoming the abbot of Tours. Although most abbots were priests, there were some who were simply laymen, not even deacons. Truth to tell, what qualified you to become an abbot in the Carolingian Empire was neither sanctity nor learning; it was political and family connections—like the qualifications for the presidency of an Ivy League university today.

Alcuin/Flaccus/Albinus sat daydreaming of northern England in the imperial chapel in Aachen after lunch, thinking of his last visit to his homeland in Yorkshire six years previously. Today he was expecting a visitor from his homeland, a young priest named Eanbald. There had been a Viking raid on monasteries in Yorkshire where Alcuin had received some of his education and he was anxious to learn the extent of the destruction and what the situation was there now. At times thoughts of his friend and lord Charlemagne also passed through Alucin's mind. From the first day they met in Parma in northern Italy in 780, while Alcuin was on a mission to Rome for the archbishop of York, there had been a warm friendship between the two men. In 782 at Charlemagne's repeated insistence Alcuin

had gone to work for the emperor as head of the Palace School and had carried an enormous workload of publishing and teaching for fourteen years.

There had been many good moments. Alcuin proclaimed Charlemagne as the Davidic head of the Christian Empire and Charlemagne gave Albinus the task of recovering the Latin heritage and disseminating it all over the empire. In recent years there had been tensions on matters of policy between David and Albinus but there was still a closeness between them. Alcuin wondered how Charlemagne would react to his letter of resignation from the Palace School and informal request to be transferred far away to Tours. Charlemagne too was getting old and he was increasingly short-tempered and crotchety. The number of his concubines was noticeably declining, a bad sign.

"Master Alcuin? I hope I have not disturbed you."

Alcuin's reveries were interrupted by the high-pitched voice of a tonsured English monk. "Well, Eanbald, I hope your trip from York was pleasant. There are so many brigands on the roads these days."

"I had no trouble. I am very glad to be here. I stopped first at the scriptorium and the scribes told me you were here. I was astonished to see so many clerks at work on manuscripts in one place."

"Yes, it is a very big operation, something we wouldn't have dreamed of forty years ago at York Cathedral, where I began copying and editing texts. Then we never had more than three or four scribes working at once. Now we have three or four dozen here and produce two or three hundred books a year. We use up the skins of whole flocks of sheep and herds of calves for the parchment. This is the front line of literacy here. We are providing the written material to roll back the old oral culture of the Germanic world and create a literate culture based on Latin learning and expression. I think we have had a lot of success, not only with the recovery and dissemination of literary and religious texts but in making people all over the empire conscious of the need to put things down in writing, such as in the records of land-holding and drafting of regional laws and mandates for the performance of royal and church officials."

Eanbald grimaced.

"Then, Lord Alcuin, it is all the more sad when I have to tell you the consequence of the devastation in your homeland of Yorkshire

from the raids of heathen Vikings. The monasteries that were the foundation of Latin learning in Yorkshire—Lindisfarne, where the illuminations of the Gospels in the Irish manner were made, and Jarrow, where Bede wrote his wonderful books of history and biography—were pillaged and burned by the terrible Danish invaders. The buildings are in ruins and the communities, those still alive, are dispersed. The king and nobility of Yorkshire think it too expensive and difficult to rebuild these monasteries. They will remain empty ruins."

"The king and nobility of Yorkshire are evil men! God's curse upon them!" shouted Alcuin. His pale face had turned red with anger. "I had a premonition when I visited Yorkshire a few years ago that something like this could happen. The king and nobility had become selfish, crude, materialistic. All the idealism that once graced the noble families of my homeland was eroded. The venerable Bede, our master, the wisest and most learned of the Anglo-Saxon race, saw this coming before he died sixty years ago. He warned about the corruption of the people and the decline of the high ideals that had made the English a truly Christian people after their conversion from heathen darkness. We learned Latin from the pope's missionaries, we imported Latin books from Italy, we built great libraries, we learned the delicate ways of Irish art, and also learned Greek at the feet of the Irish missionaries—and now this, decline and emptiness after a hundred years. England was God's country. It floated like a jewel in the northern sea. It was the savior of Europe, the generation of continental recovery after the devastation of the Frankish invasions through those great, wonderful English missionaries, who set out to convert and educate the Germanic peoples, alone, without bodyguards, risking their lives. You know that my kinsman, Willibrord, was a missionary among the wild Frisians in the Low Countries. The incomparable Wynfrid, who became St. Boniface, was the apostle to the Germans on the Rhine, the first bishop of Mainz, and then the reformer of the Frankish Church. As an old man, Boniface was martyred by heathen Frisians. It was Boniface who arranged the alliance between Rome and the Carolinginan family. It was he who anointed the Carolingians to the throne and made possible the wonderful things our master Charlemagne has done."

"I am very sorry, Albinus Flaccus, to bring you such bad news," said Eanbald uncomfortably. "But the Archbishop of York thought you should know. He sent me to tell you."

For several seconds there was silence in the dark, cold chapel. Alcuin sat hunched over. There were tears in his eyes. He crossed himself and said a silent prayer. He remained motionless staring at the jeweled gold cross on the altar. Then he began again to vent his rage against his countrymen.

"What is there about the English that they begin so well and then run down into ossification, corruption, and betrayal of the high ideals they once cultivated so brilliantly? What is there about the English that they do so well abroad, as in Mainz and here in France and in the Palace School, and then behave so meanly and selfishly at home and let everything that is noble and creative deteriorate and fall apart? Perhaps the Irish were right after all. We rejected affiliation with the Irish Church because we thought it was too separate in its organization and practices from Rome. We espoused the papacy as our master, and told the Irish missionaries in northern England to pack up and go home. The Irish monks did so, but they said that in the long run the glory of Christian piety and learning would depart from us, that we were too greedy and selfish, that our lords were too interested in power and wealth, that the momentum of idealism would not be sustained in England. Now this has happened. That rich country, my homeland, blessed by God for its fertile soil and green hills, its abundant grain and thick fields of cattle and sheep, now it falls prey to the mischief of kings and the predatory accumulation of nobles. When a crisis comes, and sacrifices must be made, and heavy taxes need to be imposed to rebuild the great monastic centers of the north, Lindisfarne and Jarrow, from whence flowed the learning and devotion that transformed all of Europe and embedded themselves in the Frankish race and fired the nobility of its realm to resist and throw back the evil Moors from Spain, when this critical moment came, the English ran away. They retreated into their private affairs, their family pursuits, and betrayed the common-weal. Today I am ashamed to be an Englishman."

"Perhaps in a year or two, the king and nobility will see the error of their ways and rebuild the monasteries," said Eanbald, who felt anxious and guilty in the face of Alcuin's tirade.

"No, they will not change. The grace of God had departed from the English people. They will not recover. They are on a trip to oblivion—they will just be another offshore island, like the others, the locus of ice and ignorance. I am glad now that although my letter to Charlemagne seeking to be allowed to leave the Palace School said I wanted to retire to my homeland at York, I told several of the lords in Charlemagne's entourage I really wanted to become abbot at Tours. When last I was at York six years ago, I felt hostility to me as an alien and jealousy at my position here. I knew if I retired and went back there I would be badly received. I would be treated as a nobody. Now I am doubly glad I asked the emperor to transfer me to Tours, because there is very little in Yorkshire to go back to. Its great centers of art and learning are no more. At Tours there is a splendid library and a very active scriptorium. I can continue my work of writing and publishing there, with freedom from the heavy responsibilities I bear here. In York I would be in an intellectual backwater and be persecuted by the jealous monks and ignorant priests besides. I am sorry to have to say these things to you, Eanbald. But that is how I see what has happened over there. I am sure there are good young people like yourself at York—young monks and scholars who are idealistic and dedicated to learning. But frankly there is no hope now you will be able to do the fine things that were possible in York in my day. Perhaps you should stay here in the Palace School. Yes, I can arrange that for you."

Before Eanbald could respond, there was a clatter of metal on the stone floors. Eanbald looked up to see coming down the main aisle of the chapel a stout figure, well armored but carrying a large wooden cross on his neck. A cloak commonly worn by French bishops was thrown over his chain mail armor.

"My dear friend Arno," said Alcuin, his pale gloomy face lighting up with a delighted smile, his drooping eyes opening wide. "You have returned at last from Saxony. I have waited long for you. You are several weeks overdue."

He turned to Eanbald to introduce his friend. "This is the famous Bishop Arno of Salzburg, whom I call the Eagle not only because of his bravery in battle at Charlemagne's side against the Saxons and other enemies, but because he flits around so much, never content to stay long in one place—and certainly not in his Austrian diocese."

The smile on Arno's face was briefly broken by a frown. "My bishopric does well enough without me. I have many duties to my lord Charlemagne."

"Indeed you have," said Alcuin, "the emperor values no bishop more than you as counselor and courtier. Arno, my friend, this young monk has just come from my homeland in Yorkshire. He has brought me devastating news. The great monasteries of Lindisfarne and Jarrow were sacked by the Danish Vikings and the foolish, selfish English king and nobles will not rebuild these convents, the jewels of Latin Christendom, but will let them stay ruined and empty."

Bishop Arno's reply surprised Alcuin by its ambivalence and caution.

"My dear friend Albinus," said the Eagle, "you should not be too hard on your countrymen. Rebuilding those great old Yorkshire abbeys would be very expensive, and restoring their glorious contents would be well-nigh impossible nowadays. Remember that these old communities of monks were built up over time and lavishly stocked with books and artworks, some of which were imported from as far away as Rome. Now these abbeys' buildings are in ruins and the Viking marauders have made off with most of their precious contents. How could an English king and nobility restore the glory of these monastic establishments? It would be a crushing burden on the people of Yorkshire to re-create Lindisfarne and Jarrow as they were. To rebuild and furnish them as ordinary houses, less celebrated—what is the point of that? There are plenty of such ordinary monasteries in England."

Alcuin tried to restrain his anger.

"You speak as a courtier, Arno, more than a bishop, as layman rather than as a priest. My beloved friend, the Eagle, I am very disappointed in you. You have been away from here too long—too long doing the emperor's political business, too long consorting with crude nobility and greedy baronial bishops. I would like to ask you, in view of this compromising attitude you have expressed: What do you think we are doing here? What is the point of the Carolingian Empire? Is it just another big Germanic kingdom? Is our lord and master Charlemagne just another military commander seeking booty and land? Have not you and I always agreed that the empire was dedicated to the highest Christian ideals? To learning and

liturgy, to art and philosophy? Didn't we want to supersede the noto-
riously violent, selfish, and illiterate way of the nobility of northern
Europe? Did we not get from Charlemagne a commitment to create
something special, founded upon Latin learning and Christian
piety? I thought we aimed at a Christian world dedicated to the
highest ideals of conduct and learning. If centers of learning and
piety like the two in England are lost, how can we advance to our
goal? I did not leave my English homeland and my family to provide
services for selfish and violent nobility. I did it to advance the cause
of the City of God. Isn't that what we are doing here?"

"My dear friend Albinus," said an anxious Arno, "you know I
believe in the same ideals you do. But this is not a simple world. Dif-
ficult choices face us all the time. You know that this is the Eagle you
are talking to, who has stood beside you all these years and tried with
all my being to realize your vision of a Christian empire. All I am
saying is that you cannot expect noble families to make great sacri-
fices. Much had been accomplished in France and England. But you
can't expect princes and nobility here as in England always to sustain
old monastic communities in the face of changing times."

Eanbald found the conversation getting too personal and tense.
He begged leave to withdraw, saying he wanted to rest up after his
long trip from England, and he was excused. "My dear Eagle," said
Alcuin, "do changing times mean acquiescence in the Viking depre-
dations?"

"Remember, my dear Albinus, that the Danes and we English and
Franks—and the Saxons whom Charlemagne is trying now to sub-
due as well, and Austrians in my bishopric—we are all part of the
same Germanic race that a long time ago started out in Denmark
and Norway."

"I don't regard the heathen and violent Vikings who sail up En-
glish rivers and sack monasteries and pillage cathedrals as my peo-
ple," said Alcuin. "In any case, shall we allow these brigands to ruin
our civilization?"

"Our civilization may suffer a bit from these Vikings," said Arno,
"but it will not be ruined. We shall go on as before. Our great
churches, our wonderful libraries, we may suffer losses here and
there, but the Christian Europe of the north we set out to build, it
will endure and in the end prosper. Still, we have to recognize that

the Viking invasions represent problems and that adjustments have to be made accordingly. Both in England and here on the continent we may have to abandon an illustrious abbey occasionally if the Danes have sacked it—it may be just too expansive to rebuild and restore. Whether we like the Danes or not, they are becoming part of our existence. I hear that Ireland has suffered much more severely than England from the Viking intrusions. You can be sure the Vikings will descend upon us here in France, too, sooner or later, if not this year, then in a few years' time. We should take the advice of St. Augustine when the Roman Empire was invaded by our ancestors, the Germans. We should convert the Danes, educate them, and incorporate them into our world. Eventually they will settle down, engage in commerce and agriculture, and be just like everyone else."

Alcuin saw an opportunity to raise an issue that had been greatly bothering him—Charlemagne's continuing war against the Saxons in northern Germany, which was taking up a great deal of the emperor's time and attention and the resources of the empire. Arno had just come from the Saxon front.

"Eagle, is that what Charlemagne is doing in Saxony? Has he succeeded in pacifying and converting the people there? The Saxon war seems to be endless. The Saxons are still resisting and those whom Charlemagne forced into the Church by the sword are discontented and rebellious."

"I can tell you what happened" said Arno. "It is an unfortunate situation. After the Saxons were brought in large numbers into the Church, bishops were appointed over them, who proceeded immediately to levy a tithe upon the people in their dioceses. The Saxons were angry to discover their conversion to Christianity meant an ecclesiastical 10-percent tax and rose in rebellion."

Alcuin shook his head in disgust.

"What was the bishops' hurry? Why not wait a few years, perhaps a whole generation, before levying tithes on them? The Saxons have to be won over with love and generosity, not power and greed."

Arno sensed trouble arising from Alcuin's persistent indictment of the nobility and clergy. He foresaw a bitter split between Alcuin and Charlemagne. He decided it was time for plain speaking.

"I regret to say, my dear Albinus," said Arno, "that you have become too idealistic and out of touch with political reality in your

old age. You don't see things from the point of view of the French nobility. You are after all a colonial, a man from the frontier of the empire, and like all colonials you are too idealistic, too puritanical, too harsh in your judgment of the rulers of the empire, too hasty to indict the nobility upon whom falls the burden of ruling the empire. Those who hold this responsibility know that extremism will do no one any good. Your expectations, Albinus, are too high, and perhaps a little bit dated. You have misjudged the significance of Willibrord and Boniface and the other great English missionaries. They made great progress in imposing Christian ideals upon society. But they started from almost a zero base. Now we have all been converted in France. Now the Church is triumphant here and about to be in Saxony. We are now at a different stage of development. We have gone well beyond the era of Willibrord and Boniface. Now the situation is more complex. *It is no longer a matter of imposing the Christian faith upon society. It is a matter of how the faith will function within society—quite a different issue.* We will never get the high-born and noble families to offer their sons to the service of the Church if their only prospect is to imitate Willibrord and Boniface as missionaries and martyrs. The nobility are glad to prepare their younger sons for episcopal careers but they take a more settled, complex, practical view of office in the Church than you do. We need these nobility. It is from their ranks that the Church leadership in France is drawn, and has to be drawn if the Church is to play a dominant role in society."

Alcuin did not give way. He felt his self-image at peril and he replied bluntly.

"You tell me, Eagle, that I am an old man, an obsolete impractical dreamer, an unsophisticated colonial, a man from the fringes and on the fringe. Yet I have been here fourteen years, and I think I have accomplished much. This I can say: literacy is much more secure in Europe now and the classical texts and an improved text of St. Jerome's Vulgate translation of the Bible are much more accessible as a result of what I have done here. Remember, Arno, I am not a cloistered monk, dead to the world and its ways. I am not even a priest. I have been a hardworking teacher, editor, and publisher. But I value the high ideals. I don't like to see so much of the Church I worked to make more effective taken over by the nobility and put to their private uses."

"Neither do I, Albinus, my beloved friend." Arno sensed that he had said too much.

The two old friends sat quietly in the gloom of the chapel for several minutes, saying nothing to each other, distressed by the split that had developed between them and at a loss for words to overcome it. There had been so many happy years when they were the closest of friends, when there was such unanimity between the two of them on every conceivable subject that the discovery of a difference of opinion on significant matters was deeply disturbing to both of them. Their concern was more grave in that they sensed that something yet more fundamental underlay their separation on particular issues.

Alcuin's outlook was that of the early Carolingian world, a springtime of exuberant hope and simple idealism and high expectations. Arno, from his place in the nobility, from his presence at the imperial court, from his diurnal involvement in business and politics and his familiarity with the ambitions of the great families of France, had come, more than he had realized until this moment, to share the view of the mature, later Carolingian Empire, with its congeries of contending worldly interests and interactive pressures and demands.

Both Arno and Alcuin understood now where the other's mentality and anxiety were rooted. But this understanding only made each more conscious of the irreconcilable mindset the other held on to.

The Eagle groped to find a subject they could still fully agree upon. The adoptionist heresy seemed a good prospect. A group of northern Spanish clergy, domiciled within the Carolingian Empire, headed by a certain Bishop Felix, had enunciated the heretical doctrine that Jesus was adopted by the Father, not begotten of the Father. This antitrinitarian theology made it easier for Spanish clergy to communicate amicably with the large Moslem and Jewish population in their parishes and dioceses and rendered them less subject to doctrinal attack from adherents of the other religions.

"I am pleased," said Arno, "that the emperor has supported us in condemning the adoptionist heresy of that obnoxious Spanish priest, Felix."

Arno had touched another nerve. The subject was not as innocuous as Arno had believed. Alcuin resumed his critical and acrimonious discourse.

"I was also pleased," said Alcuin, "that the emperor condemned adoptionism. But he has not silenced Felix. This vile heretic is free to move about the empire, advocating his errors. The real problem is not the abominable Felix. It is the Jews. There are too many of them and they are too wealthy and powerful. I blame the Jews for Felix and the adoptionists. This heresy is a judaizing of Christian doctrine. Felix and his scurvy followers are trying to please the rabbis and gain rewards from the rich Jews by denying that Jesus is the begotten son of the Father."

Arno was alarmed to hear this pronouncement from Alcuin. It was a radical questioning of the liberal policy the Carolingian family had always adopted toward the Jews.

"Albinus, the emperor has always been on good terms with the Jews and I think he would be distressed by the animosity toward them you have expressed. The emperor thinks the Jews make an important contribution to our economy, through their commercial relations with the Moslem world and the money-lending service they provide in the realm. And they are also important landlords in the wine-growing regions of Gascony, especially in Narbonne in the far south of the realm. Remember that Charlemagne chose Rabbi Isaac to be his ambassador of goodwill to the Caliph Haroun-al-rashid in Baghdad."

Alcuin smiled.

"Yes, and remember the abominable elephant that Rabbi Isaac brought back from the Caliph as a gift. An elephant! Here in France! Remember all the fuss about getting the poor creature over the Alps. The rabbi had to wait four months for the snows to melt in the Alpine passes before he could get the animal here from Italy. And of course the poor animal didn't live very long. As for the region of Narbonne that you mention, and the Jewish landlords there, I have heard rumors that one of them has married a Carolingian princess! Jewish arrogance and ambition know no bounds. It is true that St. Augustine said we should leave the Jews to Christ's judgment. But he also said the Jews should be segregated from Christian society and they should not prosper. As long as there are so many rich and prominent Jews in the empire, mischievous priests like Felix will try to appease that cursed race."

"I may share your feelings, Albinus, but I think you should use

more discretion in what you say about the Jews. You know the Jews have always been under the protection of the royal family, and I see no prospect for a change in the emperor's Jewish policy. He believes, I am sure, that Jews are valuable and should be left in peace."

"It is the same story as before, my dear Arno. It is a choice between idealism and social accommodation, between truth and compromise, and we are constrained always to choose the latter. This is not the way to build the Christian commonwealth. It is the road to corruption, decadence, and hell."

There was a long and painful silence in the gathering gloom of the late afternoon in the chapel.

"I suppose it is true that I am a naive colonial," said Alcuin. "I truly believed that anointed kingship would dedicate itself to the highest Christian ideals. When Boniface the English missionary poured holy oil on the head of Charlemagne's father, I am sure that Boniface thought he was not just implementing a diplomatic deal between the Carolingian family and the papacy, but that he was starting a new political era in France. A king who was also designated a priest would undertake the task of creating a Christian commonwealth. Yes, there would have to be a compromise here and there—the great noble families would have to enjoy their lands, titles, and other benefits of their status. But this new theocratic, God-appointed monarchy would strive to promote the common welfare according to the prescriptions set down by St. Augustine and the Church fathers. So Boniface must have believed. So I have believed. And what a man there was in Charlemagne to implement the ideals of the Christian Empire! He bestrode the north like a colossus. He was strong and handsome and intelligent, an admirer of monks and a lover of books. And indeed wonderful things were accomplished in the early decades of his reign. Nothing like it has been seen since the fall of the Roman Empire. And surely things were even better than they were in the days of the Constantine and the Christian Roman emperors. There was here in France a freshness, a vigor, a determination that seemed to overcome every obstacle. A new European world was taking shape here in the north, different from anything that had gone before. We were fulfilling Augustine's hope that the Catholic Church would convert the Germans and the state that would emerge from this conversion of

Europe would pursue eagerly the Church's ideals of justice. The rich heritage of the Christian Mediterranean world, rescued and revivified by the northern peoples, would start to grow again, to put out branches in new directions, to define its own distinctive texture. When I first came here to Aachen and for many years thereafter, I sensed these things. Something new and special was happening in the Empire of Charlemagne."

"Yes," said Arno, "I couldn't agree more, Alcuin, and the story has not run its course. There are great days yet to come."

"I suppose that may happen," said Alcuin sadly, "but I feel now something fundamental has changed. I feel that onset of a new smugness and a kind of arrogance. The great families look upon what has been accomplished since Boniface anointed Charlemagne's father as something given them, something to be assumed as their birthright, rather than something attained by the most strenuous efforts against very great odds. The ideals and institutions of the Christian Empire are for the higher nobility just a backdrop now against which they can play out their ambitious maneuvers, family feuds, and accumulation of infinite wealth. The empire has become a static thing. It is no longer, I feel, an inspiring force."

"Nothing in history ever stays the same," said Arno. "Much has been accomplished here in the north. We are at a resting point now before another era of progress commences, perhaps only a few years from now."

Alcuin was not mollified by Arno's sagacity.

"When Count Roland died fighting the Moors," said Alcuin quietly, "I had an intuition that was the beginning of the end of all our dreams. He was the hope of the future, a beautiful man who could have led the way to achieving fully the Christian Empire. He was the emperor's nephew and the most admired of the younger members of the royal family. Roland represented the essence of aristocratic honor. He was the flower of the French nobility. He stood for the highest ideals without compromise and accommodation. And of course that is why he died. He sacrificed himself for aristocratic honor and the Christian cause. Now I miss him very much, especially as the emperor grows old and his iron will is beginning to weaken and he gives into the dukes and counts and bishops who seek privilege for themselves and their avaricious families whose ambi-

tions for land and office will tear this great empire apart. The day that Roland died at the hands of the Moors was the day that dream of the Christian Empire began to fade."

"There is no point looking to the past. We must look forward," said Arno. "I will say again that you are too hard on the nobility and have too readily lost your patience with the world of lordship and power. We will work it out. This will still be a great empire. The good days are not all behind us. It may be a more complex society we are developing, but it will still be a good one. Here in northern Europe we have created something unique and very important and you, Albinus, have played a major role in that."

"More than a major role," said Alcuin sharply. "I stood at the center of things. I gave up my homeland and abandoned my kin because Charlemagne convinced me—or so I understood him—that something could be done here at Aachen that was more than good teaching and the making of books. I could gather scholars from England and Italy as well as France and create an intellectual and literary center for this great empire. I brought together here and trained young people, monks and others, who could then build up satellite schools and publishing agencies through the length and breadth of Europe, from the Rhine to the Thames, from the Seine to the Rhone. We would impose ideals upon society—the ideals of the Bible and the Church fathers. We would make this empire a pilgrimage society, a flaming chariot speeding on to the triumph of the Heavenly City. I feel now that I am old and tired and feeble that I have been betrayed, that I have failed to do what I came here to do. This empire has become the breeding ground of ambitious baronial families, of aristocratic entities, who seek not the City of God but perpetual dukedoms and countships, land and privilege, booty and lordship. Learning and church are merely instruments the nobility uses in their insatiable drive for power. Books for them are merely artworks that they display in their feasting halls along with tapestries, jewels, and concubines. Scribes and scholars are merely the servants of the great families, along with the knights and the land stewards. For this outcome I did not abandon my beloved York and my kinsmen. For this end I did not sit for all those years in the smoky scriptorium here, the pen freezing in my hand through the bitter winter days. I have heard the young nobility making fun of Count Roland, saying that he was

foolish not to have blown his horn and summoned Charlemagne when he was surrounded by the Moors, that Roland's fidelity and honor were vain and arrogant things. So they must laugh and mock me even more, this silly old Englishman with his weird tribe of scribes, scribbling away on their vellum manuscripts. Foolish old Albinus, who never sought preferment, who remained a lowly deacon and never gained the fat bishopric that was his for the asking, silly Alcuin with the obsolete dreams of a Christian empire. How they must laugh at me behind my back, the young nobility. And I suppose some of my young scholars too mutter under their breaths that they will not stay here for long but will gain preferment in the Church as fast as they can. Arno, your Albinus is a used up man, a tired man, an obsolete man. Like Count Roland, I am a dream figure from a superseded past, a chimera hanging in the air from a time that has gone, and perhaps never was."

The tears were rolling down Alcuin's face. He put his hands to his face and sobbed. Arno embraced him, and held him long, and kissed the old man on the forehead. When Alcuin had composed himself, the Eagle spoke some comforting platitudes and then said in an officious tone of voice:

"Now I must tell you that I have been sent here to deliver a message from the emperor to you. He instructed me, in response to your request to leave Aachen and retire to Tours as abbot of the great community of St. Martin, first to try to get you to stay here and continue your work. But if I thought you were adamant and unhappy, to deliver to you this letter which accepts your resignation and appoints you abbot of Tours."

From beneath his cloak Arno suddenly produced an ornate parchment document with the emperor's distinctive seal affixed at the bottom. He placed it in Alcuin's hands. Albinus read it carefully, taking in each rotund Latin phrase.

"God bless you and the emperor," said Albinus. "This is my wish. I will leave next week for Tours. Now let us go and have dinner with my colleagues in the Palace School and the scriptorium. I must break the news to them."

Alcuin of York died at Tours in 804 A.D. Charlemagne died ten years later. His son and successor, Louis the Pious, was in many ways loyal to Alcuin's idea of a Christian empire. But the forces of feudal

disintegration were already so strong that Louis could not arrest the breakup of the Carolingian Empire, which was fully under way by the last quarter of the ninth century. On the ruins of the Carolingian political world emerged in the tenth century the feudal kingdom of France and east of the Rhine the medieval German Empire.

CHAPTER FOUR
REVOLUTION

HUMBERT OF LORRAINE

For two millennia the name of Rome had stirred men's hearts and intoxicated their minds with visions of awesome imperial power. But the city on the seven hills in June of the year 1061 only in a fractured and diminished way reflected the glory and the grandeur of the ancient imperial city on the Tiber whose name had immemorially sent armies to march and kings to quake in fear. This was now in 1061 the Rome of the popes who had inherited rule of the city when the last Roman emperor disappeared in the fifth century. The pope extravagantly claimed devolution of imperial authority as well as the keys of the kingdom of heaven. But the bishop of Rome's earthly habitat was a ruined and thinly populated urban enclave that only in fleeting and distorted glimpses recalled the beauty and wealth of the ancient metropolis.

Rome was yet in its early medieval phase, not the elegant and congested city it became after 1300. Half of the old imperial metropolis in the mid-eleventh century was still deserted. The most common sight in the city was the ruins of buildings dating from ancient times with homeless paupers, wolves, and wild dogs their only occupants.

Hundreds of churches, chapels, and monasteries were spread amidst this devastated city. Frequently these ecclesiastical buildings were rededicated or renovated ancient pagan temples. Among the Roman population of not more than 50,000 people, half lived on the papal dole, as the populace of ancient Rome had depended on impe-

rial largess. Then it was bread and circuses. Now it was bread and prayers.

Hundreds of unemployed and homeless people wandered the streets, gathering around campfires to keep warm in the winter or to cook meals. Episcopal visitors from all over Catholic Europe with business—often divorce actions for kings and lords—rode on horseback or in litters through the pillaged streets, hustling on their way to the papal court.

The pope lived on one of the high ridges that surrounded Rome in the architecturally ambitious, meagerly furnished, and filthy Lateran Palace. Inconveniently far away, down below, was the old cathedral of Rome, St. Peter's Church, where the pope appeared on Sunday mornings and holy days to conduct services. The princes of the Church and heads of the papal administration, the cardinals, conducted the local and international business of the papacy from bleak apartments in the Lateran Palace.

"I hate this place," said Abbot Hugh of Cluny, perspiring heavily. "It is a dreadful climb up here to the Lateran Palace and when I get here I find it is still the same shabby, run-down, ill-furnished, stinking place it was on my last visit to Rome. Why do you let your cook throw garbage in the courtyard and why do the hallways stink with urine?"

Cardinal Humbert of Silva Candida—to give him his official title, derived from a small church in Rome for which he, as a Roman cardinal, was the titular priest; but also known as Humbert of Lorraine, from his origin in the aristocracy of Lorraine in western Germany—was nonchalant in his reply to Abbot Hugh of Cluny's complaints about Rome and the Lateran Palace.

"I can understand your distaste for our rather humble quarters here, my lord Abbot Hugh," Humbert said. "But you must not compare the papacy to the wealthy Abbey of Cluny, the glory of Christendom. The endowment from the pope's lands here in central Italy and in Sicily do not produce any more revenue than you get from Cluny's vast estates and we have to spend our income on the government of the Church and on supporting thousands of poor and unemployed people in Rome. We can't afford your elegant rooms, your exquisite furnishings, and your up-to-date plumbing and garbage disposal. The pope may be the Vicar of Christ on earth, but

he is also the mayor of a half-deserted, impoverished city and he can't spend the papacy's wealth on comfort for himself and his officers, the cardinals."

"Now I remember you, Humbert of Lorraine. Now I realize why you know so much about Cluny, although you haven't been there since I became abbot twelve years ago. You were there in the mid-forties, weren't you? For a few months or perhaps a year and then you left. Did you run away?"

Cardinal Humbert's delphic smile grew broader. Now he was laughing.

"I am not a runaway monk whom you can take back to Cluny in your baggage train, my lord Abbot, if that is what you mean. I was just a novice then and I never took my full vows. I decided that the luxurious and regimented life at Cluny wasn't for me. I wanted something more intellectual. If I had been interested in cuisine or liturgical innovation, I would have found Cluny challenging. But my interests were intellectual and scholarly. So I quietly departed from Cluny early one morning for a law school in Lorraine. Among the three hundred monks and a thousand servants in your elaborate establishment, I am sure I wasn't missed any more than if a scullery boy had absconded from the cavernous kitchen."

Hugh wasn't bothered by these sarcastic remarks. His two previous visits to Rome had taught him that Cluny was an object of envy and derision in the papal curia.

"Here in Rome it must be a slow day, Cardinal Humbert, when you don't score points against the Abbey of Cluny. Cardinal Peter Damiani published the same tiresome line about our luxury and also condemned our liturgy as overelaborate and then he took it all back."

"Damiani is a mystic," said Humbert, his sharp tongue clacking on. "Perhaps he had a divine revelation that Cluny was really a company of saints and martyrs and your overstuffed music was angelic after all. I have long ceased trying to account for Cardinal Peter's ejaculations."

Abbot Hugh laughed appropriately at this reference to Damiani's famous treatise on the sexual immorality of the clergy, complete with graphic details that made it the sex scandal book of the eleventh century, and required that the copy in Cluny's library be kept under lock and key lest it get the young monks overexcited.

"Well, my dear Abbot," said Humbert, suddenly switching to a gracious aristocratic tone. "Will you have a cup of cool red wine from the pope's own vineyard?"

Hugh was a gentleman to his fingertips. He was a scion of the family of the Dukes of Burgundy who had originally endowed Cluny 150 years earlier. He could not but accept the papal cup politely and he actually enjoyed the wine. It was cool, and full-bodied, although perhaps a year or two before full maturity—a bit tart, but in Rome what could you expect?

Hugh of Cluny was a tall and elegant man of thirty-seven. He had become the Abbot of the largest and perhaps already most prestigious Benedictine monastery in Europe, located in central southeastern France, at the very young age of twenty-five. His phenomenal rise was not surprising in view of his descent from the endowing family of the abbey and even more from his history as the personal assistant and hand-picked successor of the aged previous abbot, Odilo, who ran the place with an iron fist for many decades. Hugh showed himself to be a first-rate administrator: he brought in new endowments, began the building at Cluny of the largest church in Europe (and it would remain so until the erection of the new St. Peter's basilica in Rome in the sixteenth century), recruited brothers from top noble families in France and Germany, and enhanced Cluny's reputation as a progressive center of liturgical music and religious art. He also hired new chefs—while Cluny's monks were limited to the two meals a day prescribed in the Benedictine Rule, they ate exquisite repasts—and he expanded the wine cellar.

Hugh's personal interest, however, was in diplomacy—to settle disputes on the high political horizon, to be the all-European arbitrator and mediator of fair and lasting settlements. He was a man of peace and compromise. This was why he had come now to the city he hated, in spite of its place in Catholic legend and theory. He had been sent to Rome by the imperial Salian family that ruled the German Empire to head off a looming conflict with the papacy and to get the Roman curia to back off from a radical move it had undertaken two years previously involving the method of electing a pope.

That was why Hugh had chosen to talk with Humbert. Later he would only make a courtesy call on the current pope, a chronically ill and intellectually feeble aristocrat. Cardinal Peter Damiani, Hugh

thought, was inscrutable and unstable. The other prominent cardinal, Hildebrand, the manager of the papal administration, Hugh regarded as a grubby upstart, a backstairs political hack.

Humbert was clearly the one to talk to in Rome. He was the chief theorist of the new reforming papacy that was creating so much concern in the Church north of the Alps. He knew Greek and had been papal ambassador to Constantinople. There Humbert had precipitated the troublesome schism with the Greek Church in 1054 by throwing a bull of excommunication against the patriarch of Constantinople on the high altar of Saint Sophia and taking the first boat out of town. Nine centuries later this schism is still in effect.

It was Humbert himself who was the reputed author of the controversial papal election decree of 1059. Hugh had been asked by the German government to get it rescinded. It was Humbert who too was the author of that fiercely anti-German and provocative book that stirred theologians, bishops, and canon lawyers from one end of Europe to another, *The Three Books Against the Simoniacs*. The alleged simoniacs were three quarters of the clergy in the Western Church, now damned by Humbert as heretics.

Clearly Humbert was the man to see in Rome. Abbot Hugh was not altogether happy to find himself negotiating with a man who had once run away from Cluny, but he had been in much tighter spots. Hugh was supremely confident in his capacity to make a deal. As he sipped the unready wine and held a perfumed cloth to his nose to hold off the stench of rotting garbage and stale urine, Hugh could not but feel confident that he would prevail in this tawdry world of the Roman cardinalate.

Hugh dismissed his two secretaries and his bodyguard and prepared for a personal conversation with Humbert—Burgundian lord to a lord of Lorraine. As one ecclesiastical aristocrat to another, they would work it out.

Humbert was only ten years older than Hugh of Cluny. The great Abbot felt he was talking to a contemporary who would respond to plain speaking about issues that affected them both. This small intense man with the refined aristocratic features of the old high nobility of Lorraine was also the product of that generation of clergy that had come of age in the second and third decades of the eleventh century.

In many places in Western Europe—but particularly southeastern

France, Belgium, the Rhine valley, and northern Italy—a generation of clergy had then emerged that exhibited a reforming and missionary zeal and a burning personal piety that had rarely been seen in Europe since the cohort of Englishmen who had crossed the channel in the eighth century to work in the Carolingian Empire.

As in the case of all religious upheavals and movements of spiritual reformation, it is difficult to pinpoint the social cause of this new piety of the eleventh century. Possibly it was ultimately due to the increasing wealth and rising numbers of the European nobility, to a time of economic and demographic expansion that triggered a series of social reactions that culminated in the new piety. The accumulated learning of the great Benedictine abbeys certainly contributed to this change.

Perhaps a cause lay in the dynamic cultural forces unleashed by the transition from an oral to a literate society, by the growing literacy of the lay population who in turn demanded from the clergy a more intense commitment to social activism. Whatever the origins of this religious transformation, the generation of Humbert and Hugh was its carriers and they would alter the shape of European civilization.

Hugh chose his opening words carefully.

"I want to affirm," he said in his best diplomatic manner, "the honor in which the bishop of Rome, the pope, is held by the clergy and nobility of northern Europe, and especially by the Salian house that rules the German Empire. None of us of course questions the status of the bishop of Rome as the successor of St. Peter and the Vicar of Christ on earth, the holder of the keys of the kingdom of heaven. We bow in reverence before the crossed golden keys on the papal banner. We revere the divine traditions of the Roman pontiff. No longer is the College of Cardinals—the hinge on which the great papal door moves—disgraced by the presence in it of unworthy scions of the local Roman nobility. Now scholars and religious leaders and canon lawyers are recruited from both sides of the Alps, the very best people, and brought here to work in Rome. I'm sure that is how someone like yourself came to be here. Without the intervention of the Salian Emperor Henry III this reformation of the papacy would not have occurred, and the papal curia would still be in the hands of Roman gangsters."

Humbert had fully anticipated the line of argument Hugh would open with. He could have given the same speech himself. He heard him out smiling quietly and responded in his characteristic provocative manner.

"My dear lord Abbot, you have not made the long and arduous trip to this uncomfortable city to give history lessons. We could debate endlessly the motives of the Emperor Henry III of Germany and his role in papal history. My view of Henry would not be as benign as yours, but that is not the point. You are here to represent the imperial government which has been sending us a stream of letters protesting the papal election decree that the pope issued two years ago. Why do we not go right to this issue?"

"My lord Cardinal, I assure you I am not here as the German ambassador. I was asked by the archbishop of Cologne, who heads the regency for young Henry IV, to come down here and try to work out an amicable agreement on this matter. The archbishop could not come himself because, as you know, the imperial government is engaged in putting down a major rebellion by the Saxon nobility. With their long traditions of resistance going back to Charlemagne's time, the Saxon nobility have chosen this awkward moment for the Salian house, with a child on the throne, to make yet another attempt at independence."

Humbert had stopped smiling and his words came sharp and quick.

"As a son of noble family in Lorraine who were subjugated by the German rulers and forced into the German Empire against their will, I can imagine the intensity of the struggle going on now in northern Germany that is keeping the archbishop of Cologne at home, protecting the interests of the imperial government."

Hugh did not like to hear these remarks. It reminded him of the hostility toward the German imperial dynasty that had marked Humbert's unfortunate treatise on the simoniacs. There he had referred in biting terms to the Ottonian dynasty, the immediate predecessors of the current Salian ruling family, who had begun the subjugation of the proud nobility of Lorraine. It had been easy to estimate from Humbert's aspersions on the Ottonians what he thought of the Salians as well, and now his nationalist comments,

from the perspective of the dissident nobility of Lorraine, confirmed that projection.

"Let us then talk about the new election decree," said Hugh. "It places the election of the pope in the hands of the clergy and people of Rome."

Humbert's enigmatic smile had reappeared.

"There is nothing novel or radical about that. Election of a bishop by the clergy and people of the diocese is a very old tradition in the Church. That is how St. Ambrose was chosen bishop of Milan many centuries ago, and this was the prototype for the manner of election of all bishops. Election of a bishop by clergy and people is what the canon law texts prescribe. The election decree of two years ago merely confirmed old tradition and canon law."

Hugh's temper was aroused.

"My dear Cardinal, your smooth words are disingenuous. You are playing games with me. You know as well as I do what the new election decree represents—defiance of the authority of the Salian house, taking advantage of its momentary weakness and distraction, with a child on the throne and a major rebellion under way. Certainly election by clergy and people is the catchword phrase of the canon law, but it all depends on how the formal rules are implemented. Henry III respected the formalities, but you know that in fact he selected the pope, and the clergy and people of Rome merely did his bidding. That is how the great reform of the papacy was instituted. Otherwise the papacy would still be prey to Roman lowlifes and gangsters and you and Damiani certainly wouldn't be here—Hildebrand I am not sure of. The imperial government thinks *this* is what the new election decree means: The College of Cardinals will henceforth choose the pope, the people of Rome will stand outside the Lateran Palace and cheer the cardinals' selection, and after the emperor is informed, he is expected to send a nice letter of congratulation. Isn't that what is intended?"

"Yes, it is," Humbert soberly responded. "It is the conviction of myself and Hildebrand and Damiani and the other reforming majority in the College of Cardinals that irrespective of the services rendered to the papacy by Henry III—and we acknowledge of course the good outcome of his interventions—the papacy must be

liberated from lay interference. If the pope is to fulfill his divine mandate as the Vicar of Christ and the successor of Peter, the papacy must be free of external interference, whether from the Roman nobility or the German emperor."

Hugh was perspiring heavily again and breathing strenuously on his perfumed facecloth. He tried to control his anger.

"I am astonished that you put the emperor and the scurvy Roman nobility in the same category. Of course the papacy must be free of lay interference. But the emperor is not a layman. He is a priest, as much as you and me. He is the anointed of the Lord. At his coronation his head is anointed with the same chrism by which a bishop is anointed at his installation. The emperor is both king and priest. This theocratic principle and this coronation ceremony have been universally recognized since St. Boniface anointed Charlemagne's father to the royal title with papal blessing. Are you going against three centuries of tradition, against the fundamental principles of the Church enshrined in canon law?"

It was Humbert's turn to be dismissive of the Church lawyers.

"Some canon law texts say one thing, some another. The idea of an anointed king who is both king and priest, the doctrine of theocratic kingship, may have been useful in Carolingian times. But it is no longer something the papacy can condone. It is obsolete, without substance. Because something has been done and believed in for three centuries doesn't make it right. As my colleague Hildebrand is fond of saying: 'Christ said I am the Word, not I am Tradition.'"

Hugh exploded. "Hildebrand! He comes from an obscure family in Rome that were dependents of those mischievous, scheming Jewish converts, the Pierleonis. There is a rumor that Hildebrand's family too are Jewish converts. You let these people into the Church and this is what happens—the obliteration of tradition, the turning of the world upside down, a revolution."

Humbert retained an icy composure in the face of the blustering and angry abbot.

"St. Augustine regarded the conversion of the Jews as a sign of the advancement of the City of God, and when they are all converted, Christ would come and judge us all. I do not know the origins of Hildebrand's family, but if they are Jewish converts, so much the better. You should welcome that, my lord Abbot. It is a sign of divine

grace. Here in Rome we judge ideas by their intrinsic merit, by their contribution to freedom of the Church and social justice, not by the family background of the proponent of the ideas."

Hugh was embarrassed.

"I apologize for my unworthy remark. But I hope you can understand, Lord Cardinal, my exasperation with what is going on here in Rome, a concern shared by nearly every bishop and abbot in northern Europe and not just by the ecclesiastical supporters of the Salian dynasty. We sense some terrible upheaval is taking place here that will threaten our whole way of life, our fundamental social organization, and we cannot understand the cause of it—just when, thanks to Henry III, the papacy is more independent and esteemed than in many centuries. What is the compulsion now for extreme measures? Of course, you see me as a member of the imperial establishment, as spokesman for the Salian dynasty, even though, believe me, I am here as an arbitrator, as an honest broker. What I want you to realize is that I speak not just for myself but for the very best clergy of northern Europe when I question this novel and hazardous road you are embarked on. A few months ago I made a trip through northern France and I conferred on these issues with Abbot Lanfranc in Caen and with Bishop Ivo of Chartres. Would you not acknowledge that they are both authorities on the law of the Church?"

"Lanfranc is the chief ecclesiastical minister of the duke of Normandy," Humbert replied, "as the archbishop of Cologne serves the German emperor. I respect Lanfranc's great learning and piety but he is scarcely an independent authority on canon law. Bishop Ivo of Chartres is in a somewhat different category. He is a great scholar and not readily identifiable as a royal servant. We in Rome respect Ivo of Chartres. I would be interested to learn what he has to say."

Hugh was pleased. He seemed to be making progress at last.

"Ivo agrees with your views that there are two canon law traditions—one favoring independence of the papacy from monarchy and one maintaining the sacerdotal authority of the monarch and the legal right of the emperor to interfere in Roman affairs. He says it is not easy to stipulate which tradition has the best authority. He says the answer lies in reason, common sense, and the need for peace and stability in society. Ivo says that there may have been a time in the past when your radical view of the papacy and the Church could

have been instituted, but that moment has long gone. For the past hundred years, perhaps since Charlemagne's day, the Church and the secular world have been so intermingled that they cannot be separated now without creating confusion and disorder, possibly chaos and civil war. We have to go on the road we have been following, and your election decree, when interpreted in the radical way you intend, is the beginning of a social upheaval that will do no good and much harm in Christian Europe. That frankly is what Ivo told me. Church and society are now conjoined; the Church cannot be withdrawn from control of kings and the interest of the nobility. There will be little benefit and much damage in that."

Hugh was satisfied that he had made a very effective case. He had furthermore given Humbert a way to withdraw from his radical claims and yet save face. Humbert could say that the cardinals were theoretically right in their doctrine, but to prevent disorder, dismay, and unhappiness among the higher clergy, as Ivo of Chartres concluded, they would seek a compromise.

Humbert's response shocked the abbot. All diplomatic guile was abandoned now by Humbert. He spoke rapidly and in a loud voice. From time to time he raised his right hand and gesticulated to emphasize a point. He was the priest and prophet now, not the politician.

"I am sorry that Ivo of Chartres has joined the party of the simoniacs, the party of the devil that has sought to ruin the Church and betray the Lord. In the Bible we read of a certain Simon Magus who sought to buy the salvation from the Lord, but was rebuffed by Christ. The sin of simony is not only the outright effort to buy the sacramental means of salvation. It is also generally the corruption of the Church by the interests of secular society. It is any erosion of the freedom of the Church, whether it is the German emperor appointing a pope—or any bishop or abbot—or the nobility poaching on the land of the Church and using it for their family interests. The Church must be free at last, from the devilish snares of secular power and wealth. You cannot serve God and Mammon. The time has come when the pilgrimage of the Heavenly City will soon reach its end, when the Church is free and pure, when all Christian souls are directed to love of God. We are approaching the end of history, the Second Coming of the Lord and the Last Judgment, and the free-

dom of the Church from secular power is the dawn of this final era of history. We are at the breaking point, when the vessels of royal majesty will be smashed so that the pure water of God's love and justice may flood the world. Here in Rome we are like Noah, building the ark to navigate the waters in this apocalyptic time. We demand the emperor give up his control of the Church—in Germany as well as in Rome—and other kings do as well, that the nobility surrender their authority over Church lands, that the parish priests give up their concubines and children and exclusively become celibate servants of God. All priests must be pure, must make themselves whole and holy in the sight of God. And if the priests will not give up their concubines and families and if they will not be as saints, we will tell their parishioners not to receive the sacraments from them. The ministration of the sacraments by an unworthy priest is invalid, just as the effort of the emperor to appoint the pope is the sin of simony in the eyes of God."

Hugh was more afraid now than angry. Humbert's eyes were flashing and his arm pumped the air. The cardinal was in a kind of trance. His voice seemed to come from somewhere deep inside of himself, not his throat. Hugh felt he was dealing with a man in a state of mystical exaltation, hurling religious thunderbolts.

The abbot had plenty of experience with this kind of extreme religious behavior. When he beheld this among his own monks, he put them in isolation for several days, and when that didn't help, exiled them to an isolated satellite priory in the mountains. But Humbert he would have to respond to. He had no authority over him.

"Lord Cardinal, I beseech you to remember that you have just espoused the damnable Donatist heresy that Augustine spent his whole episcopate combating. I am a church administrator, not a theorist, but I know enough doctrine to affirm that Augustine stated that an ordained priest's ministration of the sacraments is in Christ's place and the sacraments are valid irrespective of the priest's personal life. It was heretical Donatists who insisted all priests be saints, as you are now doing. They wanted a sectarian church. It was Augustine who envisioned a Catholic Church wherein even among the clergy there would be saints and sinners."

Humbert's fierce discourse did not moderate.

"There is a time for everything under heaven. Augustine spoke of

when the Roman Empire had recently become Christian, when the German invasions had begun. He had to reject the Donatists, although he loved them, because the Church as a holy remnant of saints exclusively could not have accomplished the work of conversion. Now Europe has been converted to the Catholic faith, from Cracow to Edinburgh. Now we are in a different era entirely when a Catholic Church need not suffer sinners among the clergy, when we can demand that all who serve as servants of God be pure and holy or leave their privileged posts, and that selfish men with earthly desires not place their hands upon the body and blood of Christ. If Augustine were alive today, he would hold this view. He would be on our side."

There were several seconds of silence as Hugh reflected on how he might respond to this argument, how he might stop Humbert's tirade and get him to consider practical realities.

"I cannot win a debate with you based on church doctrine and history. You are too learned and subtle for me, Cardinal Humbert. Your wit has been sharpened by years of dialectical debate, mine dulled by the cares of administrative office."

"I am an administrator too," interrupted Humbert.

"Be that as it may, you argue from theory where I am not at my best. Yes, I am a man of the world, but one who serves Christ in the world, and that is your calling too as a cardinal. So I ask that you consider the consequences of the rigid implementation of your doctrines. You have already made a schism with the Greek Church which will not easily be repaired. I too have no great love for the Greeks. But they are our Christian brethren, now engaged in a life and death struggle to keep the Arabs from taking Constantinople. If that citadel falls, the Arabs will sweep through the Balkans and invade Europe via its back door. That could lead to a catastrophe, the end of the Catholic Church, such as happened in Spain several centuries ago when the Moslems invaded it. Whether your condemnation of the patriarch and the Greek emperor was justified or not I cannot say—the final break seems to have hinged on a very obscure point of trinitarian theology that I can't even understand, no one at Cluny can. Let us say you were in the right doctrinally in this dispute. But a schism with the Greeks when they needed our moral—and perhaps physical—support against the Arabs, was that wise? It

seems to me you have been rash to foment this break now with the Greeks. You have put all of Europe at risk. This is not what the papacy is supposed to do."

"The Greeks," said Humbert, "are forever seeking our support but they have increasingly become resistant to compromise with the Latin Church in the matter of doctrine. I tried to get them to listen to reason, but they would not accommodate us, at the very time when the emperor in Constantinople is talking about seeking our fiscal and military support against the Arabs. By declaring a schism, I hoped to shock the Greeks into compromise with us."

"Those aren't the Greeks I know," said Hugh. "They do not shock easily. They are very sticky on matters of doctrine. They fancy themselves great theologians and take stubborn positions on theory. I think you might well have conceded something to them. I don't think it means that much to the Latin Church how these mind-boggling, abstruse definitions of the persons in the Trinity are defined. I think we in the West have more important things to do than split hairs with Greek theologians."

"That is too relaxed an attitude," replied Humbert vigorously. "We here in Rome have started to take theory more seriously these days."

"On the papal election you are also rash," said Hugh, "whatever the theory may be. Isn't the issue whether a good candidate is chosen pope, someone who is devoted to religious and moral leadership and is a good manager? Isn't that what we all want? Why does the format of election mean so much? Henry III appointed popes but they were good ones, better than those who had sat on the throne of Peter for two centuries. Isn't the *outcome* rather than the method of election the important thing? Granted that Henry III was a little too authoritarian. There should be greater attention to the principle of election by clergy and people. In reality though, isn't what we want that a very good person be chosen as pope through consensus between the emperor and cardinals? I am sure such agreement can always be reached."

"Getting a good candidate on the throne of Peter isn't the only important thing," said Humbert. "It is important how the pope was elected, which procedures were followed."

Hugh was growing impatient.

"You and your colleagues for sake of an abstract principle are threatening to cause a war with the emperor, who will be supported by nearly all the German bishops and abbots and most of those in France as well. Henry IV will grow up, the imperial government will put down the Saxon rebellion. Henry IV will be able in time to give attention to Rome and Italy. Then what? Do you want an armed conflict between pope and emperor? Who will prevail in such a conflict? How many divisions has the pope? And even if the pope does find military allies here in Italy—the Norman kings of Sicily perhaps, or the ruler of Tuscany in the north—even if there is a standoff, how will Christendom benefit from unseemly conflict that will reverberate throughout Europe and cause controversy and confusion everywhere? And this revival of the Donatist heresy, this is sheer madness. Not only because you are bringing back a heresy that once threatened the stability of the Church, but because you are energizing parishioners to revolt against their clergy. You are going to upset the social order. First laity against the clergy, then the poor against the rich, then the peasants against the lords. You will begin with a revolution in the Church and end with a social revolution. Is that what you want?"

Humbert's apocalyptic fervor had abated for the moment. Yet he responded firmly and quickly.

"Christ said that he brought not peace but a sword, this His kingdom was not of this world, that the poor would inherit the earth, that it is easier for a camel to get through the eye of a needle than for a rich man to enter the kingdom of heaven. Jesus preached not just the kingdom of God but a revolution in society."

Scornfully Hugh replied: "I will give you another text from the Bible. Jesus said, 'Render under Caesar what is Caesar's and unto God what is God's.' St. Paul said that, 'The powers that be are ordained by God. Be in subjection to them for the sake of righteousness.' That doesn't sound like a social revolution to me."

"And Peter said, 'Obey God rather than man,'" responded Humbert.

A look of contempt had now appeared on Hugh's aristocratic face.

"We can stand here and throw biblical texts at each other or we can talk about social realities. And I say that the road you are pursuing leads to chaos and will also lead to defeat for the papacy. This is

not the way to go. These confrontational strategies won't do anyone any good and you won't even be able to control the outcomes you are going to stir up."

There was silence. Humbert seemed to be thinking about his words carefully.

Then he spoke.

"I am disappointed, Abbot Hugh, that you take such a conservative position. You are young enough to want to give recognition and support to the new generation, both among the clergy and laity, who are not satisfied with the dead weight of the past. They believe that our Christian society and culture commands so much intelligence and wealth that it can create a much more just society than the one we have known. The world of our grandfathers and fathers was still the one that emerged after the death of Charlemagne and the breakup of the Carolingian Empire. It was a fearful world, racked by violence and hunger. Everyone had to turn toward a handful of great families for protection and sustenance. That is how the great royal and ducal families came to dominate society and the Church. But now things have changed. We have plenty of labor and food. We are no longer threatened by invasions. The Vikings from the north, the Hungarians from the east, have settled down and become part of our civilization. We are not worried by the Arab pressure on Constantinople. If things get really bad for the effete Greeks, the Latin world will have the resources to go to their aid and indeed to go beyond Constantinople and free the Holy Land from the Moslems—we talk in the papal curia about mounting such a crusade soon, and I am sure we can do it if we have to. The Moslems in Spain are already in retreat. In northern Italy, in the Rhineland, and in Flanders, industrial and commercial cities have developed and the burghers are intelligent and enterprising. On all sides we see the world changing, and the Church should change with it."

"I gladly concede that these are good times," interrupted Hugh. "All the more we should take advantage of our good fortune and not cause acrimony and confusion by needless disputes."

"Good times," responded Humbert vigorously, "means that we now have the resources to right old wrongs in the social order. Instead of being the instrument of the great families, the Church can now lead society away from domination by these kings and dukes.

When I preach in Milan, people come up to me who call themselves 'ragpickers' and 'the poor in Christ.' Sometimes they are indeed poor people but most of the time they are middle class. Whatever their social status, they are deferential toward the Church and humble in the face of papal authority. These were Cardinal Damiani's people originally—his followers when he came out of that hermit's cave on a mountain fifteen years ago and began to preach in the town squares of northern Italy. These so-called ragpickers, these poor in Christ, burn with Christian zeal and are grateful for the attention they receive from Rome. Contrast this with the attitude to the Church and the papacy exhibited by the aristocratic members of the great families of northern Europe. They are arrogant and patronizing. They think they are doing something wonderful if they do not actually pillage the Church and enslave the papacy. We are supposed to be eternally grateful to Henry III because he snatched the See of Peter from the corrupt Roman nobility and brought down some good German bishops, in succession, and made them popes."

"That was not a small thing. That was a major turning point," said Hugh quietly.

"Sure that was a big step forward," said Humbert. "That is how I got here—these German popes scoured their homeland for young people who could help them in Rome, and as a graduate in church law from a school in Lorraine I was offered a good job here and I was soon made a cardinal. But Henry III was just as much interested in asserting his perpetual control over Rome as he was in improving the papacy. And once the Salian dynasty asserted authority here, they never wanted to let go. The papacy was just another territory they had conquered, and its resources were to serve the emperor, as the German Church had served the great families since the time of Charlemagne. For centuries, freedom and justice were not implemented by the Church because it was too feeble. Now that it is strong, conservative caution is urged upon us and we are threatened with retribution from the high and mighty. I say that the time has come to impose Christian ideals on society and to seek a right order in the world. We are prepared to take the risks. We are going down the road we have started."

Hugh was calm as he spoke now, more in regret than anger.

"Cardinal Humbert, it distresses me that you, a descendent of the elegant nobility of Lorraine, whose ancestors rode with Charlemagne in his wars, should want to throw in your lot with nouveau riche burghers and freshly minted knights and bloated peasants and artisans. Why would you want to commit your loyalty and great talents to these people emerging from the bottom rungs of society? The great families are far from perfect, I will acknowledge. But they have been around a long time, and as you yourself have indicated, Europe became safe and the Church secure under the tutelage of the old nobility. Why will the new people do as well? They may fall well short of the achievement of peace, order, and prosperity that resulted from the rule of the great families. And whatever they are prepared to do, it will take them a very long time to learn how to exercise power and gain social stability. You have fantasied that these new groups will somehow benefit the Church. At best they will manipulate the Church for their own purposes and exploit the Church more severely than the old nobility who over time learned restraint and moderation."

Humbert laughed.

"Restraint and moderation? The way the Ottonian and Salian dynasties crushed the nobility of Lorraine, built their fortresses on our hilltops, and deprived our nobility of their independence and dignity? I watched as I grew up the humiliation my father and uncles suffered at the hands of these German tyrants. I saw the pain and sadness in my father's face as he bowed before the onslaught of German power. I lost my respect for the empire at that moment. When I travel north to Milan and give a sermon in the cathedral there I see the faces of the new groups seeking power, the burghers and the knights. I do not know how they will turn out in the end but under papal leadership they could be molded into the soldiers of Christ. The savagery and selfishness of the German Empire has taught me to look elsewhere than to the old aristocracy, the great families, for friends and allies. We are all called to account for our actions, sooner or later. The German dynasty chose to demolish my family's honor. I am calling them to account."

Abbot Hugh felt the lash of these bitter words. Beneath Humbert's church doctrine, hazardous as it was for the old order, was a

personal and national hatred that could not be moderated. Once this hateful frame of mind was entered into there was no hope of moderation or compromise, Hugh believed.

Embedded deep within the sophisticated political theology of the papal reformers, which Abbot Hugh disagreed with but could strenuously debate, there was something else, primordial and racial, that evoked centuries of tribal conflict in the northern world, and was impossible to contest against by rational argument.

Hugh thought he heard in Humbert's speech at the close of day the war-cries of Germanic folks, the tribal blood-feuds that once endured for centuries and decimated whole populations, the ethnic cleansing of one nation against another. This archaic culture was deeply offensive to him. It was precisely what the Catholic Church had struggled for centuries to suppress. In a flash, as Humbert expressed the hatred of the Lorraine nobility for the German monarchy, Hugh saw in his mind's eye a Germanic chieftain leading uncivilized and illiterate people as they ravaged the countryside in limitless pillage and destruction.

The sophisticated abbot lost heart. He had no taste for this regressive wellspring of the European world, this echo of primordial blood-feuds between the nobility of Lorraine and the German lords. He knew such national feelings still lurked under the surface. But he always hoped they were sufficiently repressed by all the civilized things that had been done since Charlemagne's day to keep such feelings in the deep, dark past, and away from the ambience of the Catholic world he knew and served.

It was futile to continue the debate. The abbot quietly terminated it. "I have nothing more to say. I will pray to God that He change your mind."

The abbot called for his secretaries and his bodyguard and started down the path from the Lateran Palace to the inn where he was staying. Humbert stood on the ramparts of the Lateran and watched the abbot and his entourage descend.

Humbert of Lorraine died suddenly in 1061 a few months after his confrontation with Hugh of Cluny. The loss of the leader of the papal reform movement slowed it down for a decade. The popes chosen in the following decade under the election decree of 1059 were moderate in their actions. But in 1073, against the bitter opposi-

tion of Emperor Henry IV and the German bishops, and to the distress of Abbot Hugh of Cluny, the College of Cardinals elected Hildebrand as Pope Gregory VII. What historians call the Gregorian Reform proceeded immediately along the lines Humbert had delineated in 1061 in the debate with Hugh of Cluny. By 1075 pope and emperor were at war with one another and ten years later Emperor Henry's army drove the pope from Rome and Gregory VII died shortly thereafter in exile. The disputes about the Gregorian Reform reverberated around Europe for another four decades, finally resulting in face-saving compromises that left the clergy in northern Europe as before under the control of the monarchy and the nobility.

But the Gregorian Reform did have a positive impact. Until the early fourteenth century the papacy was to enjoy freedom from control by a northern monarch. The enforcement of clerical celibacy made a significant start under the Gregorian Reform. The papal bureaucracy was expanded and modernized. The Church as a legal and administrative entity down to 1300 was more unified. And it might be argued that the emerging secular monarchies of the twelfth and thirteenth centuries learned the arts of bureaucracy from the papacy.

The schism with the Greek Church was never healed. The Donatist heresy became highly active in Western Europe even though the papacy now condemned it. By 1200 A.D. Donatism was espoused by somewhere around 20 percent of the population of Western Europe.

Hugh of Cluny died in 1109, revered as the elder statesman of the Latin Church.

THE FORM OF WOMAN

HILDEGARD OF BINGEN

The wind whistled through the thin trees on the high, rocky hills overlooking the Rhine far below. Low-hanging clouds pressed down upon the deep ravines and in the reflected sunlight gave off an eerie light that was further refracted at river level through the spray rising from the water crashing against the boulders in the Rhine's inlets.

Here on the Rhine was the western limit of the German Empire, a cold unsparing land that opened eastward from the Rhine through fearsome forests and long stretches of dry flatland, only with difficulty and patient labor turned into productive farmland. The German people of the twelfth century, gathered tightly around their tribal dukes and fiercely energetic bishops, created a peaceful and prosperous homeland from within the thrust of their intense energies and anxious determination.

Germany was not naturally blessed. It was very much a human product and the German people of the Middle Ages exulted in their own creation and were sensitive to the labor and commitment that were required to maintain it. A successful emperor would always gain messianic quality in their eyes because they continually hoped for a strong leader to reduce pressure upon themselves.

Until the heroic emperor came along, the Germans would take solace in the religion, art, music of the Church. East of the Rhine Christianity had come late, brought in by the Anglo-Saxon mission-

ary St. Boniface in the eighth century. He was the first archbishop of Mainz, and this episcopal city still retained in the twelfth century a special aura in recognition of the gift of faith and civilization that had radiated from there to the rest of Germany.

Within the archdiocese of Mainz, there was strung out, often on the hills overlooking the Rhine, a series of Benedictine abbeys. They were often built perilously high and secluded on the windy crags above the deep river. These monastic communities were heavily aristocratic in their membership. They were the German lords' gift to the Savior and His mother. These communities served rigorously as the negotiators of deals with Christ and Mary for the comfortable repose of the souls of the noble families and their early release from purgatory to heaven. This was no cant, no vague sentiment. It was a sober contractual arrangement between God and the privileged section of humanity.

To the German mentality of the twelfth century, it was emotionally satisfying and self-evidentially rational that the communities of monks and nuns should be an integral part of an artfully articulated system of personal salvation and social piety. The nobility regarded the abbeys with respect and high expectation, as we might perceive business corporations in which we have heavily invested.

The marchioness of Stade looked with disdain at the unkept grounds of the abbey of Bingen in the Rhineland near Mainz as she entered the convent's main door on a July day in 1151. Once inside she stood in the entrance hall and smelled its stale air punctuated with a faint whiff of cooking odors. By the contempt on her fine aristocratic face, she indicated how unhappy she was to behold the simple furnishings and bare walls and floors of the abbey.

"This place hasn't changed at all in a year," she said. "I came here last year when Abbess Hildegard moved her little community of twenty nuns up here to the Rupertsberg from Disibodenberg."

Hildegard's nuns had moved from one hill overlooking the Rhine to another. But Disibodenberg was well settled, with a large monastery to which Hildegard's community was attached. Here on the Rupertsberg there was nothing—just a desolate craggy hill on the great river.

"I rode the whole dreadful 15 miles in procession from Disiboden-

berg to Rupertsberg and when we got here on this barren mountain the only pleasant sight was the Rhine below. The building was rough and there were no plantings on the ground."

The marchioness of Stade was in a customary blaming mood as the wind kicked up the dust on Rupertsberg.

"Abbess Hildegard last year gave us this rosy vision of how things would change immediately. She led us to believe it would be a paradise up here in no time, a suitable convent for an aristocratic community of Benedictine nuns. I have come back a year later, and what do I find? Almost nothing has changed. The grounds wouldn't be suitable for an ambitious peasant and this building is still unfinished and unfurnished. No tapestries or carpets have been brought in. This is not a place for women of the German nobility. Not even a knight would be happy to see his daughter here. I am very glad, dear Richardis, that you have listened to me and your brother the bishop and have decided to leave this place. Even if we hadn't found you a community who elected you as their abbess, after we gave them that splendid endowment, I wouldn't want you to stay here anyway. It isn't working out well here at Bingen at all. The nuns should have stayed at Disibodenberg where they had the protection and guidance of the monastery. Abbot Kuno warned me that Hildegard couldn't build a new convent from the ground up. We all should have listened to him. He had the experience of dealing with her at Disibodenberg."

Richardis the young nun looked at the doorway with anxiety, afraid that Abbess Hildegard would suddenly appear, overhear the complaints uttered by her mother the marchioness of Stade, and there would be a fearful row. Abbess Hildegard and the marchioness had never gotten on very well. There was a natural tension and rivalry between the two women, both high-born, yet of different social status. Although the von Stades were among the top families of the German Empire, related to the Staufens who were about to take over the imperial throne, Hildegard of Bingen was a product of the local nobility, down a rung or two from the blueblood von Stades.

And now there was a maternal rivalry. Richardis knew they both regarded her as their daughter. Both wanted to control her life. And

there were intellectual differences between the two great ladies—all
sorts of disagreements on church, state, and sexuality. Richardis was
tired of their bickering and their struggle over her body and mind.
She was glad she had made the decision to leave Bingen and get out
of this long-standing conflict situation.

But Richardis was very nervous that her departure was not going
to happen without one last terrible scene as the abbess tried to pre-
vent it. Richardis discounted her mother's complaints about the
abbey's accoutrements. The marchioness was so fastidious that she
even wore her linen underwear in the summertime. Nothing ever
seemed to please her, except the behavior patterns of the imperial
aristocracy.

Yet it was true that the abbey at Bingen on the Rhine hadn't made
much physical progress in the year since the community of twenty
nuns had moved with Hildegard from Disibodenberg after years of
conflict in which Abbot Kuno tried to block the change. Richardis
knew that Bingen's underdevelopment sometimes made the abbess
take to her bed and weep for hours on end that things weren't going
well at the convent. But somehow Hildegard hadn't got around to
doing much about the ambience, in spite of all the lovely images she
had placed in the minds of her nuns before the big move, while she
was fighting with Abbot Kuno to move away from the monastery to
which the convent had been attached since it was founded by Jutta of
Spanheim, Hildegard's predecessor.

There were unanticipated money problems at Bingen. The big
endowments hadn't flowed in yet. The von Stades' gift was disap-
pointedly small. Richardis realized now her family was saving its
money to give it to that abbey up north near Bremen which had just
elected her to head it.

"Where is Abbess Hildegard, by the way?" said the marchioness,
impatiently tilting her head back in that inimitable lordly manner of
hers, the better to show off the gold chains around her neck and that
marvelous jeweled broach that held her scarlet cloak in place, a
broach that once belonged to Charlemagne's family itself, it was
believed.

"Your Grace," said the priest Volmar, the abbess' secretary and the
other person standing with the von Stade mother and daughter in

the entrance hall of the Abbey, "Abbess Hildegard had been off on a preaching tour. We are expecting her back at any moment. In fact she is overdue. We thought she would be here by now."

"Well it is noon already," said the marchioness imperiously, "and I want to get down the mountain before sunset and we have all the packing to do. Why does an abbess go off on preaching tours? Isn't she supposed to stay with her community? Isn't that what being a nun means? What do all those vows of Benedictine stability mean if she can roam the countryside? The only unmarried women I know of who go off on their own touring the countryside are whores."

Volmar and Richardis both winced. If Hildegard heard that, there would be a fearful scene.

"Mother," said Richardis, "you know that the abbess is now recognized as Germany's leading visionary and mystic. Even the pope has certified that. And her music is played and sung in all the best choirs. Bernard of Clairvaux, France's famous saintly author and abbot, has expressed his admiration for her. Her book *Know the Way* is widely circulated, read, and discussed in ecclesiastical circles from Vienna to Bremen. So she gets speaking invitations to cathedrals, monasteries, and colleges. So many people, highly educated, important people want to hear her speak on divine and human matters."

"I still think it indecent," said the marchioness firmly, "for a nun to go off traveling the countryside like an actress. I should think there is enough to do here at Bingen. She ought to fix up this place first before declaiming her visions all over Germany."

"Your Grace," said Volmar, "by accepting these speaking invitations the abbess can also raise the money to finish the building and planting here."

The marchioness promptly changed the subject. She felt an implied criticism from Volmar that the von Stades hadn't given Bingen the expected big gift and that was why the abbess had to seek funds elsewhere.

"We have to see the abbess today because Richardis is leaving. I have to show Lady Hildegard letters from Pope Eugenius and from the archbishop of Mainz giving Richardis permission to leave Bingen and assume that abbacy up north. It is entirely legal."

Volmar eagerly mollified the great lady.

"Of course, Your Grace, canon law is being strictly observed. No

one would expect other from the great von Stade family. But you real-
ize, I expect, that Abbess Hildegard will be very unhappy at the
move. She regards Richardis as her daughter just as she regards the
first abbess of this community, the famous hermit Jutta of Spanheim,
as her own mother in Christ. And you know how important
Richardis is in the task of writing down Lady Hildegard's visions.
Know the Way wouldn't be the wonderful, popular book it is—praised
by the pope himself as well as by Bernard of Clairvaux and officially
approved by a church synod—if Richardis hadn't helped us."

Volmar's somewhat rash remark gave the marchioness an oppor-
tunity to utter another complaint from on high.

"Indeed, Master Volmar, Richardis should have been listed as a
co-author."

Richardis was nervous now as she saw another huge argument
emerging. She would never get out of here without some terrible
confrontation. She wished Volmar were more discreet. She rushed to
deflate this authorship issue.

"Mother, my role in the making of Hildegard's great book was
really very small. I was a sort of editor. Volmar's role was actually
more than mine. Volmar helped the abbess turn her visions from
memory and notes she scribbled on a wax tablet into expository
prose on parchment and I improved the Latin a bit here and there."

"Really," said the marchioness, her bracelets clanging. "When I
was at Disibodenberg yesterday on my way here, Abbot Kuno said at
lunch that Hildegard doesn't know Latin, that she thinks her visions
in German, that Volmar tries a rough draft in Latin, and that it is
you, my dear, brilliant daughter, who turns it all into that striking
Latin prose that has made the book so impressive."

Volmar tried to backtrack.

"I can testify, Your Grace, that Abbot Kuno is mistaken or per-
haps even malicious. Richardis' editorial contribution is valuable but
this is all Hildegard's work. She never went to a Latin school but
Abbess Jutta tutored her when Hildegard was very young. They were
locked up together for several years in that hermitage at Disiboden-
berg, before the hermitage became a convent, a splendid opportunity
to learn Latin. In recent years I have given Lady Hildegard further
instruction and her Latin is now excellent. I can testify Richardis
and I are helpful, and of course it is a privilege to assist the abbess. It

is not easy to get these complex visions that come to Lady Hildegard while she is lying down with migraine onto vellum and into book form. But to say that *Know the Way* wasn't Hildegard's own work is a mischievous rumor. Abbot Kuno shouldn't say that. When I make my monthly visit back to the community at Disibodenberg, I will tell him that, you can be sure. I am still subject to his authority even though I am on permanent leave here to assist Lady Hildegard, but I feel so strongly about this authorship issue, I will be forthright with Abbot Kuno."

There was noise in the courtyard of horses arriving. It was the abbess and a couple of servants back from her speaking tour. They heard her loud, low-pitched voice instructing the groom and the servants. She entered the hall of the abbey wearing her riding clothes, her face still dirty from the dust of the trip.

Hildegard of Bingen in the summer of 1151 was not young. She was already fifty-three years old, more than middle-aged by medieval standards. Despite her famous illnesses when she would lie immobile and racked with migraine for days or even weeks at a time, she was a robust woman, not tall but quite muscular and strong. Her hair, cropped short in convent fashion, had turned all white. The prominent features of her handsome face were bright blue eyes and a sensuous mouth that showed her large white teeth. Her hands featured long slender fingers whose nails were carefully trimmed. Over her black Benedictine nun's habit she wore a blue silk shawl that an admiring lord had given her. The expensive black riding boots were a gift from a Roman cardinal, another one of her horde of fans.

At this time Hildegard was beginning to gain a reputation as a physician and pharmacologist, and her own robust health (in spite of the recurring migraines) was testimony not only to her superior genes but also to her biomedical assumptions. She made little use of the still fashionable murky medical textbooks descended from Greek antiquity and instead stressed the benefits of diet, herbal remedies, and hydrotherapy. She anticipated today's holistic medicine, and her physical strength, mental alertness, and longevity demonstrated its utility.

The abbess' boots now pounded heavily on the rough, bare, wooden floor of the abbey's entrance hall. Hildegard knew from the

crowd of knights, servants, and horses outside that comprised the marchioness' appropriately large entourage that Richardis' detestable mother had descended on Bingen again and Hildegard knew why Lady von Stade was here. When Hildegard was preaching at the Cathedral of Mainz the week before, one of the cathedral canons had tipped her off that the archbishop of Mainz had issued a letter giving Richardis permission to leave Bingen in spite of Hildegard's vehement opposition, to take the leadership of that convent near Bremen that the von Stade family had recently enriched with a lavish endowment.

Hildegard fully expected the marchioness to show up soon and claim her daughter. She had the time to think about it and compose herself to meet this crisis, which was hurtful personally because Richardis she regarded as her beautiful, beloved daughter, and which was troublesome for her writing. Richardis' Latinity was indeed much better than Hildegard's or Volmar's, and her finishing touch had improved the *Know the Way* manuscript by a clear margin. One of Hildegard's favorite expressions was "everyone lies," but she did not lie to herself. Although a visionary and mystic, she was down to earth about herself, her talents, and her difficult life experiences.

Hildegard's vehement efforts to keep Richardis in Bingen stemmed from her emotional attachment to the young nun but also from her need of Richardis' excellent Latinity. Hildegard also thought Richardis was unsuited for the hard life of an ecclesiastical administrator. The responsibilities of even an abbess' office were wearing.

"My dear Marchioness," said Hildegard, taking the initiative, "how splendid it is that you have honored us again with your presence." There was only the slightest mockery in her voice.

"I apologize for being late. Before I left Mainz, I spent some time as I often do with Rabbi Eleazar, the Jewish mystic and visionary, and our conversation lasted much longer than I anticipated because I was so fascinated by what he had to say. I have learned much from Rabbi Eleazar's readings of the Bible and especially of the Book of Daniel. Do you know Rabbi Eleazar? He is a descendent of Rabbi Kalonymos, the founder of the Jewish school of piety and learning in Mainz."

"I do not associate with Jews," said Lady von Stade sharply, "except on business matters. I cannot believe that we have anything to learn from them about the Bible and religion."

"On the contrary, Marchioness," said Hildegard smiling, "the Jews know deep truths embedded in the words of the Old Testament, and I seek truth wherever I can find it."

Hildegard was pleased at the opening exchange with Richardis' mother. She felt she had scored a point. Now she could afford to be gracious to the great lady.

"Marchioness, may I ask you to join us in the modest dining room of our little abbey. I have been traveling since sunrise and I am famished. Besides it is lunchtime and I want to say a few words to the community while they dine."

The marchioness was eager to get done with the business involving her daughter and to take Richardis from this distressing place but she could not refuse the abbess' request. Perhaps the invitation to dine indicated that Hildegard would not make a scene and would let Richardis go quietly.

"It will be a pleasure to join you for lunch. Then I have something important to discuss with you."

Hildegard made no acknowledgment of this last remark. She turned and headed for the dining room, followed by the marchioness, Richardis, and Volmar. The dining room was a coarse affair—long unpainted tables, the plainest of benches and chairs, a bare floor; nothing on the whitewashed walls except for a single plain wooden cross. The other nuns were already eating. They rose and bowed to the abbess and marchioness as they came in. The two seated themselves at the head table of the dining room, joined by Richardis and Volmar.

The meal was simple—mutton, cheese, bread, a little fruit, washed down with strong beer. It was a good deal more edible than the marchioness expected. She found herself enjoying it and eating heartily.

Hildegard had two full helpings of food and refilled her tankard with beer, saying nothing during the meal, but listening intently as one of the nuns read to the others, the prescribed regimen at mealtime set down in the *Rule of St. Benedict*. The marchioness noted that the reading was not from the Bible, the Church fathers, or the *Rule*

of St. Benedict itself, the normal mealtime reading texts in monastic houses, but from Boethius' *The Consolations of Philosophy*, a sixth-century work by a Christian martyr steeped in classical thought. It was a difficult work written in sophisticated Latin and the reader often stumbled.

Two or three times Richardis and Volmar grimaced at these oral infelicities and looked at each other. Hildegard was unperturbed.

When the reading was over and the meal was winding down, the abbess rose to speak. She spoke in German and the marchioness had to admit to herself that Hildegard was a powerful speaker and her command of an elegant, fluent German style was excellent.

"My beloved friends and daughters, I have missed you very much this past three weeks I have been away on my little speaking tour. I have prayed every night to the Virgin Mary to protect and sustain you. I am glad to be back and to see that things are in good order here. I want to report to you that my trip was successful in raising endowments for our community and recruiting new members to Bingen from leading families of western Germany. Soon we will be receiving millions of marks in gifts which will allow us to finish and decorate our building in a splendid way I have long promised you and to plant the grounds up here on the mountain with shrubs and flowers. Great lords and bishops and the pope himself are giving us this support. I know this past year since we came here to the Rupertsberg has been hard and uncomfortable for many of you. But now Christ has directed His love toward us, as I always expected He would, and we will flourish in triumph and joy. We as virgins of Christ are second to no monk and we have a right to the refinements of Benedictine living. We will never have the wealth of Cluny nor would we want to live in the Cluniacs' luxurious mode. I want us rather to follow the austere model of Bernard of Clairvaux and the reforming Cistercian Order, which is closer, I think, to what St. Benedict envisaged for his own community at Monte Cassino. But there is every reason that we should live as comfortably as the monks of Disibodenberg. After all, some of the money that came to them was because of the celebrity of my visions and my book. This is the main reason why Abbot Kuno did not want us to leave there last year and move here to Bingen on our own site. He feared the loss of revenue which I and you brought in to Disibodenberg. Now we are get-

ting the funding that justifiably comes with worldly admiration. On my trip I noticed that not only the nobility knows of our convent, but that the common people also now have heard of my mystic visions. They too attended my sermons and they are supporting us as best they can."

Hildegard's speech thus far was intended as much for the marchioness of Stade and Richardis as it was for the community. It was to let the Stades know how well Bingen was doing, how elegant and comfortable it was about to become, and to try to discourage Richardis' departure. Hildegard knew this probably wouldn't work, but it was worth a try. It was also to show the marchioness that Hildegard's leadership capacity, her skill at getting funds and recruiting high-born novices, were of a superior order after all. Hildegard knew that from the marchioness' previous visits that the great lady was not one of her fervent admirers. It was therefore satisfying to exhibit her success to this highly vocal critic.

The rest of her talk to the nuns was for Hildegard a more private affair. But she wanted the marchioness to hear it even if it contained remarks she knew the latter probably wouldn't like. Hildegard was not averse to challenging the establishment and she knew that what she now had to say was to a conventional aristocrat like Lady von Stade highly provocative and even damnable. But Hildegard was eager to stir things up, especially now that she was flushed with success.

"Tonight we will celebrate Christ's newly confirmed embrace of this community. I have brought back from Mainz a tiara and a bridal veil for each member of the community. At dinner tonight we will each wear this bridal costume because we are virgins and the fairest and most loving Man has proclaimed His love for us. We are His brides and should dress up and be beautiful in His sight. We will drink our best Rhine wine tonight at dinner and act out a wedding feast with Jesus. So you will take time from your assigned tasks this afternoon to bathe and to dress in your best clothes and put on the bridal costumes I have brought for you. I have composed a kind of wedding song for dinner as well. The form of woman in a virgin state is the most beautiful thing in the world and pleasing to the eyes of the Bridegroom Christ. He will love us and cherish us and fill our wombs with a balm-like substance."

The marchioness noted that this speech of Hildegard's did not arouse much excitement in her audience. Presumably they had heard it many times before. They merely smiled and nodded their assent to Hildegard's provocative speech. After singing one of Hildegard's songs, to the accompaniment of lutes played by two of the nuns, they quietly filed out of the dining room.

The marchioness appreciated that in Hildegard's spiritual songs the severity of liturgical chant was softened by the soft lilt of troubadour music. It was a subtle and brilliantly successful union of the two musical genres. It was flattering to the individual voice, as liturgical chant often was not. Hildegard gave an opportunity for individual expression through the delicacy of the harmonic line and the relaxed yet still necessarily disciplined control within a spiritual genre. It was a progressive, very distinctive music for the mid-twelfth century, anticipating the easier, indulgent style of the fifteenth-century Renaissance, and was understandably popular both then and now, when there are a dozen recordings of Hildegard's music available.

Richardis' eyes glistened with feeling and admiration. Hildegard's music always gave her a big lift. The marchioness had heard it before, but not in such a confined space, where the assured vocalization and intriguing harmony resounded beautifully off the plain wooden ambience of the simple dining room. She had to admit to herself that it was very good music indeed and she wondered why Hildegard did not become a professional composer and musician and give up this risky quest to be the great woman visionary of Christian Europe. Her music could only gain for the abbess universal admiration, and pursued exclusively, would take away the reputation for controversy and extremism that seemed to float on Hildegard's head. Assuredly Lady von Stade's cousin, the wonderful Staufen Duke Frederick Barbarossa, soon to gain the imperial throne, she thought would be glad to employ Hildegard as a court musician.

But there was no use pursuing that, the marchioness told herself the next moment. Hildegard would never give up her abbey and her visions and preaching.

For a moment the thought passed through Lady von Stade's mind that she would compliment Hildegard on her music. But Hildegard's announcement of the bridal feast that evening had

upset the marchioness so deeply that she turned to comment harshly on that.

"I know, Abbess Hildegard," began the marchioness, "that your theology cannot be questioned, but I wonder whether it is wise to speak with such explicit sexual imagery to your community. I wonder whether such talk does not arouse sexual feelings that nuns are supposed to disavow and repress. And this dressing up for a bridal feast with Jesus, isn't that, well, going too far? Every nun knows she is the Bride of Christ, but I wonder what mixed feelings are stirred up by the acting out of a bridal celebration that leads to no physical consummation. Isn't it best to let such images and intimations stay quietly below the level of consciousness?"

Hildegard was a little surprised by the skill with which the marchioness had expressed her dissent. The abbess felt intellectually challenged, and she enjoyed this level of discussion and responded eagerly.

"We have entered a new age of the Church, Lady von Stade, distinguished by two things. First, we are not afraid to evoke the sexual imagery, the romantic ideals, the celebration of divine and human love, that are the center of our faith. Bernard of Clairvaux has shown that romantic discourse and orthodox theology can be combined and I am following in his glorious footsteps. Secondly, controlled, subordinated, and exploited as women are in our society, even in the aristocratic households we both came from, only those women who have taken the veil are free to reflect upon and speak of woman's place in the divine scheme of things. We are no longer to be shunted to the margins, our insights and our feelings neutered to the point of effacement. Women can talk now about their bodies and their minds, about themselves. The heavy weight of family, law, and hierarchy still muzzles the married woman but we religious virgins are free to speculate on the significance of our femininity in the eyes of God. I hope that I can show the way in this area and do for woman's consciousness what the blessed Bernard of Clairvaux has done for modern spirituality in general. By giving his approval to my book recently the pope has encouraged me to believe that woman's consciousness is acceptable to the Church. I know that if the Holy Father had not given official approval my book might have very well been suppressed. I could have been charged with heresy. Many a

bishop thinks that any outspoken woman is a heretic. But the blessed Mother of God has shone her love on me, she has embraced and protected me, and given me freedom to speak."

The marchioness was not so much annoyed at Hildegard's high opinion of herself as jealous that a woman below her in the social hierarchy should be aiming to be an important voice in German culture, and apparently succeeding.

"What specifically is the message that you want to communicate, my Lady Abbess, that compares in social importance to the doctrines of the ineffable Bernard?"

Hildegard eagerly complied with this invitation. Many of the things she said she had already declaimed in her book and from the speaker's platform. But some other things she had not yet enunciated in so many words. They were ideas she was just starting to develop and would loom large in her later writings.

Hildegard could not help but feel a bond of sisterhood with the powerful and elegant woman sitting across the table from her, the mother of her beloved protégé Richardis. Hildegard wanted to persuade the marchioness to come over to her side. Not only would it be a personal coup, the gaining of a highly visible convert to her radical view of women, but it could release the large endowment for Bingen that the von Stade family had held back.

"First, I insist that the wondrous vision of the three towers I have had and the one in which God and Lucifer appear as concentric circles moving past one another—such mystic visions come about when I lose consciousness of my body and my womb is convulsed with divine spirit. Then God speaks through me. It is not me speaking; it is God, just as a string touched by a lutanist gives off sound not by itself but in response to the lutanist's touch. I am God's lute for the world. I have had visions from infancy, but it was only in my adolescence, under the guidance of Abbess Jutta of Spanheim, that I had the confidence to realize it was God speaking through me. I do not perceive with my senses but with my inner mind, with my soul, with my external eyes open. The migraine that accompanies these visions results from the exhaustion that comes over me when I am transported by these visions to the heights of the firmament. Or perhaps a severe headache is necessary to prostrate me first in order to receive God's speech. That is my initial message."

Hildegard had been speaking very quickly and loudly. What she had said thus far she had expressed many times during her lecture tours to highly enthusiastic responses. The marchioness listened attentively but impassively. This was a tougher audience than the cathedral canons at Mainz. Hildegard moved to a more theoretical and lyrical plane. She turned up the intensity of her declamation.

"My second message is that God wants mankind to know that the love in man and woman and their love for one another is God's creation. Masculine love is like a fire blazing on the mountains; a woman's love is much cooler, like a wood-fire, or like the sweet warm fertility of the sun. Man's sexuality is like a thirsty stag seeking a fountain. A woman's sexuality is like a threshing floor on which man pounds the woman and threshes grains inside of her. This is the role of sexuality in human life. Thirdly, the moment and manner of coitus determines the character of the person that is born of this union—whether the person will be happy or sad, strong or weak, fortunate or unlucky. I enunciate a coital astrology that determines character. Fourth, I blame the clergy, that bastion of privileged masculinity, for abusing the Church, for exploiting her for their selfish purposes, so that the Church, the most beautiful of all divine creatures, the Bride of Christ, cannot work her perfection in the world. The white silk cloak and golden sandals of the Bride are sullied and muddied and she cries out that she has no helper and no staff on which to lean. Seventy and more years ago there arose in Rome a reforming party that sought to free the Church from corruption and oppression and to transform the clergy from a selfish group of exploiters of their privilege into the soldiers of Christ. The reformers were overwhelmed by the opposition of kings and lords. Now it is up to the cloistered nuns to try where the pope and cardinals failed."

The marchioness motioned to say something in protest but Hildegard continued without interruption.

"There was a time, back in the age of the Church fathers, when women virgins devoted to Christ—nuns—tried to communicate their perceptions on ecclesiastical policy to the community. The bishops would not share their power with women, even sainted virgin nuns. St. Augustine and the other Church fathers asserted their rigid authority over the nuns and did not listen to these women on important matters. The Church fathers put it about that woman's

nature was essentially tainted by inheritance from Eve. Women were regarded as the temptresses, women were dominated by their biological fate, were inferior, and morally weak. Now a change is coming. Now a different view of women makes its way in the Church, and I proclaim it boldly. Religious virgins are the Brides of Christ. The Church is the Bride of Christ. Therefore we are the actual embodiment of Christ's Bride. We are a special, pure kind of Church. For centuries, following misogynist Church fathers like St. Augustine and St. Ambrose, the masculine clergy have taught the inferior position of women in the Church. A woman is regarded as a temptress and a snare to a man and the antagonist of the clergy. But we assert that women who retain their virginity for love of Christ are his spokesmen, his beloved spouses who address the world on His behalf. It is the masculine clergy, who because of their corruption, sully the Bride of Christ and thereby bring down on themselves the wrath of the Divine Spouse. This is my teaching. I have not yet revealed all of it in my book and in my preaching, but I will in due time reveal these truths dictated by God speaking through me. The form of woman kept pure in her virginity is the image and resonance of God. I proclaim the equality of woman in the Church."

The marchioness of Stade listened to Hildegard with a look of quiet disdain on her refined features. At times during Hildegard's speech, a momentary smile graced the marchioness' fleshy lips and her eyes flickered in recognition, as if she had heard these doctrines before, that they were familiar to her. But familiarity only stiffened her opposition. The marchioness took pains to reply in her most supercilious manner.

"So this is the vaunted teaching of Hildegard of Bingen. So this is 'the way' that is to be known, that inspires monasteries, cathedral corporations, and schools to invite you to speak, that leads lords to shower you with private gifts and endow this bleak abbey on this God-forsaken mountain, and to make your book widely circulated and discussed. I think, Abbess, that what you say is mostly a farrago of nonsense and, when not nonsense, it is dangerous to the point of heresy. You proclaim yourself God's instrumental voice so that no one can criticize you. You titillate your audience with sexual imagery that leads to nothing verifiable. It just gets your hearers and readers excited. You are a retailer of provocative sexual imagery, all the more

scandalous of course as it comes from the mouth and pen of a nun. Your coital determination of character is contrary to any scheme of Christian ethics that I have ever heard of. It consists of astrological determinism that takes away our freedom to serve God and find happiness. Your vision of God and Lucifer as concentric wheels smells of the Manichean heresy. You raise up again those irresponsible charges against the clergy that unfortunately came out of Rome during the war between the emperor and the pope and that did so much damage before hierarchy and state power were restored. No wonder the common people flock to your sermons and adore you—your debased imagery excites them, your claim to divine prophecy frightens them, and your blaming the clergy justifies their greedy assault on the property and authority of the Church."

The marchioness swallowed a mouthful of wine and resumed.

"It is your feminist doctrine that I find most repulsive, Abbess Hildegard. I should think that the Benedictine nuns like yourself would realize that they are highly privileged people. Normally their families offer rich endowments to a convent to accept them into the religious community. It is very much like the dowry families must pay at the time of a daughter's marriage, if they can at all afford such burdensome payment. But marriage usually offers benefits in exchange for a dowry. Endowment of nunneries gains nothing feasible. Once a nun has taken the veil, she is comfortable and protected, warm and well fed. She is required to do only a minimum of work. The heavy labor in a convent is usually done by hired servants. Meanwhile the nun is pleased to do pretty much as she pleases as long as she stays in the convent. It is a privileged life, compared to the world outside—and in addition to the creature comforts, the nun is greatly respected by society. It is an honorable, yet risk-free calling. The pains and hazards of childbearing that threaten most women who marry, that carry off many in the gamble of childbirth, and wear out to the point of death most of the others through numerous pregnancies—this fate the nun is spared. You, like some other religious women nowadays are, however, not prepared discreetly and quietly to enjoy your soft life. You have some vague but powerful yearning to dominate society and to rule the Church, or at least to claim for yourself exalted status in the Church. So you concocted the stuff we have just heard from you, aiming to upset the ecclesiastical order that we

know since the time of St. Paul, and to claim authority in the name of the divinely imaged woman. You are spoiled by your privileges and have fallen prey to the rumblings of radical teachers, which you further distort for the purposes of this feminist theory."

The marchioness leaned across the table toward Hildegard. She was shouting now. Her anger had surfaced.

"There are a lot of restless people about nowadays: unemployed knights, overambitious peasants newly released from serfdom, the artisans in our burgeoning cities. These people do not easily fit into the prevailing social order, so they want to overthrow it. They will give heed to any itinerant preacher who spews venom against the clergy. They will applaud your hostility to holders of masculine power. Why not? They have nothing to lose. I see how your message appeals to these rebellious and alienated people. But you should not yield to the temptation of satisfying this kind of audience. If you feel called to communicate with the world by pen and voice, do as Bernard does: use the enthusiasm and deep feeling you arouse to lead the commoners back into recognition of their betters, the old nobility, the monarchy, and the bishops. Otherwise you will encourage an upheaval that you will not be able to control and which will overwhelm you."

Both Richardis and Volmar were very distressed at the turn the conversation had taken. They had expected a row over Richardis' leaving. Instead they were getting an intellectual conflict that was turning very ugly. They were trying to think what words to utter in order to calm things down when Hildegard herself undertook this task.

"I apologize if I have offended you, Marchioness. I know these new ideas must seem dangerous, arrogant, and distasteful. That always happens when novel cultural trend makes its appearance. You greatly respect Bernard of Clairvaux, but I can assure you that my doctrines are not more radical than his. Indeed what I say is close to his teaching, but mine is from a woman's point of view, which in our male-dominated society makes it seem more provocative. Essentially you believe that all the truth comes from tradition, that everything is handed down to us from the past, that the only function of education and learning, of art and philosophy, is to repeat endlessly these inherited doctrines, that new ideas in the Church are wrong and

dangerous. I see a much more active forum for the human mind and its communication through speech and art. I believe in ongoing discovery and newer perceptions of divine truth. I see myself and others of my generation who are propounding this new culture, evolving this new way of speaking, as workers of divinity, as shapers of the image of the divine mysteries. Rest assured, Marchioness, that I love the Church, I accept the authority of the pope and the bishops, and I respect the dignity of the emperor, just like you."

"Nevertheless," said the wily marchioness, seeing an opportunity now to get to the main purpose of her visit, "I find your ideas too provocative, your speech hazardous, and your purposes mysterious. Therefore I have no reservation in telling you I am glad I have gotten permission from not only the archbishop of Mainz but from the pope himself, the same pope who legitimated your book, to take my daughter from you today. We have been talking about this for some time, and I know that you are much opposed to this move. I know you love her, you loudly profess to, and that she has been very helpful to you in your writing, that she puts the final draft of your heated text into schoolman's Latinity that makes it more palatable to the scholars and clerics. You will have to find a new editor because we are leaving now. Richardis will become an abbess herself in the north of Germany. I and her brother have arranged this."

Richardis and Volmar were relieved that Hildegard did not explode at this news. Her reply was calm, surprisingly cool.

"My dear Marchioness, I know Richardis better than you. She came here when she was very young and I have raised her as a daughter. She is like a flower in its beauty, like a symphony in this world. The world loves not only her beautiful looks but her prudence. Her Latinity is excellent. But she was not meant to be an abbess. She is too delicate for that. She will be worn down and made ill by the cares of office. You are making a mistake, and I cannot understand why. The only criticism you can make about the situation here is that Bingen is still a humble place, its ambience, furnishings, and endowment are not suitable for daughters of the nobility. I grant you that. But we had to leave Disibodenberg because we were treated there as inferior, our feelings were ignored, and my celebrity was exploited by Abbot Kuno who kept most of the money my fame brought in. Now we are getting our own funding here and we will be

able shortly to turn the buildings and grounds here into the habitat that you—and I—think is necessary for this kind of community. Your snatching of Richardis away is therefore impetuous and untimely."

Richardis and Volmar sensed that the contest between these two strong women that had begun on such an elevated plane of theory and sensibility was about to turn personal and nasty. The psychological tension between the two titans was surfacing. Perhaps that could not be avoided. There was nothing they could do to stop it. They sat quietly and fearfully, transfixed and anxious.

"It isn't the inadequate resources of this place that bothers me so much," the marchioness said. "It is that your feelings toward Richardis are too personal, too emotional. You want to dominate her completely. You want to express what? Certainly motherhood, and release perhaps some of that sexual energy your doctrine stresses so much."

Richardis and Volmar leaned back in their chairs waiting for the explosion. But it didn't come. There were a few moments of silence. Then Hildegard spoke very quietly.

"My love has been a good love for Richardis and a pure one. I raised Richardis as a mother should. I never exploited her or abused her. You don't know what exploitation and abuse can be like in a religious community of women. I know. I experienced it. I was the tenth child of my parents and most of my siblings survived. I was unnecessary and unwanted, prey to be given away as soon as possible to the Church. When I was seven years old, my parents surrendered me to a famous woman hermit Jutta of Spanheim, and abandoned me. I never saw them thereafter. Jutta found it hard to live up in the mountains with a young child. She made an arrangement with the monks of Disibodenberg that they would create a special hermitage for her and me on the grounds of their abbey, and would give us food once a day and arrange for taking out the refuse. I remember not realizing what was happening until I saw a wall being built around Jutta and myself. Yes, we were walled up. I sat in a narrow coffin-like darkness with that woman for many years, until she decided to turn the hermitage into a normal nunnery attached to the monastery. That was domination! That was abuse. And who was there to protect me? No one. Did the monks care? No. Did the abbot inquire?

No. I suffered in the dark silence and alone. We may not have the facilities here at Bingen that accord with aristocratic standards. But I have always shown love to Richardis and treated her with honor. She is as pure and dignified now as the day she came here."

They had sat in the dining room for two hours. The nuns in charge of the refectory appeared and requested the opportunity to clean up.

The four of them rose from the table. The marchioness gave Hildegard the kiss of peace. Richardis waited for a kiss from Hildegard. But she did not offer it. Nor did she even speak further to Richardis.

Instead Hildegard said: "I wish you and your daughter Godspeed. Now I must go and bathe and dress for tonight's bridal dinner."

Richardis of Stade died within little more than a year after she left Bingen. Hildegard of Bingen died in 1179 and was revered as a saint in the Catholic Church by the early fourteenth century. Her writings are closely read today in women's study courses and a scholarly organization devoted to professional study of Hildegard's writings exists in the United States. Recordings of her music are much in demand. The Green party in Germany regards the abbess as their medieval forerunner because of her advocacy of holistic medicine and natural remedies.

Increasingly Hildegard of Bingen is regarded as one of the most important religious writers as well as the leading feminist theorist of the Middle Ages. Many of her writings have been in print since the seventeenth century and were yet neglected by scholars. No longer.

CHAPTER SIX

THE GLORY OF IT ALL

ELEANOR OF AQUITAINE

"I am very tired," said Queen Eleanor to her courtiers lounging on the grass outside of her palace in Poitiers in France on a warm September day in the year 1169, "of this interminable, nasty quarrel between my husband King Henry and Archbishop Thomas Becket. All this fuss over a handful of murderous and thieving priests. I once saw the king become so angry with the archbishop and his extreme demands upon the Crown that Henry took off all his clothes in public and began chewing straw."

The courtiers laughed suitably, particularly Queen Eleanor's daughter Countess Marie of Champagne, the countess' intense, inscrutable chaplain Andrew, and the court poetess Marie de France.

Whether in London or in Poitiers, Eleanor of Aquitaine's court was the most brilliant in Europe. She was always surrounded by literate and articulate nobility, by poets and artists, and by the more radical and provocative kind of university graduates seeking clerical or governmental posts. She welcomed lords and ladies of great wealth and bold private lives, poets attuned to fashionable eroticism, and brilliant young churchmen thirsting with ambition and love of both the earthly and heavenly variety.

Poitiers was where Eleanor had grown up until she was fifteen and whisked away to Paris to become Queen of France. She loved the old Roman city of Poitiers with its well-used churches and monasteries, its high protective walls, and its spacious houses. Lying halfway

between Paris to the northeast and Bordeaux and Gascony to the southwest, Poitiers was the crossroads of French culture, the meeting place of the old Roman and the later Frankish worlds.

The landed wealth of Eleanor's family, the ducal house of Aquitaine, lay especially in Bordeaux and Gascony, with its incomparable vineyards and access to the western sea. But here in Poitiers was a memory, a tradition, an aristocratic elegance, and a very old Latin culture that made Eleanor feel confident and relaxed, secure in her lineage, gender, and sensibility.

A sunny day, a familiar palace in the background, the deep green color of spacious lawns, an exquisitely prepared picnic lunch, the finest red vintages from her ancestral vineyards near Bordeaux, and the banter and wit of superior young people—this was the best that medieval society had to offer, in Eleanor's view. It would have met the highest standards of good living among rich people at any time or place, whether the Rome of Cicero or the New York East Hampton crowd today.

"As the archbishop's secretary and confidant, John of Salisbury," said the queen to the well-known English cleric, humanist, and writer who had suddenly turned up at Eleanor of Aquitaine's court, "I should think you could do something to settle this dispute and get the archbishop back from his exile in France to England. I don't understand why Henry and Thomas profess such hatred for one another now. When Thomas was the king's chancellor they used to go around drinking and carousing together, the closest of friends. The king used to give Thomas his used-up mistresses, and Thomas was glad to take them secondhand off the king's hands."

"Your Majesty," said John of Salisbury, "I have tried to heal this dispute, I assure you. It has been most painful to me. The issue of what are called criminous clerks is not trivial—you must remember that most of the parish clergy are from the ranks of the local peasantry and are as prone to violence and theft as other peasants. So a fair number of these clergy get indicted for serious crime and then the question is: Shall they be tried in the royal courts or the bishops' courts?"

"I have heard the king say," replied Eleanor of Aquitaine, "that the bishops' courts are notoriously lax. Of course they don't hang convicted felons like the royal courts. The punishments are easy and

some of these criminals get off with their promise they won't do it again."

"That happens sometimes in the royal courts too, Your Majesty," said John of Salisbury.

"Really?" said Eleanor of Aquitaine, looking suspiciously at John. "Then what was all the fuss about during the meeting at Clarendon, the royal hunting lodge, three years ago with all the barons? The catering needs were onerous I can tell you, and there weren't enough beds for them all, and all those horses overfilling our barns and devouring the hay. Wasn't the legislation promulgated there supposed to clean up the criminal procedure in the royal courts?"

One of the courtiers standing to the side of Queen Eleanor interrupted. He was Richard Fitzneal, the head of the Exchequer, the accounting division of the royal treasury. Normally he wouldn't be at Queen Eleanor's court; he would be in London. But he was here on business for the royal government. He had just reviewed Eleanor's household accounts on which her husband kept a tight rein.

"I can assure Your Majesty," said Richard Fitzneal, "that great improvements were made in common law criminal justice by the assize of Clarendon that you refer to. The king is quite right—the bishops' courts are lax, and Archbishop Thomas was wrong to protect felonious clergymen. They must hang with the others if we are to maintain equal justice before the law. You must know, Your Majesty, that John of Salisbury here, while a distinguished scholar and writer, is no friend of the royal government. He has recently published a very critical account of the working of royal law and government. He says that we who serve you and King Henry are a pack of corrupt tyrants."

"Really?" said Queen Eleanor, looking with increasing disdain at John of Salisbury. "Then why are you here petitioning for a job—that is why you have sought an interview with me, I am told—when you don't admire what the king and his ministers are doing?"

John of Salisbury took a deep breath and bit his lip. He hadn't expected that his political treatise would be known in royal circles. There was no use denying that Richard Fitzneal's accusation against him was substantially true.

"Your Majesty," John said, with a plaintive look on his face, "I cannot deny that I have been critical of some of the king's ministers

and judges. I find them coarse and arbitrary. That doesn't mean I am not loyal to the monarchy. I am just holding the royal officials to high standards. Some years ago, after working as the pope's secretary, I wrote a similar critique of papal government. That shows I am not biased against the English monarchy. In any case, I am seeking a position working for you, using my learning and writing skills in personal service to you. I seek your support as a renowned patroness of the arts and letters, not a position in the king's government. The truth is, Your Majesty, I am currently unemployed and with little prospect of getting a job outside of royal circles in which I can use my literary talents. Now that negotiations between Archbishop Thomas and the king's representatives have broken down again— because the king has refused to give Thomas Becket the kiss of peace on the mouth that the archbishop demanded—I don't know when Thomas will return from his self-imposed exile in northern France. I must seek another employer. You have supported many writers and artists, Queen Eleanor. I was hoping you could find something for me to do. Perhaps I could write a history of your illustrious house of Aquitaine, an account of the exploits of your grandfather, the famous poet-duke, and other chivalric ancestors of yours. Perhaps I can write your biography. All over Christendom people want to read about the glorious Eleanor of Aquitaine."

The queen and her entourage were now relaxing after their heavy picnic lunch, washing it down incessantly with the red Bordeaux wine of choice vintage from the queen's own vineyards in Gascony. It was turning into a warm, lazy afternoon and Queen Eleanor was giving interviews to a few selected petitioners for her favor.

These petitioners were the usual group of "young men"—university graduates looking for a governmental or clerical post that would produce a steady income and plenty of leisure time to write poetry and philosophy. There were young women of the middle class, like Marie de France, hoping to latch onto a position at Eleanor's court and escape for a few years an arranged marriage with a boring under-educated country squire and the endless lottery of childbearing that almost inevitably followed, as often as not to an early grave. And then there were middle-aged writers who had suffered a reversal of fortune and were very short of money, like John of Salisbury.

"Do I look that old, Master John," said the queen, half smiling,

half annoyed, "that I should set about commissioning my biography? I suppose when having reached my forty-seventh year and have produced a brood of children and seeing lines appear on my face and streaks of gray in my hair, people expect me to die soon and that I should start thinking about finding a biographer. The king does not lie with me anymore, as everyone here knows. He is too busy with his concubines and mistresses. But that doesn't mean I am in my dotage. I expect to be around for a long time yet. But perhaps a famous writer like yourself can write a suitable life up to now. Tell me, John, what are your qualifications to be a writer of my biography?"

"I am a native Englishman," said John, "the orphan son of a peasant, who was adopted by a priest who educated me and then persuaded his bishop to send me to Paris for my advanced education. There I sat at the feet of Peter Abelard and other famous professors, from whom I learned little. But because I wrote Latin very well, the pope who was an Englishman and wanted an English secretary—Adrian IV—brought me to Rome. After the pope died I came to England and worked at Canterbury, becoming in time the archbishop's secretary. Thomas Becket does not know Latin very well—he did poorly at the university in Paris—so he dictated his letters to me in French and I translated them into Latin, and I also translated all the incoming letters from churchmen from Latin into French for him. I have written some works of philosophy, an account of life in the papal curia, and most recently a political treatise that Richard Fitzneal referred to. There is no subject on which I cannot write in elegant Latin, whether in poetry or prose."

"You wouldn't know how to write a royal writ and do something practical," said Richard Fitzneal.

"Do not interrupt us, Master Fitzneal," said Eleanor crossly.

"Tell me, John of Salisbury, the story of my life, and I will see if you know enough about me and are sympathetic and insightful enough to be my biographer."

Fitzneal, the court poetess Marie de France, the countess of Champagne, and the other half-dozen members of the queen's current entourage laughed and giggled except for the countess' chaplain, Andrew, who looked straight ahead and said nothing. Eleanor was making fun of this tiresome ecclesiastic, John of Salisbury, leading him along before dismissing him with contempt. It would be

good fun. They refilled their wine cups and prepared to enjoy the show.

John of Salisbury felt that Eleanor was playing a game with him. Almost anything he could say would be rebuffed by her. He knew now that it was a mistake to come seeking Eleanor's patronage. He belonged to a very different world from that of the royal court. He could never get a job here. But to refuse the queen's request now would be an insult. He proceeded as best he could, drawing upon his knowledge of the queen's life, mostly gained from Thomas Becket's remarks but leaving out phrases like "the high-born whore" that the archbishop customarily employed in reference to the queen.

John fixed his gaze on the sculptures over the doorway on the palace and commenced to recite his narrative.

"Eleanor of Aquitaine was the granddaughter of the troubadour duke of Aquitaine, William IX, who also was famed as a crusader against the Moslems. Her parents died young, leaving Eleanor as her grandfather's heiress to the vast rich duchy of Aquitaine. Just before he died a few years later, Duke William designated Eleanor to be the ward of the French king in Paris, Louis the Fat. Following the advice of his chief minister Abbot Suger of St. Denis, where Suger created the first Gothic-styled church, Louis VI married Eleanor to his own son who soon became Louis VII. Eleanor and Louis were both very young and very much in love with each other. By Louis VII, Eleanor had two daughters, the oldest now being the countess of Champagne [here John bowed to Countess Marie]. Louis felt compelled to answer the call of Bernard of Clairvaux to join the Second Crusade. While in the Middle East, the love between Louis and Eleanor cooled. On Louis' and Eleanor's way back from the disastrous crusade, the pope tried to reconcile the young, beautiful couple, tucking them in bed together. After Eleanor returned to Paris she sued for divorce on the grounds that she and Louis were within the prohibited seven degrees of consanguinity—their blood ties were too close to conform to canon law. Since the great families of Europe were often closely related to another, belated pseudodiscovery of such a prohibited blood tie was the standard cause of annulment, convenient for the great nobility who wanted to divorce. The pope reluctantly granted the divorce. As the greatest heiress in Europe and most beautiful, Eleanor was pursued by suitors all the way from Paris

to Poitiers. She gave her hand to Count Henry of Anjou, the prospective king of England, and two years later they were crowned king and queen in London. They had many children and they collaborated in affairs of state, with Henry taking the leadership in carrying out great reforms in the common law of England. Eleanor and Henry were also renowned as patrons of literature and the arts and their court was the most chivalric and artistic in Europe. In 1168 Henry asked Eleanor to return for a while to her homeland in Aquitaine and to set up her glorious court in Poitiers, the better to ensure the loyalty of the people in the duchy to the Angevin imperial crown. That is my narrative, Your Majesty." John concluded with a deep bow.

"Yes, the glory of it all. You have highlighted it," said Eleanor, smiling. "I give you credit, John of Salisbury, for doing that. Now I would ask my court poetess, Marie de France, who amuses and intrigues us with her stories of romantic love and her social fables, to comment on your biography of Queen Eleanor. What do you think, Marie? Shall I hire John as my biographer?"

Marie de France was a well-dressed woman in her early thirties, her handsome face marked by bright blue eyes. Marie had been sitting silently on the grass. John did not know what to expect. He had never read any of her poems and he was not even sure that he had previously been aware of her existence. It was a new experience for John to have his writing judged by a woman. He was not sure whether Queen Eleanor really put stock in Marie's opinion, or if this was just a joke the queen was playing on him.

"First of all," said Marie de France, "I want you to know, Master John, that I am partly in agreement with you on your harsh comments on our judicial system in your recent book. I am closer to your view on the law courts than to Richard Fitzneal's optimistic perceptions of them. The law courts are not good places for poor men. Many times commoners are forced into ruinous lawsuits there by greedy lords who covet their land and use the law to take it from them."

John relaxed, thinking that Marie de France was going to be supportive of him. He immediately learned differently.

"As for your account of Queen Eleanor's life," continued Marie, "it gets the superficial story more or less right but it does not deal

with the human realities underlying the surface story. This is masculine history that you write, John. It is written strictly from a man's point of view. It is history written by the powerful, by the winners, by the dominant gender in society. History written from a woman's point of view is different, even the story of Eleanor of Aquitaine. You make it all seem glorious because she was the daughter of a great lord, the wife of two kings in succession, one of France and one of England, and she is the mother of sons who will be kings. Eleanor has lived a life in the midst of the greatest wealth and the highest power. But what about her *feelings* as a daughter, wife, and mother? How has she felt about her relationship to her famous grandfather, her two husbands, and her sons? Has her life always been one of happiness? In the midst of palaces can a woman not be unhappy, can she not endure meanness and oppression, even cruelty? Has Eleanor been happy in love? Has she been able to follow her heart's desire? Or has she been a victim of the political system and hierarchical order? This is completely missing from your account. You have given us a pageant of royalty, with everyone dressed up in fancy costume, but you have not given us a narrative of love and hate, a story of feelings and passions. I do not blame you. Although you came out of a background of poverty, you have lived your whole adult life in the world of European power—its hegemonic institutions and its masculine personalities. You have been a loyal servant of the rulers of the Church and you have noticed a discrepancy between professed ecclesiastical ideals and mundane or even sordid reality. That gets into your papal history and your political treatise. But when you come to tell us about Eleanor of Aquitaine, this discrepancy is absent. It is glory all the way."

John saw that Queen Eleanor was taking in every word and nodding her assent. He was devastated.

"Undoubtedly you wanted to flatter the queen so you were reticent about anything in her life that wasn't simply glorious," continued Marie remorselessly. "But I feel, John, you do not understand the new perceptions that are circulating among women of the European aristocracy today, perceptions that deal with the ambivalence, stresses, and pain of their everyday life, especially in their relationships with men. This kind of sensibility is getting into the narrative love poems, the romances that I write. Some of the aristocratic nuns

in northern France and western Germany have been involved in this new women's culture. I think particularly of Abbess Hildegard of Bingen. Yours is an all-male culture in which women are merely fixtures and even a queen is an exalted figure without feeling. So I don't think you are the one to write Queen Eleanor's life, not unless she wants the standard, conventional kind of masculine narrative which is merely court propaganda."

John of Salisbury hung his head in embarrassment. He could look no one in the face. He had been humiliated, even worse than he feared that he would be. He knew that what Marie de France was saying was not nonsense. There was merit in what she said. But considering his background how could he have grasped the woman's point of view in his narrative? And even if he did, how could he have enunciated it without talking about private, intimate things that were beyond his privilege to address?

It seemed to John that he was caught in an unfair vise. Before he could find words to respond, however, Richard Fitzneal, an unlikely source, came to his help from an ideological perspective.

"New currents of thought, that Marie de France has indicated, run among the more educated women in aristocratic circles these days. The romances, including those involved with the Affair of Britain, the Arthurian stories, are currently being rewritten within this way of thinking, whether the authors are women or men writing under the patronage of women, such as Chrétien de Troyes, who is a dependent of the Countess de Champagne. There is nothing wrong with deepening sensibility in literature, in giving us a psychological perception of gender relationships within the context of traditional aristocratic settings in the stories. I enjoy this avant-garde attention to gender relationships we find in the romance literature, which is mostly a form of entertainment, but I am concerned by the intention to insert this new feminism into political ideology and demand that all literary genres, including history, be rewritten from this women's perspective. History has always been in service to the ruling elite of our society; it has always trumpeted the victories and endorsed the ethics of the dominant group in our society—which has meant the men of the great families, the princes and lords, and bishops. Women of the aristocracy have not been ignored in these histories, but they have been marginal in the historical accounts and have been

viewed from the male point of view. Now Marie de France wants to reconstruct history from a woman's point of view, which as she and others like Hildegard of Bingen enunciate it, is subversive of the social order now existent in Europe."

Marie de France interrupted and responded angrily.

"That is nonsense. How can writing a new, more truthful history subvert the whole social order, Master Fitzneal?"

Richard Fitzneal was ready with his response to Marie, as if he had carefully thought through this matter.

"We have had a male-empowered social order celebrated by male-dominated history. If we change our history to make women's sensibility the core of the story, if history becomes a record of women's pain and suffering at the hands of men, I fear this will have a long-range ideological impact and ultimately could have quite startling political consequences. A historiographical inversion will threaten to effect political upheaval. First change historical writing, then change the political order. A cultural revolution will lead to a political deconstruction. We saw in the last century the chaos when the papacy attempted a radical ecclesiastical assault on the aristocratic and royal order. Now people like Marie de France, going beyond the bounds of merely improving writing, want to change society. They threaten another revolution against the fathers and sons of the great families who have ruled Christian Europe since the time of Charlemagne. The way in which John of Salisbury has portrayed Queen Eleanor's life indeed accords with traditional culture. It is a masculine perspective. But this is the culture and the perspective on which our whole social organization and all our institutions—the royal government, the church, the law courts, the university newly emerging at Oxford—are predicated."

Queen Eleanor was listening intently to Fitzneal's argument. She was pleased to see Marie de France interrupt him again.

"So in the interests of your fantasy of a revolution against the systemic world political and social order—a paranoid delusion without a shred of probability—we are supposed to tolerate biography that never presents a life from a woman's perspective? Master Fitzneal, like all conservatives you are using political arguments to impede cultural and artistic advance."

Fitzneal appeared to be unmoved by Marie's argument.

"What concerns me is not a revisionist biography of Queen Eleanor, if that is what her Majesty really wants, but the ideological implications behind such a reconstruction of the customary way we have viewed the lives of medieval queens, as well as anyone else— from the point of view of the males of the elite families. What is it that Marie de France has really in mind? Better literature or a social revolution? And if the latter, how can it be effected and what will this new women-centered world look like? Can I imagine King Henry acquiescing in it? The pope? The barons? Is this what all our efforts at improving governmental law are going to lead to? King Henry won't allow it. We are talking here of naive assumptions and foolish expectations among the aristocratic feminists. That was true also of the papal reformers. They didn't achieve what they wanted. They couldn't possibly, but they caused commotion and upheaval and conflict for half a century. That is why, Your Majesty, I urge you to put aside Marie de France's rash comments and endorse John of Salisbury's version of your biography."

While Richard Fitzneal was talking, Andrew, the chaplain whom Countess Marie de Champagne had brought with her on her visit to her mother's court, stood aside, listening closely. As Fitzneal concluded his antifeminist remarks, Andrew, slim and sad-looking, shook his head in vigorous dissent and then burst out in anger.

"Spoken like an English gentleman, Fitzneal, who holds women in contempt. You know less about women and how they suffer— even in the highest ranks of the great aristocratic families—than you know about horses. Of course, you value a good horse more than any woman. A good horse is hard to replace. You sit in your counting-house there in London, in the Exchequer chamber, and out of your numbers you draw an abstract model of society in which everyone has his or her place, everyone has an assigned role in the great engine of the Angevin monarchy. To keep this machine going, there can be no alteration from the way that you and other royal bureaucrats have viewed people. Now comes a feminist like Marie de France who wants to reexamine the conventional role that women have played in the royal and aristocratic circles. You cannot allow that. You cannot even allow a consideration of the life of the queen in terms of what she actually experienced rather than what conventional political history assigned her. That would begin to break the mold you have cre-

ated to sustain your financial and judicial system. If the real, inner life of Queen Eleanor were told, if her true sufferings and joys were known, a shaft of light would begin to challenge your whole machinery of power and control that regards everyone—except perhaps the king, and I am not even sure of that—as merely a cipher in an accounting system."

"O, Andrew, another rebellious graduate of the university," said Fitzneal, somewhat taken aback by the chaplain's onslaught. "I can see how you are going to make your way in the world—by retailing radical opinions and fomenting disorder all over the place. You spiritual sons of that ineffable trouble-making professor Peter Abelard, you spread over the countryside looking for awkward corners in the social and political system where you can make trouble. Why don't you get a real job? Why don't you see what it is to carry the responsibility of maintaining law and order, of keeping the machinery of government that you disdain so much running for twenty-four hours? Without this system that you want to break apart, robber barons and hungry peasants would in a flash be at the throat of yourself and the countess you serve so artfully."

John of Salisbury was left confused and speechless. On the one side, he greatly welcomed Fitzneal's defense of his historical narrative and Fitzneal's intellectual challenge against Marie de France. On the other hand, his own criticism of the royal government in his recent book overlapped quite a bit with Andrew the Chaplain's. From the standpoint of traditional ethics—Andrew's moral base was somewhat different and more subtle—John too had attacked the rising engine of Angevin law and government. John's attack came from the old bastion of Christian humanism, a mixture of the Gospels and Cicero. Andrew was bruiting about new psychological insights emerging from the feminist movement. Both considered Fitzneal and Henry II's ministers the enemy.

While these subtleties were running through John's mind, and his voice remained silent, Eleanor began to speak.

"Men raise everything to the level of philosophy. All differences in feeling they want to turn into big rational arguments. Thereby once again they exhibit their propensity to dominate. The theory propounded in the schools becomes an instrument of aggression and control. What I know are particular things, not philosophic princi-

ples. What I know are the painful experiences of my life that John of Salisbury has omitted from his version of my biography and Richard Fitzneal wants to keep in the dark and be hidden forever."

Until now Eleanor had been sitting on a throne-like chair that had been placed for her on the grass. Now she rose from the chair and stood in all her regal splendor. She was still a handsome woman. The sun reflected on her long golden tresses, only modestly mixed with streaks of white hair. A ruby necklace hung around her white neck over her green silken gown. The gold rings on her fingers sparkled in the late afternoon sunlight. All eyes were fixed upon the great queen. Many childbirths had ruined her figure, but her face, while lined beneath her heavy makeup, was still one of the glories of Christendom.

"When I was fifteen I found myself heiress of a great duchy, but with no means to govern it and control the rapacious nobility who hemmed me in here at Poitiers. I was afraid to step out of the palace. Then King Louis the Fat became my guardian and I found myself carted off to Paris, where everyone at the French court made fun of my political inexperience, my southern dialect, and my brightly colored clothes. The royal government was dominated by a Benedictine monk, Abbot Suger. He accumulated power for himself and stored up riches to build his new church but he wanted to make sure I had no independence and that all my lands and wealth were put at the service of the French monarchy. I was married off, without as much as a by-your-leave, to the heir to the French throne. For a little while I had happiness. Louis VII was my age and we delighted to explore the joys of sexuality together. Then that dreadful preacher, windbag, and charlatan mystic and universal busybody Bernard of Clairvaux turned up at the royal court and tried to turn my husband into a kind of pious monk."

As if on cue, all of the queen's entourage, except for Fitzneal and John of Salisbury, hooted and hissed at mention of Bernard's role in the story.

"Louis and I stopped sleeping together. The abominable Bernard closed up my womb and then he convinced my silly husband to go on a crusade—my husband who was no military leader and was a physical coward. So off we went to the Middle East where Louis lost an army and was lucky the Arabs didn't take his

life. But while there, I learned again what physical pleasure meant when I slept with my uncle Raymond of Antioch. That ruined my marriage, of course, and I had to get a divorce. Now I had desperately to get away from the miserable, stinking Paris I had returned to—the Paris where burghers threw garbage into the streets to be consumed by the wolves that ran free there. For three years I waited in the cold royal palace, condemned by everyone as a harlot, while that feeble old pope tried to decide whether to annul my marriage to Louis. Finally the divorce papers came through from Rome. I got on a horse and rode for Poitiers, pursued by half the horny barons of France who wanted to rape me and get my body and my lands."

"For shame! For shame!" said Marie de France in mock horror.

"Secretly I sent a message to Henry Count of Anjou, a seventeen-year-old stud, eleven years my junior, whom I had met only a couple of times, that I would marry him if he would come and rescue me and he did. O he did. It isn't true I married Henry because he was going to be king of England. When I married Henry Plantagenet he was still only count of a small principality without even a good vintage wine, and was only a claimant to the English throne. After our marriage, with the great resources and prestige of the duchy of Aquitaine behind him, his prospects for the English throne improved immensely and three years later he became king in London. I chose Henry because he was handsome and sexy. I fell in love with him at first sight. And he didn't disappoint me—he was even better than Raymond of Antioch. I did not know there could be such pleasure. For a few years I was very happy. But Henry kept me pregnant all the time. In fourteen years of marriage I went through eight pregnancies. And my flowers wilted very late. Menopause was unfortunately delayed in my case. I had my last child at the age of forty-four. I began to decline under these multiple childbirths and Henry found lovers, most of them women, to keep him occupied during my pregnancies. For a few years I had a say in the government. But last year, Henry sent me away to Poitiers, ostensibly to secure the duchy, but actually to get me out his way so he could get on with his amours. I, a dried-up woman of forty-seven, no longer interested him. That, John of Salisbury, is my true history. Would you care to write it?"

Eleanor sat down on her chair and looked around smiling. She was very pleased with herself.

Now at the end of Eleanor's recital, the court poetess Marie de France and the queen's daughter by Louis VII, Countess Marie de Champagne, laughed and applauded enthusiastically. They had heard it all before, of course, but it was always good for laughs and cheers anew. Andrew the Chaplain beamed his delight at this subversive deconstruction of traditional history and conventional ethics.

Richard Fitzneal stood quietly, showing no emotion on his gaunt face. He had encountered the queen before, although never in such a frank and animated mood, and he took what she had to say as just another one of those discomforts of bureaucratic business, like a momentary shortage in the accounts from Yorkshire.

John of Salisbury was dumbstruck, and felt a sense of vertigo—not from the actual events recited, for Eleanor was known by Church writers to be a foul-mouthed, promiscuous woman—but from hearing these things from the queen of England and wondering how he should respond, if at all. That crazy Archbishop Becket with his violent mood swings was trouble, but commenting on the salacious history of the queen of England was a novel challenge to him.

"Your Majesty," he finally said, "Marie de France is right. I would judge from your autobiographical account that I am not the person to write your life. I could handle scandals in the Roman curia, as I did in my papal history, but the inner life of the English court, that is beyond my humble talents."

Eleanor looked at John quizzically and for a moment thought this might be a sarcastic statement, then concluded it was cant, and decided to ignore him.

"The afternoon is wearing on, Master Fitzneal," said Eleanor, "and with all our fun and games we haven't got around to the Exchequer business you came out all the way from London to deal with here. What is it you want to say?"

"Your Majesty," said Richard Fitzneal, "I have reviewed your household accounts this morning and they are in order. But the king wanted me to advise you that you will have to cut back on your spending—the whole royal government and court will have to cut back, because the Angevin Crown has suffered a fiscal adversity. You know that 20 percent of the royal income in England is derived from

taxing the Jews. We have a whole separate branch of the treasury, the Exchequer of the Jews, to bring in this money. The king licenses the Jews to engage in their usurious money lending and then we tax them heavily, getting most of their profits into the Exchequer. Some rich abbots would like to get in on the credit business but the Crown presently licenses only Jews to be money lenders. We say that the Church forbids a Christian to take usury from another member of his religious community. But the real reason is we can tax the profits of Jewish usury at three or four times the rate we could impose on Christian bankers. But suddenly there has been a change in fortune. They are killing Jews in England now. Pogroms have broken out in Lincoln, led by the bishop there himself, and are spreading now to York and London, wherever Jewish bankers are at work. The bishop of Lincoln claims that the Jews at Passover slaughter Christian children, drain their blood, and ritually mix the Christian blood into their matzos that they eat at Passover. Christian mobs are aroused and attack the Jews. They kill the Jewish bankers, and destroy the records of their loans to Christians. Our income from the Jews is therefore falling rapidly."

"How convenient," said Eleanor. "You kill your creditor and feel saintly about it. Why doesn't the royal government put a stop to this?"

"We are trying, Your Majesty," said Fitzneal, "but with the support from some of the clergy the mobs are getting, it isn't easy. We are compiling duplicate records of the loans the Jews give out, so that if they are killed, the Crown itself will step in and collect the loans. The royal judges, when they go out on circuit to the county courts, are instructed to find out who the slayers of Jews are and fine them heavily and to collect directly for the Crown the loans from the deceased Jewish bankers. But it isn't easy. Grand juries won't indict Jew-killers very readily. It takes time and lengthy litigation to collect the loans. Meanwhile the Exchequer has suffered a sharp decline in income. King Henry says we have to cut back on our expenses. That also involves you, Your Majesty. In going over your accounts I see you have bought thousands of pounds worth of imported silk for gowns for yourself and your ladies of the court here. We might begin by economizing there."

"Tell me," said an angry Eleanor, "has the king cut back on the

support he lavishes on his mistresses and his bastard children? In any case, my income comes from taxation here in Aquitaine. I get little or nothing from England. Is the king suggesting that he wants to ship money from Poitiers to London?"

"In the current fiscal stringency that is what the king and his ministers have decided to do," said Fitzneal, swallowing hard. "King Henry is moving toward a more united, imperial government for all his domains."

"Tell the king," said Eleanor, "that I will not comply. This is my land, my ancestral land. The dukes of Aquitaine have been here since Charlemagne's day, while King Henry's ancestors were still heathen Viking pirates rowing up northern rivers and looting monasteries and raping nuns. This is my land. I will administer as I see fit. I, Eleanor Duchess of Aquitaine, Countess of Poitou, tell you this."

"Your Majesty," said Fitzneal, "allow me one last remark. In England under the leadership of the great King Henry, the officials and lawyers of the royal government are constructing a new political and judicial order. Monarchy will no longer depend on the king's personality and the strength of his arm in combat. We are building a permanent administrative and judicial order which will always prevail over any group or individual in society. At the same time, everyone, whether a duke or a peasant, will find justice in the royal courts. Assuredly, Your Majesty, you can see the advantage of these changes to yourself and your progeny. But in order to do this we have to likewise bring order also into the expenditures of the royal family. The king of course wants you to live well, in accordance with your supreme status and your exalted lineage. But unrestrained consumption can no longer be the privilege of monarchy, if we are to have the resources to build a new kind of judicial order and administrative state."

"What you are saying, Master Fitzneal," said Eleanor with quiet fury, "is that I must restrain my expenditures so that the king has the resources to pay middle-class hatchet men like yourself. I know who you are and where you come from—from the dust, from bottom rungs of society. The king's grandfather found your grandfather one day when that king stopped to pray in a parish church in Normandy and the priest ran through the service in record time. Henry I hired

the obscure priest Roger on the spot for his government and made him head of the treasury and rewarded him with the rich bishopric of Salisbury. That is your lineage. And you are the man the king relies on to control his fiscal affairs! I regret the passing of the days of aristocratic glory, when the honor of noble lineage was the hallmark of legitimacy and power, not the persiflage of the law courts and the countinghouse."

Eleanor rose from her chair again and spoke with anger and contempt to Fitzneal.

"I notice also that this new judicial and political order you are so enthusiastic about looms over us, just when women of the nobility have raised their voices to assert for the first time their equal dignity in the ranks of aristocratic power and royal majesty. Isn't all this talk of law and administration just another way of saying we are going to put these uppity women back in their towers of confinement and renew their ancient subservience? When women have shown they can learn, talk, write, and govern as well as any man, you come along, you and other middle-class creators of the new order, and say: We are changing the rules of the game—those personal qualities don't count anymore. It is the arts of the law court and the Exchequer that gives power and status now, and guess what, no women are allowed in ruling precincts! You need a university degree to obtain high preferment in the royal administration but women aren't allowed in the university. Lock up the wives and daughters and keep them away from learning and power. That is your plan. Now sir, we have both said our pieces, and demonstrated our hatred and contempt for each other. So begone from my presence."

In 1173 Eleanor of Aquitaine, with support of three of her young sons, rose in rebellion against her husband, apparently with the intention of regaining the independence of the duchy of Aquitaine. Henry II easily put down the rebellion. Eleanor was brought back to England and kept in comfortable but strict confinement until Henry died in 1189. Eleanor died in 1194, during the reign of her son Richard the Lion-Hearted.

Thomas Becket suddenly returned to Canterbury in 1170, his bitter dispute with Henry II still unresolved. Soon thereafter four young knights from Henry's court slew Becket in front of the high altar of Canterbury Cathedral. John of Salisbury was present when

the knights broke into the cathedral in pursuit of Becket. John ran away. He was the author of one of several lives of the Canterbury martyr that were written in the 1170s. John's *Life of Becket* is pious and formalistic and not of much historical value. But John finally got a good job—as bishop of Chartres, where he died in 1180. His fund-raising efforts prepared for the building of the great Gothic-style cathedral at Chartres.

CHAPTER SEVEN
THE PARTING OF THE WAYS

ROBERT GROSSETESTE

"As your physician, my Lord Bishop Robert," said the Dominican friar John of St. Giles, "I have to tell you that your strength is declining and you cannot continue with the very heavy schedule you have followed in the eighteen years you have been here in Lincoln as bishop. You are eighty-three years of age, now, my dear Bishop Robert, and God gave you the strength of a lion, but very old age is creeping up on you."

A quiet and small city today, Lincoln was in the thirteenth century one the three largest cities in England and aside from London its most prosperous urban center. Lincoln was the trading venue for the booming agricultural life of central England. With a national population approaching five million, a level not to be achieved again until the middle of the eighteenth century, England's midland soil was mined for grain and livestock and Lincoln was a principal market town for this thriving rural society. On market day, its narrow streets were clogged with farmers bringing in their grain, cattle, and sheep and with merchants ready to offer cash for agricultural produce.

The wealthy and learned Lincoln cathedral priests served the spiritual needs of this transient population of sellers and buyers as well as the citizens of the city. To be bishop in Lincoln was to hold a position of high visibility in this prosperous rural world as well as to be one of the three or four top ecclesiastics in the country.

Sitting in his messy study next to Lincoln Cathedral, Bishop Robert Grosseteste shut out the clatter of the streets and the market and in the dim light responded to the assessment of his health and strength he had just received from his physician, Friar John of St. Giles.

"It is all a matter of use of time," said Grosseteste. "I spend no time on frivolities. I work all the time, as God has called me. And I find new things to do in this wonderful world we have been given. That renews my energy. Remember, Brother John, that I learned Greek at the age of sixty and have made some important translations of theological texts from the Greek, with the help of Oxford Franciscan scholars. I started learning Hebrew at the age of eighty. I haven't mastered it yet; it is a strange, very difficult language. I don't know how the Jews can read their Old Testament with no vowel sounds in the text. But I am sticking to it. Rabbi Aaron is coming later this afternoon to give me my weekly lesson."

"Rabbi Aaron?" said the physician John of Giles. "You are known as a great enemy of the Jews but you take Hebrew lessons from the chief rabbi of Lincoln?"

"I am not an enemy of the Jews as individuals," said Bishop Robert. "I would be very happy to welcome them into the Church. Rabbi Aaron's conversion to our faith would be the greatest triumph of my episcopate. Meanwhile I learn Hebrew from him."

"Studying languages and translating texts is suitable for a man of your advanced age, and I regret to say, declining health, my Lord Bishop," said Brother John. "That is not the kind of activity I meant you should eliminate. It is now the end of March and soon the roads will be passable again and no doubt you want to go out on visitation, on inspection tours again all over your diocese, scaring the wits out of the lazy monks and nuns and corrupt cathedral canons, as you have been doing since the first day you came here from Oxford to be bishop. But I have to tell you that you can't travel around like that anymore. I always thought it was a miracle you didn't collapse under the weight of your obligations—writing all those books, directing all that research on ancient Christian philosophy, supervising both Oxford University and the Franciscan order in England, making two trips to Rome inside of five years and tangling with the cardinals and the pope there for weeks on end—no one I have ever heard of could

do all those things and here you were also bishop of Lincoln, a diocese that stretches over eight counties. Doing the ordinary work in this diocese alone would have drained the energy of someone forty years younger than you. You are a physical phenomenon, Bishop Robert. You should have been written up in the annals of medicine. Someday I will write my medical history of your life—others will write about you as a philosopher, scientist, scholar, and bishop, I am sure. But for now promise me you will take things easier—and no more of those crushingly strenuous inspection trips."

It was March of the year 1253. Robert Grosseteste, bishop of Lincoln since 1235 as well as chancellor of Oxford University and protector of the Franciscan order in England, was a very old man and his health was fading. His once robust and muscular body was wasting and he was showing geriatric thinness now. He sat hunched in a chair in front of the fire in the bishop's study in Lincoln Cathedral in the eastern midlands of England, a rough woolen shawl over the gray Franciscan habit he liked to wear, even though he was not technically a member of the Friars Minor. The eyeglasses, which Grosseteste, as an expert on the science of optics, had ground for himself, hung loosely from his ears. The wisps of hair on his head were ashen white. His straw slippers seemed too loose for his feet. He was ill. He breathed heavily and looked sullenly into the fire. He took a mouthful of mead and looked off into space in the gloom of a late afternoon.

"Sometimes, Brother John, I wonder why I chose you, a Dominican friar, as my personal physician even though I am the protector of the Dominicans' rivals, the Franciscans, in England and have been associated with the Brothers Minor since they turned up at Oxford in the late twenties and enticed me to teach them theology and the Bible. You know how I dissent from some of the teachings of the Dominican prodigy in Paris, the aristocratic Neapolitan ox, Thomas Aquinas. I suppose I hired you because I liked your style when I heard you preach at Oxford twenty years ago. I didn't agree with some of what you said, but I liked the precision with which you organized your ideas, your care with words. When I learned that you were a respected physician, I thought you were the man to be my doctor of medicine. You had the mind of a scientist and all the other physicians I have ever known—except for some of the Jews—aren't

scientists. They are magicians and astrologers. That isn't my view of what medicine should be—it should be dispassionate, calculating. And so you helped greatly to prolong my years far beyond the normal expectations of a human life. Yes, I am not well, I am weak. I am in decline at last. I will not last long no matter what you and I do. Still I shall give up my diocesan inspections, as you demand. The slovenly priests and the scurvy monks and those dreadful high-born nuns, with their greyhounds and birds and parlor games—they will be happy when I won't bother them this spring, nor ever again. Now buggery and fornication in the monasteries will resume their normal course. Now the dog and bird population in the nunneries will freely multiply."

Hubert, Grosseteste's secretary, had appeared in the doorway. "That man is here to see you again—Master Innocent, the papal agent."

"Again?" said the bishop. "They have great patience in Rome to want to bother me once more. I thought we had agreed to let the matter ride. Brother John, don't leave yet. As a Dominican you are supposed to be a papal hound protecting the Holy See. I want you to hear this conversation with the papal agent in England."

"He is a tiresome Italian lawyer. I don't like Master Innocent," said John of St. Giles, "but if you wish I will stay a while."

Master Innocent was a tall, elegantly dressed Tuscan nobleman. He had been in England for two years. He did not have the title of legate but only of agent, because he did not have a general commission to represent the pope but only to deal with the matter of provisions—papal appointments of someone chosen by Rome, usually an Italian, to receive the income from an office in the English Church. The appointee of course didn't fill the office personally—he appointed an English cleric as a surrogate to do the job while the papal appointee pocketed most of the income. This practice was justified by Rome as a way of getting the wealthy churches in northern Europe to cover some of the administrative personnel costs of the papacy—it was held to be a kind of tax. Of course, provisions were resented in the northern countries and especially in England and the practice fanned nationalist feeling against the papacy as a money machine run in the interests of Italian nobility.

"I will get right to the point, Lord Bishop," said Master Innocent

in a firm and loud voice in impeccable ecclesiastical Latin, "since I can't tarry here long. I have to get to Winchester as soon as possible. I am on my way back to Rome and I want to know what to report to the Holy Father on this long-standing dispute over the papal provision of an appointee to a canonry here in Lincoln. You have blocked this appointment for two years, Bishop Robert. You even went to Rome and personally made your case to the pope and the cardinals. They were unmoved by your presentation. You have three dozen cathedral canons here in Lincoln, which are high-paying positions. It should be of small moment to you that one should be held by an absentee Italian cleric. It won't cost you anything—it is a prebend, an endowed position. In return, you will store up credit in Rome and that will help you in further litigation there. Perhaps some lord you wish to favor wants a divorce? The pope won't forget your concession, Lord Robert. The return to you in time will be substantial. You have made your point on this. You have gained much admiration in England for your stand. Now will your recognize the absolute power of the pope and accept this appointee?"

"The appointee," said Grosseteste, "happens to be the pope's nephew, which makes the whole thing reek of corruption. But even if the candidate were less questionable, I cannot accept this appointment. The pope cannot make such a provision without my express approval. The previous pope acknowledged this in writing, and now a new pope ignores this agreement. As for the pope's absolute power, I am not sure what you mean. First of all, the bishop of Rome is not higher in dignity than any other bishop—he just has a wider jurisdiction, the whole church, whereas mine is confined to eight counties in England. But that doesn't mean in such an administrative matter he can order me around. Secondly, no pope can exercise power to do wrong, to carry out an erroneous act, and in my view we have the smell of heresy in this appointment. So I refuse to give way."

"That is absurd, Bishop Grosseteste, as you were told in Rome," said Master Innocent impatiently. "A pope loses his power if he preaches doctrinal heresy—if he is a Manichee or a Donatist—not if someone disagrees with him on a purely administrative or judicial matter."

"No matter is purely administrative or judicial," said Grosseteste. "Behind every administrative act is a consideration of moral values

and therefore an implication of Church doctrine. I say this act reeks with heresy."

There was silence for a few moments. Master Innocent looked angrily at Grosseteste and then he exploded.

"I shall probably be reassigned after I report to Rome and not be back here. So let me say something personally and not as papal agent. You are a foolish and ungrateful old man, Robert Grosseteste. You are a peasant whom the pope graciously accepted as bishop to please the king. That was a mistake. Your celebrated learning is undigested and chaotic and your understanding is negligible. You have poor judgment. You are unsuited to be a leader of the Church. You are held in contempt in Rome, and justifiably so. Indeed you are held beneath contempt—it is only your old age that dissuades the pope from proceeding against you by the law of the Church."

"I know they hate me in Rome," said Grosseteste firmly. "The effete tribe of Italian parasites who feed upon the Body of Christ hate me. Should I care? No, I am proud of their contempt. Mark my words sir, the papacy is on a trip to oblivion. There is growing hostility here among the English people toward Rome. The pope is seen less as the Holy Father than as a selfish, ruthless Italian tyrant. I may be a voice crying in the wilderness now, because the other bishops are willing to make cynical deals with Rome, such as the one you scandalously proposed to me. The time will come when the English episcopate is interested less in the art of the deal than in the righteousness of Christ. Then woe unto Rome. Its day will end."

Master Innocent stood glowering with fury at Grosseteste, then turned and left, bowing to John of St. Giles on his way out.

"My Lord Bishop," said the physician John," I am glad you have allowed me to witness the latest peculiar episode in the papal follies. I shall not comment on this exchange. I am only a friar and medical doctor, and thank God I am not involved in these confrontations. I do wonder whether anyone benefits from them. My Lord Bishop, I should say that in your delicate health you should not engage in such furious exchanges, but you seem none the worse for wear. Indeed the color in your face is richer than before. You seemed to have benefitted from heaping abuse on a papal agent. Perhaps you need more of such exercise."

"My Lord Bishop, your Grace," said Hubert, Grosseteste's secre-

tary who had appeared again in the doorway of the study. "Justice Bracton is here to see you. You remember he sent us a letter requesting an interview with you."

"Henry of Bracton, chief justice of the Common Pleas, I haven't seen that tough lawyer in almost two decades. I wonder why he is here. He always goes on circuit in the southwest—he is a Devonshire man himself. Well, Hubert show in the good judge. You will excuse me, Brother John. I think this must be trouble that Judge Bracton brings and he wants to scold me about something in private. I take English lawyers much more seriously than Italian ones."

Grosseteste downed the rest of his cup of mead and John of St. Giles departed as Henry of Bracton's riding boots sounded on the stone floor of the episcopal study.

The old bishop turned toward the doorway to receive Henry of Bracton, adjusted his spectacles until Bracton's not unfamiliar plain ruddy southern face came into view. Grosseteste smiled with pleasure at the judge.

"Justice Bracton," said Grosseteste, motioning to the judge to sit down in the other chair in front of the fire," my dear Henry, I have not seen you since the summer of '34, the year before I came to Lincoln. You may remember that I was lecturing at Oxford in the Franciscan college and you used to attend my sermons on Sunday mornings in the university church—that, I recall, is how we first met. And you were at Oxford looking up some Roman law manuscripts. You were then Justice Walter Raleigh's law clerk and he had sent you to work at Oxford and to write some huge treatise on the laws of England. Do I remember it correctly?"

"It was just as you say," said Bracton smiling broadly. "And what a great pleasure it is to see you here, still in good health, my Lord Bishop."

"Let's not talk about my health. Unfortunately I am very busy today, and I suppose you are too, holding the assizes here in the county seat and all that legal business, so let us go right to the subject of your visit to me—I trust it is a judicial matter and this is not a personal visit?"

"Your Grace, I would be delighted to have made a personal visit to pay my respects to a churchman and scholar of such great renown as you are, but you are right, I have come to see you in my capacity as

chief justice of the Common Pleas. That too is why I am up here in this town, holding the assizes in Lincoln whereas my normal circuit when I go out on the road is the southwest. I have come to see you because of complaints from justices and sheriffs that you have been granting too many letters to criminal perpetrators testifying to their ecclesiastical status. Thereby they can claim benefit of clergy after they are indicted by grand juries and get off from being tried in the royal courts, where they are appropriately punished."

"Aha," said Grosseteste, leaning forward, "you are complaining that I am saving the oaks of England, so that because of my judicial intercession on behalf of clergymen there are less people hanging from the trees when the judges ride back to London after presiding in the county court of Lincoln."

"Well, something like that," said Bracton, "but it is a serious matter, your Grace. At the last meeting of the county court here in Lincoln six months ago 20 percent of the adult males indicted produced letters from you and successfully claimed benefit of clergy to be tried in your court—where there is no capital punishment and perhaps even little of any kind of punishment—rather than face trial by jury. When the judges got back to London, after the last assizes, they were furious that Bishop Grosseteste was impeding the exercise of royal justice. We had a conference, and since I was a chief justice and it was known that we were once friendly at Oxford, it was decided I should trade places with another judge on circuit and come up here when the assizes were next held and talk to you about this matter."

"Henry of Bracton," said Grosseteste warmly, "you are England's greatest legal scholar and I await eagerly publication of your treatise. It will be a masterpiece I am sure, demonstrating your knowledge of Roman as well as English law. But since you are so learned, you must know that benefit of clergy is perfectly legal—it was acceded to by King Henry II after St. Thomas Becket's martyrdom. For someone to claim this judicial privilege nowadays he has to produce an episcopal letter confirming that he is a clergyman. All I do—or strictly speaking instruct my archdeacon to do—is issue the letter to someone who can show his clerical status in this diocese. After that it is a matter for the law courts. What is wrong with that? Perfectly legal."

"Technically yes," said Bracton, "but so many defendants in the county court of Lincoln are claiming this status and showing a letter

with your seal on it that the justices feel the whole thing is getting out of hand and impeding criminal justice up here."

"Less hanging, less justice," said Grosseteste, "that's what they think in London isn't it? You of all people should remember that Oxford is not yet a county seat. The county seat is up here in Lincoln. So that students and faculty at Oxford must defend themselves in the court here. And I am involved in two ways. I am the bishop of the diocese who issues the letters and I am chancellor of the university—a position that normally doesn't involve much on the educational side of the university, but obliges me to protect the students and faculty."

"But all those students and faculty who get into trouble with the law escape from the due process of the law with your help," said Bracton.

"Again I say it is not illegal," insisted Grosseteste calmly. "All the students and faculty at Oxford are clerics. I don't lie when I issue letters for them to show the court."

"You know very well, my dear Grosseteste," said Bracton, "that most of the students at Oxford aren't clergy in a real sense—they aren't going to be priests. They just want to get a university education and prepare for some learned profession. Oxford is an ecclesiastical institution—perhaps that will change in the future but that is the way it still is—and so the students have to be officially in holy orders. I did the same when I was a student but you wouldn't regard me as cleric nor would I seek that status. A great many of these students are just ambitious young people. With your help, they violate the law. They are getting off with your excessively liberal use of that dreadful concession that King Henry II had to make to the pope to get absolved from Becket's murder."

Grosseteste sat quietly for a few minutes or so, looking into the fire. When he spoke, the warm friendliness and easygoing charm was absent from his voice. Bracton had touched something deep inside the old bishop. A button had been pressed. He was no longer sitting slouched in front of the fire. Grosseteste now sat upright in his chair and spoke forcefully.

"It may come as a surprise to you, Justice Bracton," said Grosseteste addressing the judge now in a more formal manner, "but I am not a fervent admirer of the legal system you administer so assidu-

ously. It is merely human law which is not related to divine law. Human law is just a set of pragmatic arrangements. It has no intrinsic moral legitimacy and certainly no divine sanction. I believe in the independence of the Church and the clergy from the state. The common law you administer seeks to embrace everyone in the whole kingdom and swallow up every man, woman, and child, including the clergy, including the university students. It is a great Leviathan that swallows everything in the country. I don't agree with that. I resist it. By giving out these letters activating benefit of clergy I am resisting this great national machine that you operate. I am ultimately supporting individual freedom against the power of the judicial order."

Bracton was taken aback by this radical statement. But he had no difficulty responding immediately.

"Your political and judicial principles are a little out of date. They would not be upheld by the Dominican theorists at the University of Paris, Albert the Great and his disciple Thomas Aquinas. They see the law of the state as reflecting the law of God and thereby naturally gaining legitimacy."

"I have heard what fat young Thomas is saying these days and I don't buy it. He is carrying water on both shoulders for the government of King Louis of France, buttressing its authority over French society. Thomas Aquinas doesn't speak for me, nor for the Franciscan philosophers at Oxford, many of whom were once my students—barefoot and with one cloak each to wear they were my students back in the late twenties and early thirties. The Franciscans realize that Thomas Aquinas is seeking to strengthen the moral status of the French government. I agree with their hostile view of what Thomas is doing. This new Dominican spokesman has sold out, like so many of the Church's theorists and leaders before him. No, citing Parisian Dominicans doesn't impress me. Your legal system doesn't command moral qualities. It is outside of divine law. I shall continue to try to take business away from the royal law courts. I shall not stop trying to help people claim benefit of clergy. It may be the best thing in the current English legal system."

Bracton shook his head and got up to leave.

"We have created a unique legal system here in England. It is much more respectful of the defendant's rights than Roman law. It

gives everyone a chance to defend themselves. It provides equal justice before the law. But if benefit of clergy runs unchecked, that will damage the common law because it will create two separate judicial communities in this country, one privileged and protected in the ecclesiastical courts, the other subject to the justice meted out by the royal courts. We can't allow you to hack away at our magnificent legal system. Therefore I am going to appeal over your head to the archbishop of Canterbury, your superior, and to the king."

"Every bishop is directly responsible to God. I don't care what the archbishop thinks. I will go my own way."

Henry of Bracton regretted being involved in a sudden confrontation with an old friend and scholar he greatly admired from the past. But he could not let Grosseteste undermine the operation of the common law in the diocese of Lincoln. Bracton decided to try a more subtle approach, to put aside jurisprudence and political theory, and try to deal with this problem in a direct personal way.

"Let me speak frankly, Robert Grosseteste," he said. "You are causing trouble for the judiciary and as a leading figure among the judges I have to address it. Let us leave aside your views on law and even your dislike for Thomas Aquinas' theory of law. Let us consider this in a more practical and human way. You are the bishop of one of the three or four richest dioceses in England. The bishop of Lincoln is a very important person in this country. You have many interests and commitments. For years you have been engaged in a quarrel with the pope and the cardinals and the papal agent in England over the power of Rome to appoint someone to an office in your cathedral without your prior approval. The papal system of provisions results in the occasional appointment of an Italian cleric to be a cathedral canon in Lincoln, as elsewhere in northern Europe. Of course the Italian thus appointed never turns up here; he appoints a cheap surrogate to do the job required and pockets most of the income from the position. This is the way the pope poaches on the churches in northern Europe to get some support for his ever-growing administration. You said: 'Nothing doing; only with my permission and I won't give it.' Three years ago you went to Rome and spent a year away from here to make a personal statement of your side of the dispute to the Roman curia. They ignored you. I won't say where I stand on this issue. Obviously there is lots of nationalist feeling in

England that takes your side against the Italians. The point I am making is that you are already embroiled in a legal, jurisdictional dispute with Rome. Where do you have the time and energy for a quarrel with the English judges and the royal government? As a member of the ruling elite, as the holder of one of the top jobs in the country, why do you want to do that? I don't interfere in theological matters or tell the faculty and students at Oxford what to study. You shouldn't undermine our national legal system, which is one of the best things about this country. To get along you have to go along, my dear Robert Grosseteste. You have to accommodate people sometimes when they are also part of the ruling class you belong to."

Grosseteste listened intently. He thought for a few moments, then he replied.

"Henry of Bracton, you are a clever man, a subtle negotiator. I can see why you have risen so high in the legal profession and in the royal service. Your argument would make a lot of sense if I was your typical bishop, if I came from the nobility or at least from a wealthy gentry family, who had studied theology and canon law in Paris, had sat at the feet of the great scholastics like Aquinas, and all that. That is the background of your typical bishop these days. But that wasn't my life—or didn't you know? I am an outsider, catapulted into the elite through appointment to the bishopric of Lincoln eighteen years ago by a series of unusual circumstances behind which I see the hand of God. Christ chose me to be a prince of the English Church and that meant He placed great responsibilities on me. I wonder if I ever told you when we met in '34 at Oxford that I was born in very humble circumstances.

"I cannot recall that you did," replied Bracton dryly.

"I was born in a village here in the midlands," said Grosseteste. "I was orphaned when I was a boy. I turned up homeless here in Lincoln and begged in the streets. Maybe that is why I love the Franciscan mendicants so much. Finally the mayor of Lincoln felt sorry for me, saw to it that I had a place to live, and sent me to school. I did well and with lots of help from local rich people I went to Cambridge and studied philosophy there. You will notice that I couldn't afford to go to Oxford, let alone Paris. I went to the newly founded very small university at Cambridge, raw and poor as it was, and still it is. Did you know that it only got going forty years ago after a

town-and-gown riot in Oxford and some of the faculty and students seceded and departed for the swamps of East Anglia and founded a new university, which hasn't done very well? That was the only formal higher education I ever received—at Cambridge. After college I held all sorts of jobs of a secretarial and administrative nature in various dioceses, far down the ladder, for many years, while I studied philosophy and mathematics on my own time. I got a reputation as a scholar and when the Franciscans came to Oxford in '29 they hired me to teach them. I didn't ask for much of a salary and the friars used to walk a mile every day to my classes barefoot through the mud. You will notice I wasn't elected a fellow of a college. I was just an extension instructor, an adult education teacher. But I continued my writing and began to publish, influenced intellectually now by the Franciscans who were going in different directions from the Dominicans at Paris—away from the Dominicans' comprehensive rationalism toward a more humanist, personal, emotional kind of philosophy."

Bracton was not very sympathetic to Grosseteste's autobiography nor was he friendly to the kind of philosophy that Grosseteste was claiming the Franciscans were developing. It sounded like soft stuff to him. Bracton's lawyerly mind was not interested in any intellectual construct that was not closely related to the world of money and power. He was prepared to think hard and long about property, process, and privilege and to consider theoretical constraints arising from this hard world. But a humanistic, personal, emotional kind of philosophy seemed pointless to him. The kind of speculation that occurred in Parisian scholasticism was closer to the hard world of law and much to be preferred.

Grosseteste was still rambling on enthusiastically about Franciscan philosophy.

"It was very hard to work out and it still isn't fully worked out but its not the comprehensive Dominican rationalism that prevails at Paris, I can tell you, not your standard scholasticism. I also conducted experiments with light and optics—this was influenced by Franciscan neoplatonic mysticism and Plato's love of mathematics. This scientific work was outside the academic main line, but important. Nonetheless I got there on my own, without the academic establishment."

Bracton was impatient with the old man's recital of his life but there was no stopping the bishop now.

"One other thing I had going for me—back in the twenties I had worked for a while as a secretary to the young King Henry III while he was still in his minority and not yet in charge of the government. I was good to him when everyone else ignored him, as often happens with underage kings. He didn't forget. Now we come down to what you know about—my election to the bishopric of Lincoln in 1235, which shocked most people. Who was this obscure, unfamiliar adult education instructor who was suddenly made a great bishop? It was God's doing. But there are some empirical explanations. The cathedral canons here at Lincoln were split and couldn't agree on someone to nominate to the king, who appointed the bishop. Finally, they decided to make an interim appointment—some innocuous old man who would take the job for a little while and not bother them. I was sixty-five and an academic philosopher of marginal reputation. I seemed a very safe choice. The king to everyone's surprise was delighted about my appointment as bishop, remembering how good I had been to him when he was isolated and unhappy. He got the pope to go along. The pope also thought I would soon die and meanwhile this obscure oddball night school teacher certainly wouldn't give Rome any trouble. I fooled them all. You see, God called me to this position. There is no other way to explain it and I have an obligation to fight for truth and justice and not compromise my principles."

The old man was quite animated now. The shawl had slipped from his shoulders. His face, relaxed and sallow a few minutes ago, was now determined and color had returned to his cheeks.

Bracton, used to endless victories in the law courts, felt he had surprisingly been rebuffed by this strange old man. Grosseteste seemed to belong to a different cultural world from the one Bracton took for granted and perhaps the bishop was also slipping into senility. Bracton was puzzled and frustrated. There was no further point to the conversation.

"I shall have to take up the matter with the chancellor and the king," he said. "Meanwhile, Bishop Robert, think about what I have said and consider whether you can bring yourself to moderate your

support of indicted clerics that impedes the course of royal justice up here."

He left and Grosseteste sat in front of the fire and dozed off for a half hour until his secretary Hubert appeared and announced the arrival of his best friend and ally, Adam Marsh, the head of the Franciscan order in England. For a quarter of a century they had been close allies and confidants, since the time Adam was a student at Oxford and Grosseteste was a part-time teacher there.

"O, Adam, I am glad you came today," said Robert, as Marsh settled down in front of the fire and took a cup of mead for himself. "Do you know who was just here? Henry of Bracton, the chief justice himself. Do you remember him back in '34 reading Roman law manuscripts at Oxford? Do you remember we dined with him a few times at the Tackley Tavern?"

"Yes, I remember him. I never found him a congenial dining companion. He bored us with long lectures on the law of contracts," said Adam. The friar was a short, wiry, animated person who talked in a high-pitched voice. "I could never understand why Bracton was so fascinated by the law of contracts. It seemed just common sense to me. He seemed to find some kind of mystique in it. But Bracton is certainly a famous personage now. Recently at Oxford the Franciscan library received a draft of part of that huge treatise on English law that Bracton is writing."

"Is it any good?" asked Grosseteste.

"It is a strange work—an enthusiastic exposition of common law procedure using Roman law concepts and language. I don't think it quite works," said Adam Marsh. "It takes Magna Carta very seriously. It seems to parallel the political theory that Thomas Aquinas, I hear, is propounding among the Dominicans in Paris. I remember one statement in Bracton's treatise—'In England law rules and not the king.' I am not sure what that means but it sounds good. At any rate, Bracton is not in favor of tyranny; I guess he is a constitutional liberal—a good heart and a soft head." Adam laughed heartily.

"I think," said Grosseteste, "that we who are the party of truth and love will have to ally ourselves for a while with the liberals like Bracton. We have the same enemy in common—the implementers of absolute power, the hard people who want to keep the world as it is, with control by a very narrow elite who will exercise power from the

top down. You know who I am thinking about—the men from the aristocratic families, the royal dynasties, the pope and the cardinals. They want to keep all control in their own hands and subordinate everyone to themselves. I sense that someone like Bracton, also perhaps Thomas Aquinas and the Dominican scholastics in Paris, don't want that. They want a degree of consensuality, of a moderate political system in which there is participation upward in decision making from the people. Above all, they want the rule of law to restrain tyranny. You know, Adam, this is not what we in the Franciscan movement really believe in. This is not our perception of the world. It is all very thin and two-dimensional. But for now we can ally ourselves with the Bractonian and Thomist liberals against the proponents of the tyrannical old regime, of narrow power. I think Earl Simon de Montfort is also a consensualist and rule of law man, and I think we should support him as he tries to form a party among the higher nobility to constrain the royal government. Earl Simon was here last week and we had a good conversation."

"Earl Simon is a benefactor of the Friars Minor," said Adam. "We will support him should the time come when he makes his move and tries to improve the political system."

"I endorse that," said Grosseteste, "but at the same time you know I don't really believe in political solutions. You know I am a cosmic idealist. I want to see divinity working its way in the world, transforming it. I think that too was Augustine's vision. Politics is such a small part of this and it is relatively insignificant. Law may actually be an obstacle because law wants to categorize everything, pin it down, and stop the thrust forward of change and fulfillment. I believe in a new dimension which will bring to reality the divine idea working itself through the world and especially the mind of man, which is the image of God."

"I think that is what St. Francis envisaged," said Adam eagerly. "A little band of holy men and women who are the seed of transformation of the world, the movers of history to a new stage. I think that is what Joachim of Flora was talking about. On the one side is the tyranny of the old order signified by Satan sitting in Rome on the throne of Peter. On the other side is a little band of brothers and sisters who light up a corner of the darkness that Satan has imposed on the world through power and traditional institutions. Then the light

begins to roll back the darkness and the final age of history begins with the Brothers and Sisters Minor, the Franciscans and their followers, the agents of divine light, entering the world and transforming it in the final segment of time."

"I think I agree with you on the importance of the Franciscans," said Grosseteste "and you know how hard I have worked to establish the Minors here in England and to help them come to dominate Oxford intellectually. But I see things a little differently than the Joachimist teaching that you have just referred to. For many centuries there have been children of light who have now and again emerged to propound God's truth and seek justice and love. There were the papal reformers two hundred years ago who fought against the imperial power, and even though the papacy today is an engine of tyranny and corruption in our midst, I think that back then two centuries ago there were good people in Rome. Then there were all the scholars and poets and publishers and artists who from the time of the Englishman Alcuin in Charlemagne's day to those now who teach and create with their pens and hands and who compose music—all the writers and artists, I see them also as children of light unrolling God's word in the world, as doing so much good. Then there were the aristocratic women of the last century like Hildegard of Bingen and Eleanor of Aquitaine who fought against the prevailing order that was cemented by masculine privilege but in the end the good women were crushed by the lawyers and the bureaucrats and the selfish cardinals in Rome. Somehow I think in all these people there was divinity activating itself through the world and transforming it in anticipation of the Kingdom of God that will appear at the end of time."

"Then," said Adam, "at heart Robert you are an Augustinian and see history as a locus for the pilgrimage of the City of God."

"Yes," said Robert, "I suppose I am an Augustinian. All true believers in Christianity are Augustinians at heart. But St. Augustine's vision of the membership of the Heavenly City is a little too austere for me, too much an angelic host. I see these agents of divine creation as a more varied, joyful, noisy, colorful, boisterous group. They are singing and dancing in the streets, they are making love in chivalric courts, they are doing scientific experiments in the universities, they are putting together great libraries and publishing books,

they are painting frescoes and sculpting figures. They are very much alive and three-dimensional, all these people. And of course there are mendicant friars curing the sick, helping the homeless, comforting the desperate but singing and shouting while they are doing it. This is my vision, Adam, of the good people against the tyrants and the rich, the cardinals and the lords, the lawyers and the logicians, the enemies of humanity. I believe there is coming a parting of the ways between those who love mankind and celebrate humanity in all its wonderful creativity and its infinite capacity for joy and love and those who take, and instruct, and control, and suppress. This will be the final struggle."

"In this struggle," said Adam, "the Dominicans will be of little use. The Parisian scholastics have done damage in these times. The Dominican academics have created a new tyranny in the guise of avant-garde thinking."

"Not being officially a member of the Franciscan order," said Grosseteste, "I can afford to be more charitable to the Dominicans at Paris than you, Adam. But I regret that I have to agree with you. When Albert the German's work first appeared, I thought there were many things in it I could agree with. But in time I have come to realize that what Albert—now pretentiously called by his students the Great instead of the German—has done is create a new kind of intellectual tyranny through congealing traditional Christian doctrine within a vast system based on Aristotle's philosophy. And Thomas Aquinas, Albert's precocious protégé and the rising star in Paris, is carrying this even further into an even more comprehensive intellectual program that imposes Aristotle upon philosophy and science at almost every opportunity."

"What I can't understand," said Adam, "is why the bishop of Paris keeps giving Aquinas such a hard time and interfering with his teaching. Well, I do know. The bishop, like so many reactionaries, is stupid and ignorant. In time the establishment will see that Thomas and the moderate liberals are the old guard's best hope of covering their dehumanizing tyranny with an intellectually respectable facade. Thomas is condemned now by the reactionaries but in time he could become the Church's official philosopher, you will see, the one favored in Rome. Everything in Thomas' theory gets integrated into that universal machine of his—the bad as well as the good in the

Church. What starts out deceptively looking like a liberal and rational critique of the prevailing order ends up as rationalizing legitimation of the status quo."

"Yes," said Grosseteste vehemently, "just because he uses Aristotle so much Aquinas upsets the bishop of Paris and other dumbbell reactionaries. If they would bother to read Aristotle, they would find that Aristotle was the great Athenian conservative, the defender of the prevailing world order. Plato was the radical. Aristotle wasn't the chosen tutor of Alexander the Great for nothing. Aristotle makes you feel good that flashy tyrants like Alexander are in charge. He gives moral quality to the way things are always done and says it is the golden mean. The Paris Dominicans support the pope, the cardinals, the Inquisition, and the whole tyrannical engine of French monarchy, and try to make you feel good about them too. He is a very learned and clever young man, this young fat Thomas, but he could do an infinite amount of damage, I agree. He is already making a lot of trouble for our cause. Even more than Albert the German, Thomas has raised liberal rationalism—which is really a conservative doctrine—to a new intellectual level and threatens to make us look like obsolete, marginal eccentrics without standing in the academic community, the oddball Franciscan fringe. We have to find a way to resist the subtleties of that Neapolitan nobleman turned Paris professor and make our claim."

"Aquinas means well, I suppose," said Adam. "He hopes to bring all knowledge into synthesis and create an intelligent order of nature and society. Bracton his ally aims to bring all law both Roman and English into a comprehensive order fully integrated with all parts defined and their relationships exhibited. So did the architects who built the new cathedrals at enormous expense try to integrate and lay bare all traditional knowledge at the same time. I suppose we have to live with these people. They are not the real enemy. But their academic integration helped the enemy by driving out feeling from thought, by closing down the search for truth within a finished cathedral of intellect."

"We know that there is no final truth outside the Gospel," affirmed Grosseteste, "no grand synthesis, no final definitions while the world and humanity exist. Everything evolves; everything changes. While each particle is absorbed into the divine spirit pul-

sating through the world in time, this evolution never stops to define and frame, never assigns precise place to human and material things. We only know the force of divine thrust pushing forward in time and pulling everything into it. That is why I regret the celebrity of the Parisian scholastics in spite of their reason and their learning, and their liberalism. Because intellectually they have gotten the story wrong. They are closing down the past and congealing culture. We want to pull the past into the future and open up all culture to new and ever-changing revelation. This is where we stand in opposition to the Satan of power and we are also separate from the scholastic liberals. We are the other party in the world."

Both Grosseteste and Adam Marsh were excited now. They were stimulating each other, pumping each other up intellectually and emotionally, as they had been doing for a long time. They needed each other all the more because neither had status in the burgeoning academic world.

Oxford, like Paris, was turning into a full-fledged, elaborately articulated university. But Grosseteste, although he was as bishop of Lincoln the official chancellor of the university, had no academic status there, any more than the president of the Board of Trustees of a major American university, the equivalent position, has intellectual respect from the faculty or involvement in its curriculum and research. Adam Marsh as head of the Franciscan order in England enjoyed support from the important Franciscan component in the Oxford faculty and he exercised disciplinary control over them. But he too was not a member of the inner academic circle that was rapidly raising Oxford to competitive level with Paris.

Furthermore, the ideas that Adam Marsh and Grosseteste believed in and the culture their writings and lectures communicated were increasingly marginal within the academic world and in danger of falling outside it altogether. Academia, then as now, formulates its marks of legitimate intellectuality largely by a process of radiation from one or two centers to the collegiate provinces. In the mid-thirteenth century Parisian neo-Aristotelian scholasticism as developed by Albert the Great and now further by Thomas Aquinas held court. Even those who didn't agree with Aquinas on major issues would have to frame their responses within the Parisian manner of heavy syllogistic argument.

Grosseteste and Adam preferred the more open, rhetorical, humanistic, personal mode of argument that had been popular sixty years before but was now being shunted to the sidelines in the university arena as amateurish, obsolete, idiosyncratic, unacademic. That Grosseteste had made breakthroughs in the science of optics, that he had devised a method of proof and falsification of paradigms through experimental method, counted very little with the regnant scholastics. They found it hard to distinguish Grosseteste's experimentation from the techniques of the alchemists and his flee-flowing discourse seemed to resemble the disquisitions of the astrologers who were popular in the literary marketplace but were on the fringe in academia. Grosseteste and Adam knew they were losing ground in the academic world, and so they clung to each other all the more warmly.

"Aquinas means well," repeated Adam Marsh. "I do not want to be too critical of this endlessly industrious, brilliantly precocious Dominican friar, especially when you consider the damage that some other Dominicans have inflicted on society by their participation in paranoid inquisitorial panels, hunting down so-called heretics all over the place, and causing commotion and fear. Young Thomas is a benign, generous man, I suppose. Yet he does have the same compulsion as Albert and other Dominicans to build finished systems that in the end turn out to be more oppressive and bothersome than useful. I particularly admire the way in which Thomas Aquinas has mastered just about all the writings of Aristotle, which seem infinite—I wonder if the old Greek really wrote all the stuff attributed to him nowadays—and manages to internalize them all and regurgitate them back from his consciousness into smooth expositions on just about any subject one could think about. I admire this feat but I wonder what is the point of it all, especially since Aristotle isn't the last word on science, and he is being superseded now, especially by the Oxford Franciscans, whom you, Robert, trained in physics. The trouble is that Aquinas hitched everything to a fading star. He would have done better not to embed his ideas so much in such a firm Aristotelian casing. Thomas' ideas will look more and more vulnerable as the current enthusiasm for Aristotle wanes in European universities."

"What I have against Aristotle," said Grosseteste, "is that he wasn't really a scientist at all—he was a wonderful popularizer of other people's science. But he didn't verify anything; he didn't even have a principle of verification, or of falsification—and unless you give others a chance to prove your proposition right or wrong you may be a poet or a visionary or a popular writer, but you aren't a scientist. So despite Thomas wanting to be a progressive thinker—and appearing to the bishop of Paris and other mossback reactionaries as a radical one—Thomism isn't a new mode of thinking at all. It is a skillful form of vulgarization of an old culture that has reached a dead end, and that's where Thomas' system is also—in a dead end, in obsolescence and redundancy. Of course I am prejudiced against him, because he is a Dominican, and I don't like the Dominicans, even though I employ one as my physician."

"It is unfortunate," said Adam Marsh, "that because the Dominicans became troubleshooters for Rome, it has come to be widely assumed that there is an authoritative quality to Thomism. I see why young Thomas appeals to a fashionable liberal elite. Thomas, like Bracton, is a moderate; he doesn't upset anything, or challenge anything in a significant way, but he looks intellectually correct. So just put the massive tomes he has started to write on your shelf and you can sit back and think that intellectual issues have been resolved in Europe for a long time."

"They haven't been resolved, I agree with you," said Grosseteste emphatically. "We are just beginning to address them, and down the road the solutions won't look at all like Thomism. In some ways I find the liberals like Aquinas and Bracton harder to live with than the reactionaries like Master Innocent and the other papists, even though I know we should ally for the moment with the liberals against the diehard obscurantists and authoritarians. Thomas and Bracton tell us that an easy solution can be worked out, a middle way can be found. I don't think any longer there is a middle way. Meanwhile Thomas and his Parisian professors and Bracton and his London lawyers throw smoke in everyone's eyes and calm things down, whereas it is polarization, conflict, that offers the only way forward. The fat professor and sleek lawyer—at the end of the day, they are sitting on their endowed chairs and on the judges' benches and look-

ing good, for themselves at any rate, while the Franciscans and others committed to the truth are on the fringe of intellectual and political power."

The old man's bitterness was showing through. He was talking now in a more heartfelt manner—and more visionary as well.

"Rabbi Aaron who instructs me in Hebrew has introduced me to a beautiful idea that he received from the Kabbalists of southern France and I have started to read a kabbalistic text written in Provence. God sometimes becomes depressed, and withdraws his *Shekinah*, his shadow, momentarily from the world. Then the vessels of the universe that hold the structure of nature together are shattered but flashes of light fall from the broken vessels into the foulness and evil of the world. And these particles of light are the beginning of the healing of the world. Out of them God will create a better world. I think there is much wisdom in this vision. We know who are the healing particles of light by which a new and better world may be reconstituted. The Franciscans certainly, but also the poets and artists, the scientists, and mystics, the spiritual women, the beautiful and loving people. This is my vision of the future. I feel it will happen."

"I am glad to hear, Robert," said Adam Marsh, "that you still have faith that our cause will triumph. I have to admit that some days I lose heart and think we will be overcome, shunted aside, consigned to the margin and then to oblivion. Everything now is systems and summaries and collectivities of this and that, adding up to power and dehumanization. Aquinas wants to summarize all theology and philosophy; Bracton summarizes all law. There are collections of all the saints' lives, encyclopedias of all scientific knowledge, and so forth. The freedom of the individual is restrained by systems which provide easy vehicles for the tyrants, the rich, the materialists, the well-born, to control thought and culture, channel all feeling, in these great collectivities. Even the university has become a means of empowerment and control. Remember how we used to gather in that little room above a carpenter's shop in Oxford and you would hold your classes there. Then we built a simple wooden building so we could have a library and study room for the friars as well as a classroom. That was our school of general studies. That is what Oxford was still like a quarter of a century ago. Now rich lords and merchants are endow-

ing colleges and they are putting up fancy stone buildings and the sons of the gentry are pouring in to get advanced degrees and jobs from their degrees. The general studies, the intellectual subjects, philosophy and the humanities, are getting shunted to the bottom, routinized as basic, introductory pedestrian requirements. And now the dons strut their stuff in the Oxford High Street and boast of their connections in Church and state. Everything expands into a system, every good idea and deep feeling gets impacted into an institution. So I wonder, Robert, if we shall ever prevail."

Grosseteste leaned forward in his chair and pulled his shawl over his shoulders and put his straw slippers squarely on the stone floor.

"Yes, Adam, I despair sometimes too these days. But I still have faith that the party of humanity will prevail against the tyrants and their collaborators, the Thomist liberals. Think of the little poor man of Assisi, St. Francis himself. Let his life be a continual inspiration for us. He came out of nowhere, out of the obscure dust of a little hill town in Italy, and by the force of his mind and body, the power of his love and sacrifice, the miracle of the stigmata on his body, this homeless beggar in the street became so powerful a force in society that the papacy had to throw itself at his feet and beg him to support the old order."

"Maybe that is the trouble now," said Adam. "St. Francis should have told the cardinals to go away. He should have made the revolution there and then."

"No," said Robert, "St. Francis did the right thing. He had confidence, he had the vision, that the individual can prevail against the system, that love can triumph over power, that idea can transcend matter, if only the belief, the faith, the feeling is pure enough. I think this is the right way morally; it is the Christian way. It is the scientific way too. Aquinas, like his teacher Albert, has got it wrong. The truth is not in the comprehensive blown-up system. It is in the smallest particle; that is what my experiments have taught me. God is in the detail, not in the system. The smallest ingredient of reality, that is God working His way in the world. The system is just a human creation and in time like all human creations becomes oppressive and evil and decays. The Kabbalists are right—salvation begins with the breaking of the vessels, with cosmic chaos. Then in the particles of light, in the smallest carriers of the divine spark, the

great renewal begins. We must have this faith, that the little sparks of divinity will be the beginning of the salvation of mankind. St. Francis showed us the way. That is why he was the only true imitator of Christ who is the Eternal Way."

They were sitting now in the damp gloom of an English late March afternoon. Liturgical singing came from the cathedral chapel. The wood in the fireplace was burning down. Adam Marsh finally posed the question he had come to ask Robert, the state of the bishop's health, a question that he feared to ask because he already expected a sad answer.

"Was your Dominican physician here today?"

"John of St. Giles was here."

"And what did he say?"

"The prognosis wasn't very good. He made me give up my inspection tours in the diocese. My very dear friend Adam, I know I am dying. I feel the divine strength is leaving me. The Holy Spirit is departing from me. You will have to go on alone. I shall not be around much longer to sustain the great cause we are committed to. I will not live to see the spiritual revolution I have fought for all my life."

Adam wept softly and embraced the old man.

Robert Grosseteste died in June of 1253. No churchman of the thirteenth century was as sincerely and widely lamented in his passing as the great bishop of Lincoln. In 1265 Earl Simon de Montfort, the leader of the barons' rebellion, with the moral support of Adam Marsh and the Franciscan order, won a victory over King Henry III, took over the royal government, and called the first recognizable meeting of the English Parliament. But three years later the heir to the throne, the future Edward I, defeated and killed Simon de Montfort at the Battle of Lewes. The Franciscan poem the *Song of Lewes* lamented this critical reversal of fortune.

In the 1280s at Oxford a brilliant Franciscan scientist and philosopher, Roger Bacon, consciously tried to continue Robert Grosseteste's intellectual work. But a decade later the seminal Franciscan philosopher, Duns Scotus, whose work in logic in some respects anticipates Wittgenstein, after reading Grosseteste's manuscripts, decided that Bishop Robert's work was too amateurish and personal to be of permanent academic value. Scotus worked within the conti-

nental scholastic tradition, although philosophically he was an opponent of Thomism.

In 1953, the seven hundredth anniversary of Grosseteste's death, the Oxford historian of science, A. C. Crombie, identified Grosseteste as the founder of modern experimental science. A little belatedly, Oxford recognized the intellectual grandeur of its first chancellor.

CHAPTER EIGHT
THE WINTER OF THE MIDDLE AGES

JOHN DUKE OF BEDFORD

Time ran down until there was left only the thinnest edge of unexpired hope. England's great French Empire, the theater of so much heroism and pillage, of glory and gore, was slipping toward the precipice.

"My dear friends, vassals, and guests," said John Duke of Bedford, the regent of the English Empire in France, with genuine enthusiasm, "it is most pleasing to me that you have joined me here in this great hall for a festive dinner and that you will participate tomorrow in the annual Arthurian pageant we are preparing. It is my delight to see such a splendid company of gentlemen and ladies that not even King Arthur at Camelot could surpass in his summoning of valor and beauty to his Round Table."

But Duke John's festive mood this year was circumscribed with anxiety and doubt. His good humor and aristocratic panache this time were partly contrived and the celebratory welcoming words to his companions were designed to forestall the shadow of the looming crisis.

It was the second day of Christmas in the year 1427, in the later stages of the Hundred Years War between England and France. The English forces still held the western third of France, including Paris, but the Valois king of France, Charles VII, had started a counterattack. The English forces in France were fortunate to have as their commander the formidable soldier and shrewd governor, John Duke

of Bedford. He was the brother of the hero King Henry V, the victor at the Battle of Agincourt in 1415.

Henry V died suddenly in 1422, leaving a nine-month-old infant, Henry VI, as the heir to his vast realms. The head of the government in England during Henry VI's minority was Cardinal Henry Beaufort, bishop of Winchester, an ecclesiastical prince with vast personal wealth and many international connections. The Beauforts were the cousins of the reigning Lancastrian family from which Henry V and VI stemmed.

John Duke of Bedford served as regent of France for his very young nephew, Henry VI. Bedford was the heroic reflection of the other great leaders of his dynasty, his brother Henry V, and his grandfather John of Gaunt. The founder of the Lancastrian dynasty in the late fourteenth century, John of Gaunt, duke of Lancaster, established a vast domain stretching from the English border with Scotland through estates in western France and across the Pyrenees down even to the plains of central Spain at one point. For half a century millions of people in England, France, and Spain of all social classes professed a very deep loyalty to the Lancastrian dynasty, the nemesis of the Valois kings of France.

The House of Lancaster signified for contemporaries more than enormous wealth and power. The Lancastrians (like the Kennedys in recent American history) were one of those families that came to stand for an ethos, a culture, a way of life, an expectation. The Lancastrian family's assiduous patronage of writers and intellectuals sharpened its positive image. The poet Geoffrey Chaucer and the radical Oxford theologian John Wycliffe adorned John of Gaunt's entourage. John of Gaunt had the finest house in London until the rebellious peasants burned it down in the great upheaval of 1381.

John of Bedford's younger brother, otherwise known as a mean and unsuccessful politician, is memorialized today by the manuscript room of Oxford's Bodleian Library—Duke Humphrey's Library. Its fifteenth-century ornate painted wooden ceiling is a monument to the Lancastrian family's patronage of letters and learning. Like Humphrey of Gloucester, John of Bedford was an assiduous collector of illuminated manuscripts. Bedford commissioned two exquisite French books of hours.

Many devoted servants of the Lancastrian dynasty regretted that

Duke John of Bedford was not regent of England and head of the English government. But if he were, there would have been no royal commander of the first rank to defend the English lands in France against the resurgent and determined French King Charles VII. So Bedford ruled the English Empire in France while his cousin Beaufort ran the royal government in London.

Duke John's Christmas camp was located in a chateau just outside the walls of the old city of Chartres. In the throne room that had been set up for the regent, next to the great dining hall, a window looked out upon the Gothic spires of Chartres' famous cathedral.

Duke John was still in the feasting hall, hosting companions and dependents of both genders, when three men left the dining table and entered the throne room next door to discuss affairs of state. One of these was Sir Thomas Blount, a gentleman from Derbyshire in the heart of the ancestral lands of the Lancastrian family. Thomas Blount's father had died fighting for King Henry IV, John of Gaunt's high-strung son and his brother for Henry V, John of Gaunt's Arthurian-mode grandson. Thomas Blount was Duke John's treasurer and paymaster of the English forces in northern France. He was a muscular man in his late thirties, incongruously and expensively dressed in velvet and silk. His weathered face and large gnarled hands reflected his many years of military service to the Lancastrian family.

A second man in this group of three was Cardinal Beaufort, the head of the English government in London. Over his ecclesiastical garb and red cloak he wore an ermine jacket. From his neck hung a jeweled golden cross that English mercenaries had pilfered from a monastery on the Loire in the feeding frenzy of booty-taking after Agincourt. Beaufort was a stout man in his early forties. He was tired and impatient and not happy to be spending Christmas far from home. But he had been summoned by his cousin Duke John on business and Beaufort could not afford to offend Bedford.

The third person in this group of three was a tall figure in his late forties, dressed chastely in simple black woolen cloth, spectacles dangling from his nose. This was Sir Edmund Smythe, barrister of the Inner Temple, justice of the Common Pleas, son of a millionaire Lord Mayor of London. Smythe was Duke John's civil and legal administrator in France. At six feet Smythe was inordinately

tall for a medieval man; he towered by a head over Blount and Beaufort.

Pensively Beaufort looked out the window at the spires and stained glass of Chartres Cathedral. Blount sat down at the head of a long refectory table and rustled through some papers. Smythe went to the other end of the table, in front of the crackling fireplace, and poured himself a goblet of red Bordeaux wine from one of several earthen jugs on the table. He downed the wine in one gulp, refilled the metal goblet, motioned with it first to Beaufort, who remained partly turned away from Smythe and still looking out the window, and then to Blount who looked up from his papers.

Smythe spoke with a cheerful, almost jocular lilt in his voice.

"Claret, red Bordeaux wine, the drink of English gentlemen and ladies. Did you know that my father got rich in the Bordeaux wine trade? King Henry IV gave him an import patent, immensely lucrative. I have drunk nothing but claret since I was five years old, and I am better for it. The pope can keep his famous Avignon vineyards with their heavy Burgundy grapes. Give me the quick clear wine of Bordeaux, the heritage of the incomparable dowry that Eleanor of Aquitaine brought Henry Plantagenet nearly two centuries ago and held by the English Crown ever since. I propose a toast, Lord Bishop Beaufort, to your glorious family, the greatest in Christendom since Charlemagne, nay since the Romans. The Plantagenets and Lancastrians in exaltation! May they rule Aquitaine forever, from beautiful Poitiers and Bordeaux's priceless vineyards to the icy Spanish slopes!"

As Smythe drained his goblet, Blount looked up from his papers with a scowl on his face. He began to speak softly but soon he was shouting and gesticulating with a handful of papers that he shook at Smythe.

"Perhaps, good Justice Smythe, you will tell me where I will find the coin to pay the soldiers to defend those blessed vineyards that fabled Eleanor brought to Henry of Anjou's fertile bed. Every day, the French armies threaten our positions from down in Gascony to up here in the northern valleys. The government in London is now hard pressed to support us and that is why Duke John has asked my Lord Beaufort to join us and discuss the straightened fiscal circumstances that afflict the English army in France. The soldiers' pay is

several months in arrears. Some are going home. Some irreplaceable commissioned officers, after paying the soldiers from their own pockets for a month or two, are giving up and returning across the channel."

Beaufort stroked the lapels of his ermine jacket while he too responded to Justice Smythe's toast, although quietly, almost diffidently, as if the whole matter was a nuisance that was beneath his dignity.

"Smythe, your gentry and merchant friends in Parliament grant few and meager taxes to the king, and even then after long debate and much meddling in the affairs of state that do not belong to them. That is the source of all our trouble, why Blount cannot balance his accounts and pay his soldiers. The ingratitude of the Commons, the meanness and selfishness of gentry and burghers, that is where the blame lies. And that is why the scurvy, degenerate French threaten to undo the triumphant ordeal of Agincourt."

"My Lord Beaufort, it is not as simple as that." Justice Smythe was used to plain speaking in the courts. "I have not been in London for two years but my friends in the Inns of Court write me that all is not well in your government. There is conflict within it. There is use of the king's seal for personal enrichment. The Commons lacks confidence in this government that you head. That is why they are reluctant to vote subsidies."

Beaufort was annoyed.

"I see that politics has followed me from Westminster to Chartres, Justice Smythe. The gentry are great critics, but they take no responsibility for the complex problems of government. They cheer the Lancastrians when we triumph but they are not eager to help us in our times of trouble. A child on the throne is at all times a difficult matter and anyone who serves in the royal council during a minority is subject to incessant criticism from those who think they can do it better, or who seek to be in the government in order to enrich themselves. We have done well to maintain the order of things in these difficult times. You know there is a trade depression that has reduced the income from the export tax on wool. The English climate has deteriorated and we recently have had short summers and long winters. The crops are smaller and the gentry say they are too poor to pay taxes. You know the peasantry, stirred up by radical preachers

and led sometimes by impecunious gentry, engage in rural distur-
bances. You know that barons gather around them demobilized sol-
diers and form private armies that threaten the peace and stability of
the kingdom."

Bishop Beaufort paused and swallowed a mouthful of wine.

"After my cousin glorious Harry vanquished the French nobility at
Agincourt, he gained from the feeble French King Charles VI the
hand of his daughter Catherine and the promise of the French
Crown. But her brother the Dauphin would not concede this union
of the English and French Crowns, personified in our child-king
Henry VI. The Dauphin claims to be Charles VII, legitimate Valois
king of France. He has not been crowned and anointed at Orleans,
the crowning place of all French monarchs, and therefore he lacks
legitimacy. But he is gaining loyalty of the people and he has shown
that he is stubborn and wily, so different from his feeble-minded and
weak father. Now I hear Charles is gaining the support of country
visionaries and peasant prophets on his behalf. I fear the future. I
fear for the great English Empire in France. I fear for my Lancas-
trian house!"

Blount rose from his end of the table, poured himself a glass of
wine, and addressed Beaufort in a loud and sharp voice.

"My Lord Cardinal, I am surprised at your pessimism. We invited
you here to receive our petition for money, and at least to cheer us
up. Now you give us tales of woe. Something is amiss in London, to
cast such a cloud of anguish over you. These are days of trouble, it is
true. But our young King Henry VI will grow up in time, and unless
you know something we are not aware of, he will prove his Lancas-
trian mettle. Meanwhile Duke John of Bedford will hold the center
together out here and defend the honor of England and of Lan-
caster. This vast golden land of France is still within our grasp. Our
fortresses still stand firm from the Flemish border in the north to the
Spanish mountains in the distant south. Millions of Frenchmen still
prefer to live under the banner of St. George, its golden lion tri-
umphant, and the red rose of Lancaster, rather than the crown of the
degenerate Valois king, who respects no one's freedom and dignity
and is a wretch without honor. The banner of the lion and the rose
still fly triumphant in the damp winds of France while the infamous
Valois, a cursed, miserable family, welcome in their desperation the

fulminations of the abominable peasant witch Joan of Arc—imagine that for a glorious monarchy! We have ruled here in the north of France since your blessed, noble ancestor William the Conqueror crossed the channel and took the English throne from Harold Godwinson. We have ruled in the marvelous south since Eleanor of Aquitaine brought her incomparable dowry to join Henry Plantagenet's domains. Yes, we are having some hard times but we have had hard times before and triumphed again. Imagine what it was like on the eve of Agincourt, the harsh cold rain pelting down on the undermanned English army and yet on the morrow they destroyed the flower of French chivalry. So it will be again!"

Beaufort's voice rose in anger.

"I know the narrative of my family, Sir Thomas. I need no history lessons from a commoner, particularly a northern vassal of the Lancastrian house. But fortune has perhaps smiled once too often on my dynasty. Our problems mount. The government in London is impoverished. I have no money to maintain the army."

Smythe responded with equal heat.

"My Lord Beaufort, your job is to find the money somehow. You have been resourceful in the past. You have not lost your wits. As long as Duke John is here to lead us, we shall prevail."

"Indeed, I am resourceful," said Beaufort. "We will borrow the money that we need. That is the traditional Plantagenet way. Easy on the Commons, tough on our creditors. It worked before. Why not now? But there is no money to be had on loan in England or France, not in the sums Duke John claims he needs."

"He *does* need them" said Smythe, flushing with anger. "The cost of war gets ever greater now that long sieges are so often the key engagements."

"They are ruinously expensive," added Blount.

"Well then, you can rely on Cardinal Beaufort to help you out. On my recent journey to Rome I made the acquaintance at the papal court of Abraham de Mendoza, a Spanish Jewish convert to the Christian faith and a prominent papal banker. Further, he is well connected to the Medici and other Florentine bankers. He has access to much capital. I have invited him here and he is waiting in the next room. I will fetch him."

In the few seconds Beaufort was out of the room, Blount sat

gloomily at the end of the table, shook his head and drained his goblet, and Smythe muttered, "More loans, and from a cursed Jew, so it has come to this."

Beaufort reentered followed by a short, thin, swarthy person, with a trim beard that came to a point, impeccably dressed in black velvet with a black, red-bordered skullcap. "May I present," said Beaufort with a smile, "the eminent banker from Cordoba and Rome, Abraham de Mendoza."

"My Lords," said Mendoza, and made a slight bow.

"Well, Mendoza," said Smythe," you are Cardinal Beaufort's alleged easy remedy for our fiscal troubles. An indispensable Jew. The pope cherishes you, I understand, but we have our moral reservations about dealing with you."

"I am a banker, not some street-corner usurer," Mendoza replied without hesitation. "And it was my father who converted to the Christian faith and had me baptized at birth at the holy fount in Cordoba Cathedral. I am as much a Christian as anyone else in this room."

"I do not believe that," shouted Blount. "A Jew is a Jew. I know your kind. You eat no pork. You do no business on Saturday. You are one of those infamous Spanish crypto-Jews, a Marrano. Secretly you spit on the cross and urinate on the sacrament."

"This kind of uncivilized banter is of no use to anyone," remarked Beaufort, who seemed to have mostly recovered from his depressed mood. "Let us get down to business. May I offer you, Mendoza, a glass of Bordeaux wine from the ancestral vineyards of the Plantagenet and Lancastrian family, from the vineyards of the incomparable Eleanor of Aquitaine herself."

"I am honored, my Lord Cardinal," Mendoza said without emotion. He accepted a glass from Beaufort and touched it briefly to his lips. Beaufort now stood face to face with the little Jew, Smythe and Blount several paces from him. Beaufort addressed Mendoza with characteristic bluntness and impatience.

"Mendoza, you have access to great resources. There is your private bank. You are also well connected with the Medici and other Florentine bankers. Duke John needs a large loan for two years to stabilize his finances and maintain the English forces in France. There have been political troubles at home in London. We have not

been able to get the taxes we wanted from Parliament. I have myself provided major loans to the Crown from my personal and episcopal resources and from a crusading tax that was levied on the English people with authority of the pope. Now I can provide no further support. Most of the loans I made to the Crown have not yet been paid back, and the pope is not happy that I used for the general purposes of the English government the crusading money which was supposed to send an English army to fight the Hussite heretics in Prague. Believe me, I am not at ease turning to you like this, but I can think of no other resource. Remember this is a good business deal for you. The loans we seek will be paid back fully and on time. You can rely on the full faith and credit of the Lancastrian house, the greatest imperial dynasty in Europe, whose Crown lands extend from the borders of Scotland to the plains of Castile."

Mendoza smiled, and made a little bow before responding to Beaufort.

"My Lord Cardinal Beaufort, the Lancastrian faith is good, and its historic glory is undiminished. Your credit, however, is not as good. You yourself, second in the kingdom only to Duke John in dignity and power, have had difficulty recovering your personal loans to the Crown. You will understand if I proceed with caution."

"Well then," said Beaufort, anxiety creeping into his voice, "what are your terms?"

"A loan of 150,000 English pounds at 40 percent interest, to be recovered from assignment to me and my Florentine colleagues of the export tax on wine from Bordeaux to England for five years."

"I knew it," said Blount, "the little Jew wants to humiliate the Lancastrian family."

Mendoza ignored this interjection and continued. "In addition," he said to Beaufort, "we would want half of the income coming to Chartres Cathedral from the contributions the canons there receive from pilgrims over the next two years."

"Blasphemy," shouted Smythe. "What did I tell you—he is a crypto-Jew, a Marrano."

Beaufort motioned to Smythe to be quiet. "If you are prepared to draw the contract now," the cardinal said to Mendoza, "and assure us receipt of half the loan by the end of January, we will agree to your

terms, as severe as they are. It so happens that the episcopal See of Chartres is currently vacant. I will advise Duke John to keep it that way and not appoint a new bishop so we can better control the cathedral's income and see that you get half of the pilgrims' donations."

"You will have the money within a month if the contract is drawn now."

Beaufort was pleased and the hard look on his face moderated. "Chancellor Smythe and Treasurer Blount will draw up the contract tomorrow morning and we shall seal it after lunch. Meanwhile, Mendoza, you are welcome to enjoy the duke's hospitality."

"It is a great honor to be received by the Lancastrian house, Lord Cardinal. I have a room at Chartres' best inn. But I will stay for this evening's conversation and entertainment."

With the sound of a trumpet, Duke John at last entered the throne room from the great feasting hall and occupied his oak throne. Bedford was wearing a blue velvet tunic edged with white fur, black hose, and a cloth of gold cap edged with dark fur.

He was accompanied by five people: three men and two women. The women were, first, Mathilde of Hainault, a women of about thirty, who was a distant cousin of Duke John and Cardinal Beaufort. She was a Benedictine nun. A large wooden cross was tucked into the belt of her black monastic robe. She was the abbess of St. Mary of Rouen, an old and very aristocratic convent. The other woman was elderly—about sixty—but walked with a firm step. This was the Parisian poet, social critic, and book publisher Christine de Pisan.

Two of the men were Brother William Marsh, a tall, handsome twenty-five-year-old Franciscan friar, who was currently Duke John's confessor and personal spiritual adviser, and a forty-five-year-old muscular mercenary captain, the Irishman Dennis Hennessey, who was a longtime military companion of the duke.

The third man and the fifth person who accompanied Duke John from the great feasting hall to the smaller throne room was Lancelot Highgate, fellow of Merton College, Oxford, and a scholar and teacher. Highgate was also renowned as a troubadour, musician, and court entertainer. For the past three years this slim, fair-haired, blue-eyed, feminine-looking young man had entertained Duke John and

his guests at Bedford's Christmas camp, and now he was here to do the same again, to tell and sing the familiar Arthurian stories that Duke John loved so much.

Duke John mounted the low platform on which the oak throne was set and sat down. A smaller chair was brought in and placed next to the duke, and Cardinal Beaufort occupied it. The rest of the company stood in a semicircle in front of Bedford and Beaufort, the Lancastrian cousins.

In 1427 Duke John of Bedford was thirty-eight years old. He resembled his handsome brother Henry V. His stocky figure reflected the physical strength of a man who had spent his life since early adolescence mainly riding, hunting, and fighting. His sensual mouth and high forehead, characteristic of the Lancastrian family, gave the impression of a wise and sympathetic person, friendly, curious, and outgoing, and that impression was confirmed by his behavior and speech. Like all members of his family, Bedford was highly literate and well informed and enjoyed conversation not only about politics and war but about the arts and philosophy.

By 1427 the tremendous daily burden upon him of maintaining the English possessions in France against a resurgent and skillful enemy and doing so with inadequate fiscal resources had begun to take its toll on Duke John. At times he was visibly weary, distracted, and withdrawn into himself. He sensed the decline of Lancastrian fortunes and was not sure how he would meet this awesome challenge.

Because of his problems and stoical pessimism, Duke John enjoyed all the more the relief offered by the conversation and entertainment that lightened the ambience of his Christmas camp. Beaufort knew this and after the duke had taken his seat the cardinal bishop hastened to get business over with.

"Duke John, we have reached agreement on a substantial loan with Mendoza here. He and the Florentines will give 150,000 English pounds which should solve your fiscal needs for the next two years. By that time we should be getting new taxes from the stubborn Commons."

"The terms are very harsh, My Lord," said Blount.

"Insulting" added Smythe. "Mortgaging the pilgrim donations to Chartres, as well as committing all the Bordeaux wine customs. I don't approve."

"We have no choice," Bedford replied diffidently, as if such talk about business was offensive to him. "I am sure my dear cousin Beaufort has done his best for us. The banner of the golden lion of St. George does not fly stoutly in the French breeze nowadays. We must make the best of what we can until my dear nephew, the young King Henry, grows up and restores the might of Lancastrian rule, the glory of the red rose, as my exulted brother Harry, so quickly and early taken from us, did at Agincourt and what followed."

Beaufort used the opportunity of the reference to Henry VI to indicate further bad news. "We must not expect too much of the young king, Duke John. He is a handsome and lively lad but at times his mind seems to wander. I see—but hope I mistake—in his eyes a flicker of that imbecility that so disfigured and shamed his French grandfather Charles VI."

"This is bad news," said Blount. "Has the Valois curse foisted itself in revenge upon Lancaster?"

Duke John was uncomfortable with this depressing discussion of the king's temperament and capacity. It was not news to him. He had already heard this from courtiers visiting from London. He sought to channel the conversation toward broader and less exasperating issues. "We will hope for the best. Like all princes, my nephew needs a careful upbringing, a fruitful education. Lord Beaufort, I advise you to speak to the king's household officials and urge them to educate our nephew in the ways of the Florentine humanists. Doesn't that classical education which the humanists prescribe make princes wise, Mendoza? Isn't that what your friends in Florence say?"

Mendoza replied with enthusiasm to Bedford's suggestion.

"You are right, Duke John. The humanist view is constantly stressed by the Medicis and the Florentine nobility. They say that royal princes, and other leaders of society, should be taught the classical Latinity of the old Romans. These young people should read Livy and Cicero, Virgil and Horace, Sallust and Suetonius. They will find therein the best models of rulership, which are applicable to our own day. And the modern humanist scholars themselves compose treatises setting forth mirrors of good conduct and the best policy for princes. They hold up these literary mirrors for young royals to mold their own images thereby."

Beaufort interjected heatedly. "John of Gaunt and Henry V knew no such humanist foppery. Theirs was the Lancastrian way. They spoke French and left Latin for scribes and schoolmen and the more pretentious kind of bishops. The Lancastrian way was that of Arthurian chivalry, not the classical mode of the Italian humanists. I distrust this new style of Mediterranean education. We are men of the north. Our distant ancestors were Vikings and later Charlemagne's fierce barons. This Florentine humanism smacks of city decadence and of bourgeois softness and could lead to the degeneration of our race. I like the old Plantagenet ways of guile and strength, of devotion to family destiny and high Christian idealism. I like the deep feeling that moved the old nobility, not this new cultural mode from the south with its excessive worship of the old Romans and its hazardous, foolish claims that classical Latinity makes you a nobleman. By itself, it makes you only a schoolmaster."

Justice Smythe shook his head in assent and then added: "I agree with Cardinal Beaufort. There is a great defect in this humanist culture that creates the alleged mirror of classical models for princes. This attitude will do no good. This is the way of tyranny. The Roman emperors, even the best of them, ruled by their own wills— they claimed that law was in their own mouths, in their royal breasts. They knew not the restraints imposed on royal wills by parliaments. The Roman law said that the people had surrendered their power to the emperor. As Justice Bracton wrote in the reign of Henry III, in England law rules and not the king! Magna Carta says that the king shall abide by the law of the land. In England we do not say that the royal will has the force of law. We say that the *king in parliament* has the force of law. We do not say in England that the law is in the king's mouth. We say that the law resides in the people, in the community of the realm, from which the king is not separated. We do not say that the king's *natural* body is sovereign in the country. We say that his *political* body is sovereign in the realm and his political body means king in parliament, a corporate union of the king with the lords and commons.

Justice Smythe had become excited. He was close to shouting now.

"I fear this classical revival, this onrushing wave of Italian fanaticism. These so-called humanist opinions remind me of ill-fated

King Richard II, who threatened vile tyranny upon the people and who had to be removed by his noble cousin, Henry Bolingbroke, John of Gaunt's son and Duke John of Bedford's father. I detest this Roman absolutism. It is not our way. It is not suitable for the free-born gentlemen of England. It is fit for the degenerate nobility of Paris, for the impoverished peasants of Germany, and for the unscrupulous merchants of Florence, but not for Englishmen.'"

As Smythe was concluding his lengthy nationalist harangue, and making hostile reference to the Florentine bourgeoisie, he turned and looked directly at the Jewish banker, Mendoza. The latter smiled and quickly responded.

"You Englishmen cherish Florentine gold but not Italian wisdom. You stick fast to the old ways of thinking and writing. You are out of date. A new culture is seeping in, and even up here in the cold north it cannot be long resisted. It will prevail in time. In Florence they say that your way of thinking and speaking is a barbarous interruption, a middle age, between the heights of Roman classicism and the reborn humanism of our own day. You are stuck in the Middle Ages between Rome and Renaissance, between the glory that was Rome and the new learning propounded by the Florentine humanists of today. As for Smythe's impassioned remarks about tyranny—I say spoken like an Englishman! The Florentines are in fact more liberal than you are. They do not have kings like the feckless Richard II. They do not have *any* kings. They have a republic, as in Athens and in the best days of old Rome. They choose a great warrior and states-man to be their *podesta,* the wielder of power, but power resides in the people. They do not crown kings and claim that imbeciles like Charles VI of France are the image of God on earth. They are not at the mercy of royal birth and premature death, such as carried off your hero Henry V. They do not have to endure the hazardous rule of child kings. They pick their rulers; they do not leave it to fortune to provide a leader. They can *always* pick a Henry V to rule them. It is a better way; it is the way of Reason."

There were looks of shock and anger on the faces of Smythe, Blount, and Beaufort and Duke John appeared to want to say some-thing in defense of the English system, but it was Abbess Mathilde, the dignified Benedictine nun, who responded first to Mendoza, in her clipped aristocratic tones.

"Nonsense, Mendoza. A podesta is just another name for a Caesar. He is a dictator, a man of irresponsible grandeur who rules by will and violence. I too do not like the new ways of speaking and writing, the new ideas that blow upon us from Italy. This so-called Renaissance is a threat to our established form of life, a departure from the traditional ways, a venture upon uncharted seas. It is a trick promoted by guileful bourgeois scholars who seek wealth and power and flatter the Medicis and other tyrants by hailing them as reborn noble Romans. What of the Church, the pope, the religious orders in this humanist scheme of things? St. Benedict of blessed memory, he too was a Roman but the right kind who blended stability with faith. I see no need to bring back the vile pagan culture. I hold up no mirror for imaging and imitating the heathen Romans. As Saint Augustine the master said, even Roman virtues were only splendid vices. The most blessed Benedict, the founder of our order, was Roman enough for me. He gave us Roman order and stability at his monastery of Monte Cassino, but he married it with faith and piety and devotion to unworldly calling."

"Well spoken Abbess Mathilde," said Beaufort. "That is truly the Christian message."

"Spoken as a Lancastrian should, who hates tyranny and loves the law," enthused Smythe.

Mendoza stood his ground, and hearing nothing from Duke John, responded warmly. "With all due respect, you remind me of the old rabbis, my forefathers in Spain with their adherence to the Talmud and the old Jewish law. I am so very glad my dear father baptized me at birth into the Latin Church, not only because it made me a full citizen of Christian Spain and gave me and my family security. Not only because it allowed me to pursue my commerce and banking through the length and breadth of Christendom. But also because it allowed me, like my friends the Florentine humanists, to choose rationally among the best that has been thought and said in the past, from the ancient Greeks to our own day. I did not have to confine myself, like my unfortunate Jewish forefathers, to the perpetual mining of one slim tradition. I have the whole world of literature and art to choose from. The Italian Renaissance is not a betrayal of the Latin Church—it is its fulfillment. It opens the way to a more learned, civilized, and eloquent kind of Christian belief and practice,

a Christianity pruned of medieval magic and fanatical conventicles. Instead we can move on to a beautiful and dignified faith suitable for modern times."

Before anyone else could respond, Duke John interjected. He seemed delighted with the vibrant tone of the conversation and high intellectual level of debate in his court.

"Now here indeed is a debate worthy of our time and attention. To speak thus of the Middle Ages and the Renaissance! I enjoy these historiographical declarations. There is something here worth defining and contemplating. It will help us to understand who we are and where we are in history. I shall hold back expressing my own opinion until I have heard from others in this company who want to speak, especially the younger people here who haven't yet joined the debate. I am curious to hear what they have to say on this issue. Brother William Marsh, my young friend, spiritual guide, and confessor, how does this issue of Middle Ages and Renaissance appear to you as a member of the Franciscan order?"

Marsh did not hesitate to respond and he did so with a vehemence that shocked the others present.

"As for Mendoza, I say: Once a Jew always a Jew. These Jewish converts! They are a menace to Christendom. The members of my order who harassed the Jews in Spain and roused the people against them—I commend them for that. But instead of seeking the Jews' conversion, leading to Mendoza's baptism into our faith, they should have insisted that the monarchs of Castile and Aragon expel the Jews, as they were exiled from England and France more than a hundred years ago and are now being driven out of the cities of Germany into the forests and swamps of Poland—where no doubt the Jews will again curry favor with avaricious kings and lords and live off the peasants like parasites on the backs of dogs. It is no surprise that these Jewish converts like Mendoza here should seek to render the fabric of Christendom by advocating the seductive classicism of the Florentine humanists. I have no sympathy for the humanists' decadent worship of antique Latinity, remote from the language of the people. These Florentine hucksters seek their own aggrandizement—so far I agree with Abbess Mathilde. But I stand also against the traditions of medieval society with its rigid hierarchy and its savage exploitation of the peasants and urban artisans. I love the little

people, the poor peasants and overworked artisans, the downtrodden and devastated among humanity, the meek whom Christ promised will inherit the earth. I stand against medieval lords and bishops and against Renaissance merchants and scholars as well—against all the powerful, the wealthy, the learned. Our beloved master Saint Francis condemned learning along with the other excess baggage that impedes pilgrimage to the City of God. 'Take nothing for the way.' I weep for the homeless, the hungry, the desperate. 'My kingdom is not of this world.' I look neither to the lavish traditions of Gothic culture nor the meretricious learning of the Florentine humanists but to the Second Coming of the Lord who sacrificed Himself for all mankind, including the outcasts and downcasts of this world, who begged in the streets for His supper and washed the sores of lepers. I weep for the criminals, the prostitutes, the lunatics—in *their* face is the visage of God. These are Christ's special children, his beloved—these are my concerns. I care as little for Renaissance learning as I do for the ornate and useless facade of Chartres Cathedral. They are equally monuments to human folly."

Abbess Mathilde exploded. "Brother Marsh you are a heretic! A Lollard! A Hussite! You want to destroy the order of the world."

"Indeed I do Abbess. I want to compensate for all the crimes you Benedictines committed on the peasantry who toiled ceaselessly on your rich lands through the centuries."

Beaufort rose from his seat and addressed Duke John.

"My beloved cousin and Lord Bedford, how can you retain this wild young man with his satanic ideas as your confessor and spiritual counselor? You know how your beloved father King Henry IV pursued the Lollard heretics after he realized the dangers inherent in their preaching. You know how I have continued this crucial work of extirpating these heretics from the kingdom."

Duke John was silent for a moment. Then he turned toward Beaufort and spoke quietly, but just loud enough for the others to hear.

"As a bishop, you must do what the pope and councils of the Church mandate and they are keen on the persecution of heretics. Therefore I commend you for being the hammer of the Lollards, dear cousin. I do not, however, think that Brother William Marsh is a Lollard, though his words are not comfortable to you, or to me, in

fact. He is a Franciscan friar, after all. Franciscans have been saying these things for a long time, to the distress of the pope and cardinals like you. As to my selection of a confessor and spiritual counselor, you will allow me the privilege of making my own choice, I beseech you. Brother William is an ordained priest and therefore his receiving of my confession and his ministration of the sacraments are valid whatever controversy his opinions may arouse. Lord Cardinal, give me the privilege of choosing my own spiritual adviser. If it is a fault, it is one you must permit me. I am chaste. I have always been true to my wife; I have no mistress—a bit unusual in our family, you will acknowledge. My way of life is simple. I have a right to seek religious instruction where I wish. The Franciscans are no longer popular in England, but they have a lot to say to me. Brother William Marsh, I thank you once again for your plain speaking, your turning over of the world, your terror upon the lords and wealthy and learned. I would not follow you in these sentiments, but it is important to hear them now and again."

Duke John turned to Christine de Pisan. "Now I want to hear the opinion of this famous woman scholar who is my guest this evening, Christine de Pisan. I brought her here from Paris to try to convince her to write the history of the Lancastrian family, a glorious and instructive tale. She has refused me, as she refused to write for my father Henry IV. She says boldly that she is too committed to the interests of the House of Valois to give her talents to burnish the glory of the Valois nemesis—too beholden to Paris to reward London with her art. I admire her frankness and I wish her well. I have asked her to join our company this evening. I am sure we will benefit from her opinions."

Duke John addressed Christine de Pisan directly.

"Madame, you are Italian, I believe, originally from Venice. What do you think of this debate about the Middle Ages and the Renaissance? Do you agree with Mendoza and his Florentines or do they see things differently in Venice?"

Christine was a heavyset woman who showed her advanced years. Her hair was white. Yet her face was luminous and her eyes sparkled. She was dressed in something resembling a nun's habit. She had come from several months of residence in a nunnery near Paris, where her daughter was a member of the community.

"My Lord Duke John, you delighted me by inviting me to your court and honored me greatly by asking me to take up my pen on behalf of your illustrious family. You have well stated my reasons for not undertaking this task. I am most grateful that you show no resentment against me but continue to welcome me in your company. I came from Venice many decades ago when I was very young, accompanying my father, who was appointed court astrologer to the French King Charles V. I do not know from personal experience what they think on the Adriatic now, but if I know the Venetians, they will not let the Florentines get ahead of them, and will give their own twist to the idea of the Renaissance. Being closer to the Byzantine Empire, they will, I expect, stress Greek as well as Latin antiquity, and in view of the parlous condition of Constantinople, hard pressed continually by the Turks, I would surmise that the Venetians would persuade Greek scholars to relocate from Byzantium and set up schools in Venice. But as to the issue so heatedly and eloquently debated here, I agree with Mendoza that a new cultural era has dawned. For better or worse, I think the Middle Ages are waning. Anyone familiar with my writings will perceive that I blend in with medieval romantic traditions the motifs and concepts derived from classical antiquity. I expect that marks me as a humanist. I do not reject the label. If the Lancastrians wish to hold their place as patrons of the arts and letters, they will have to recognize this change in mentality and discourse. Chaucer, the worthy beneficiary of the patronage of your grandfather John of Gaunt, was very familiar with Italian writings and integrated these Italian stories into his own work. But humanism implies more than that. It is indeed a more conscious revival of classical antiquity, a determined effort to write Latin in the ancient mode and to write the modern languages with the structure and rhythm of classical Latin in mind, and to hold up the mirror of Roman conduct—these things go to the heart of the humanist movement. And that is going beyond Chaucer, who still lies within the medieval romantic tradition. In the beautiful cities and gracious villas of my native Italy, a modern culture is emerging that will generate a new world of learning, reason, civility, good taste, and art. The great Lancastrians, if they are to remain at the forefront of patronage, would do well to give close attention to this shift in thought, feeling, and behavior."

"Then," said the Duke, "I take it you endorse the humanist movement?"

"My Lord Duke, I welcome it. I proclaim it. I exult in the prospect of a new culture in which the Middle Ages will have been superseded by a new consciousness derived from classical antiquity and by a more refined sensibility. Like Mendoza, I have stood on the margin of medieval society, of the hierarchic world of lords and peasants, bishops and priests, and felt alienated from its core, he as Jew, I as an educated woman. He has made himself useful to medieval power by his money lending, I by the copying of manuscripts and writing of literature on demand. But I still feel myself as a marginal other in the medieval world and I long for its replacement by a new and better culture in which the humanists will recognize my gender's equal capacity for art and writing and integrate women into the central core of social discourse."

Abbess Mathilde shook her head. "I am sorry to hear you talk this way, Christine. You sound like those middle-class women, called Beguines, who have formed women's groups and wander around our cities and towns constantly complaining that they are mistreated because of their gender and making extravagant claims for equality and privilege. I have never lacked for recognition of my dignity."

"But you gained your dignity as a religious, as a nun, by transcending your gender. I want to keep my femininity and still be treated as an equal in society."

"That, Christine, is against the order of nature," said Mathilde. She turned away in aristocratic disdain from Christine and toward Lancelot Highgate, who had stood a little apart from the rest of the group.

"Master Lancelot Highgate, you are a scholar, a Fellow of esteemed Merton College, and like Christine de Pisan, a poet. What do you think of this issue of women's status—and the other issues we have been discussing? Where do you stand on this fundamental matter of the Middle Ages and the Renaissance, which has inspired Christine to articulate her Beguine-like feminist doctrine?"

Lancelot nervously stroked the lapels of his black scholar's gown and replied in a very low voice that the company strained to hear.

"I am not here to give opinions, Lady Abbess, and make fine dis-

criminations on complex issues. Each winter your cousin Duke John brings me to his Christmas camp to organize a pageant based on the stories of King Arthur and the knights of the Round Table. Tomorrow is the time for this year's pageant and I hope I will repay my Lord Bedford for his generous hospitality by a good pageant, in which again he will himself take the role of King Arthur. It is not service to Duke John for me to express opinions in a company of people above my humble station. You should know, Abbess Mathilde, that I was the orphaned son of a Welsh peasant. My baptismal name was Llewlyn Heskwith. I was adopted by a local priest who educated me and recommended me to the bishop of St. David's, who paid for my studies at Oxford. There I achieved a certain degree of merit and I changed my name when I was elected as a don at Merton. But I feel uneasy at expressing opinions in such a noble company."

Duke John intervened in good-humored tones. "On the contrary, Lancelot Highgate, we should like to have your opinions on the issues raised here."

Highgate took a deep breath, and avoiding eye contact with anyone, spoke at some length. He fixed his gaze on the window that offered a view of Chartres Cathedral, as if the not-so-distant Gothic spires somehow energized his words.

"Here then is my opinion about this medieval and Renaissance debate. I cannot but admire the humanists. They have great learning. They have made Latin not only more classical in style but more readable than in the heavy, harsh, and even obscure forms in which the university professors and the canon lawyers and the papal bureaucrats have written it for centuries, although perhaps the humanists are able to write this more elegant Latin because they do not address the difficult, technical problems that the medieval philosophers, lawyers, and bureaucrats were concerned with. It is a change in focus that too easily perhaps allows linguistic elegance. But let us give the humanists credit for this improvement in Latinity. There are also jets of fresh ideas within the great river of humanist thought—a political theory that gets closer to the realities of government, moral philosophy that addresses itself to middle class as well as aristocratic life, convincing biography of artists and writers as well as kings and lords, and this new note of feminism that Christine de

Pisan has expounded. I expect the Renaissance will allow educated women a greater role in literature and art but the revolution in gender status she seeks will be a much longer time coming. I should also say that the Renaissance has reached such a point of breadth and depth that it cannot be resisted, or turned back. It is now taking over the better schools everywhere in Europe. That attention the humanists have given to the education of children and adolescents is paying off. School curricula are now being reshaped in the classical mode in newly founded schools that are devoted to the classical curriculum and the humanist way of thinking and writing. This change is only just beginning in England, but it will soon prevail there as well. The younger generation will be immersed in a classical curriculum, medievalism will be forgotten or swallowed up, there will be no turning back whatever I or anyone else thinks. The debate between the Middle Ages and the Renaissance will soon be over."

Christine and Mendoza were pleased to get Lancelot Highgate's support of their position, but before they could express their appreciation, he surprised them by taking a different stance in appraising the significance of cultural change.

"I want to say that I regret this turn of the cultural coin, this shift of the times, for two reasons. First, Renaissance humanism, no matter that it genuflects to Christian tradition and makes a great fuss about the texts of the Bible and the Church fathers, signifies a greatly increased secularism, a massive diminution in ecclesiastical control and the Church's leadership in education and culture. In some ways that is a good thing—a decline in partisanship, orthodoxy, and obscurantism is to be welcomed. But this leaves a vacuum in cultural power, and it means there will be much less of a counterbalance to the central government, which will now dominate everything—the schools, the universities, the legal profession, the patronage of the arts and letters. I fear the onset of the Leviathan state. It will take no great length of time before princes tell us with impunity what our religious code should be and the state seizes the property of the Church, dissolves the monasteries and religious orders, and brings all religious and intellectual institutions under its direct jurisdiction. A hundred years from now a political bishop like Cardinal Beaufort here will still be common and perhaps even more the norm than now. But I fear there will be no Abbess Mathilde and that will

be a great loss. So this is my first reservation about this glorious Renaissance that Christine and Mendoza advocate."

Beaufort and Mathilde eyed each other carefully. Highgate was now wound up and speaking in a very exulted tone.

"Yet all this is politics, the distribution of power, and not as important to me as the second reason why I am not happy with the triumph of the humanists. This goes to the heart of the cultural issue, to the question of medievalism itself. What medievalism stood for, as exemplified above all in the Arthurian literature, was romantic idealism, moral purity, and individual choice and commitment. These things were not always clearly expressed in the Arthurian stories: they were embedded in aristocratic tradition, and other social conventions, and distorted by needs of a narrative that could excite the audience. But they were there. That was the central message. The recommended form of human behavior was a loving union with someone beyond oneself; a life devoted to pure and high purposes, beautiful gestures and elevated speech and freedom to make these choices. Of course there were all sorts of problems reconciling and applying these principles, human nature and social demands being what they are. The Arthurian stories often didn't really achieve a meaningful integration but simply lumped everything into a compelling narrative and left it at that. But the ideas were there. I do not believe that humanism will allow for persistence of this threefold medievalism—romanticism, purity, and individualism. Of course these motifs won't disappear but they will be integrated into something else; they will lose their force and influence. That is why I regret what is happening now in culture, thought, art, and education. I regret the death of Arthur and what his stories represented."

Duke John leaned over from his throne and spoke directly to Lancelot Highgate.

"Master Highgate, you have spoken well. You have made the issues involved in this debate clearer to me. But I must comment on your concluding statement. It is not the Renaissance that brought about the death of Arthur. I know you spoke symbolically and meant by the death of Arthur the inundation of medievalism by the new wave of humanist culture. But there is an actual death of Arthur in the medieval stories themselves. I have always been struck by that. Every year we have this Arthurian pageant and I play King Arthur.

And I always have had cause to wonder that after all the glory of the story of Arthur, Gueneviere, Lancelot, Percival, Gawain, and the other heroes and heroines of the Round Table, after the Holy Grail is found, the story has such a sad ending. The blessed land of Britain falls apart in conflict and war. Arthur is betrayed by his wife, by his favorite knight Lancelot, and by his own kin who covet his crown, and in the end Camelot is ruined and Arthur dies a lonely and bitter death. What is the meaning of all that? Why does Arthurian medievalism end in bitterness and tragedy and defeat? I have never understood the message, the meaning of that."

Highgate thought for a moment and replied.

"You must understand, Duke John, that these Arthurian stories are rooted in history, in events that happened in the dimness of times past. These stories are embellishments but they are founded in happenings long ago. There was actually an Arthur, king of the British, and he fought against the invading Germans from the North Sea. For many years he defeated them and held back the savage German wave of conquest. But in the end he too was beaten and killed by the barbarian invaders and Camelot was destroyed. The British retreated into the mountains of Wales, and there through the long centuries, they told the tales of Arthur and his heroic knights. Three centuries ago a Welsh priest, Geoffrey of Monmouth, while a student at Oxford and enjoying the patronage of the bishop of Lincoln, wrote these stories down. Then a French cleric and poet, writing under the patronage of the countess of Champagne, the daughter of Eleanor of Aquitaine—he called himself Chrétien de Troyes—began the transformation of these familiar stories into the grand romantic tales we have come to love. Many other poets contributed to the Arthurian cycle. Just the other day I encountered a mercenary in the English army, Sir Thomas Malory, who had even better recall than I have of all the Arthurian stories. The Welsh knew that Arthur had been defeated, or else why would they be living in the Welsh mountains in exile from their happy homeland? And this dim but unerasable recollection of Arthur's defeat remains commemorated in the narrative as we know it, and that is why after all the glory of his reign, Arthur *must* die defeated and miserable. Yet in the narrative as we know it, it is not the Germans who destroy Camelot. The Arthurian Round Table is destroyed from *within*, by love and ambition. I suppose the

meaning here is that no matter how great the love, how exalted the purity, and how free the individual—the qualities of medievalism—we cannot escape the limitations of human nature. Perfection and perpetual happiness cannot be achieved in this life because we bear the consequences of the sin of Adam and Eve in their rebellion against God, and until the Second Coming of the Lord, everything we do, no matter how beautiful and loving and fine, will in the end wither and die. This is the curse upon humanity. So the Arthurian story is a Christian one and that is why Arthur dies defeated and embittered, that is why Camelot is deserted and devastated—because of the original sin of Adam, because of the defect of human nature."

Brother William Marsh stepped forward and addressed Duke John.

"My Lord Duke, that is the message I have communicated to you many times. And one that you should take to heart. The death of Arthur also signifies that the glory of the House of Lancaster cannot endure forever. It too will run its course. All the power and might and wealth of your most noble family are, like Arthur, prey to the defects of human nature. That is why even a duke must keep an inner humility and pray for Christ's loving mercy."

Duke John looked at Brother William pensively but said nothing. For a few seconds silence fell over the group. Then Abbess Mathilde spoke to the company.

"This too is the message that our master Saint Augustine taught in *The Confessions* and the *City of God*, the greatest of all works of Christian theology and ethics. In each of us there is a spiritual will, addressed to love of God, and a carnal will, addressed to love of self. Left to ourselves, the carnal will always triumphs and we are doomed to be miserable sinners. But God in his wisdom chooses some among humanity for triumph of their spiritual wills, chooses these to love Him, and they are thereby destined for an eternal life. Those in whom the spiritual will prevails, they comprise the City of God and they prefigure the company of the saints who will live eternally in heaven after the Second Coming of Christ. This is Augustine's teaching. And now I see that it is embedded in the Arthurian stories."

Cardinal Beaufort, who had been lying back in his chair, seem-

ingly indifferent to the lengthy intellectual discussion, now became quite animated.

"If that is what old Augustine taught, Abbess Mathilde, he does not speak for me. It is true that when I studied at Oxford many of the dons expounded this gloomy predestination theology. Then it was called Occamism after William of Occam, who belonged to the same troublesome Franciscan order that latterly has produced Brother William Marsh, another enthusiast for gloomy Augustinian doctrine. But at Oxford, I heard other dons, the followers of the Dominican friar Saint Thomas Aquinas, preach a quite different and more cheerful doctrine and much preferable. Man's nature has sufficient reason and moral inclination to live a decent life, and as for reaching the higher levels of spirituality, the Church assures its own good works—its sacraments and its preaching and its canon laws—will suffice for that. Augustine was far too gloomy. We are not condemned by our carnal will. There is plenty of goodness in human nature, and when you add what the Church provides, we can live a full and moral life and prove ourselves worthy of God's love. This is open to being achieved by any man or woman."

Sir Thomas Blount, who had been standing to one side of the group facing Duke John on his oak throne, now turned toward Bedford.

"I agree fully with Cardinal Beaufort. And I want to add that these learned and abstruse speculations have no value in our present situation, My Lord. Indeed if we took them seriously they would render us immobile. The French would walk all over us. We are Englishmen. We have gained this land by right of inheritance and conquest. Our presence here has given great benefit not only to our families and vassals but to all of the English people. We must concentrate on the task at hand, how in difficult political and fiscal circumstances, threatened by a French king who does not scruple to employ the help of witchcraft as well as deceit and terror, we can hold onto our domains. That is what we should be talking about."

Dennis Hennessey, the tough-looking, rudely dressed mercenary who had stood in silence through the whole discussion, now felt emboldened to speak up.

"Indeed, Duke John, that is why I am here. After all the years that we fought side by side, after all the battles wherein we commonly risked our lives, I feel I have a right to come here and petition you

personally for payment of my soldiers, who will soon depart if their wages are not given them, wages that are two months in arrears. And let me say this, if the power of Lancaster in France falls, I will not return across the channel. I have nothing to go home to. I left Ireland when I was twenty to join Henry V's army and I fought at Agincourt and then many times in your company, Duke John. I like this land. I have many times listened to stories about King Arthur's Round Table and his knights always seem to end up in France. Here is where I too want to remain. If the French king regains this land, I will make my peace, yes even with the abominable House of Valois. I already own a vineyard near Bordeaux. If Lancaster falls, I will purchase more of such land. I have learned from your Carthusian friends, Abbess Mathilde, how to make cognac by distilling wine. I will settle down near Bordeaux and raise a family, and show them the art of making cognac. I will never go back across the channel. What would I do back in England? Hire myself out as a thug for some great lord who is doing what? Beating up upon his neighbors and cheating the Crown of its power and the kingdom of its peace. I shall stay in this rich, comforting land of France no matter what."

Duke John was not pleased by Blount and Hennessey. But he took pains to respond to them in a temperate way.

"Mendoza's loan, Captain Hennessey, of which you heard earlier from Beaufort, and which is to be sealed tomorrow, will provide the money for you and my other loyal and devoted captains to pay their soldiers. I can well understand, Hennessey, your not wanting to leave this beautiful land. Neither do I. Nor will there ever be a need for you to make that difficult decision or give your loyalty to the degenerate House of Valois. The Lancastrian banner will fly here perpetually. As for what Beaufort and Blount have said, I would not gainsay them. But here in our Christmas camp I enjoy listening to other opinions and other themes. Allow me the privilege of doing that. War and politics we have enough of. Let there be a modicum of philosophy and art before we return to our normal course of thought and action. My dear cousin Abbess Mathilde, I am sure that Saint Augustine's theology lies somewhere deep in the Arthurian story. But we must not let this severe theology to which you and Brother William Marsh are so dedicated spoil the fun and sweep of the Arthurian narrative, or else tomorrow we shall not be able to enjoy

the entertainment which Lancelot Highgate is arranging for us. In this short life of ours, there are a few moments when we pause and enjoy the opportunities we have for art and companionship, for story-telling and music, for costume and revelry. Our annual Arthurian pageant at the Christmas camp is one such brief moment of pleasure I exult in. Let us leave aside tomorrow, I beseech you all, theology and history, politics, finance, and war, and dress up again as members of the shining knightly Round Table and act out stories of great heroes and heroines. There is no harm in that; it is a moment of joy we snatch from the care of normal life. Ritual, ceremony, and theater, these are good things to cultivate. They provide a therapeutic calm in the midst of incessant flux and conflict. Art communicates truth through tightly segmented bursts of feeling. Art thereby stirs the blood and sets the pulse racing and for a moment we experience an epiphany, a revelation. It differs from the revelation the bishops and saints dispense, but it is the coming on to us likewise of a deeper understanding of humanity and nature. Now that I know why Arthur dies, I shall be able to bring, I hope, a deeper shade of meaning to my role. But I shall continue to play King Arthur and to do so happily. It is the Lancastrian thing to do and I enjoy it."

Christine de Pisan had been silent for several minutes, following her rebuke by Abbess Mathilde. She had been standing to one side of Duke John and listening to the conversation intently. Now she moved toward Bedford and addressed him.

"My Lord Duke," she said, "I regret the tone of sadness and pessimism in what you have been saying, as if the weight of the world and the fortunes of your glorious dynasty lie very heavily upon you. As much as I remain loyal to the House of Valois, which I and my father before me have served at the court in Paris, I have always admired from a distance the Lancastrian family, and since it has been my privilege to be here and observe you and listen to you speak, my admiration has been enhanced. The destiny of John of Gaunt's magnificent lineage is not running down. Your glory and renown will endure unblemished, and a better day will come for your dynasty, I am sure. Your tone of sadness carries over into your identification with Arthur. Not all of the poets say that Arthur dies at the end of the story. Some say that he was borne away to the isles in the west, to Avalon, there to await a better day, when he shall return to lead the

British once again in triumph. Arthur is still the once and future king. And so it will be with you and the House of Lancaster. Not only will the Lancastrian courage and heroism bring back the euphoric moment when Great Harry your brother stood invincible on the field of Agincourt. Your family's love of learning and the arts will perpetuate the memory of the golden lion of Plantagenet and the red rose of Lancaster in the mind and sentiment of good people everywhere for all ages. The rebirth of classical culture that I hail in my Italian birthplace will be paralleled by the recovery of the chivalric ardor and heroic gesture that stamped John of Gaunt your grandfather and Great Harry of Agincourt your brother forever in the burnished pages of humanity's noblest deeds."

"Well spoken Christine," said Lancelot Highgate. "Lancaster will endure forever and its chivalric emblem will always ride at the front of heroic company. For centuries to come, a Lancastrian king will sit on England's throne and enthusiastic heralds will celebrate such a monarch's Arthurian image."

John of Bedford's face brightened. "I am most pleased to hear these fine sentiments. Yes, Arthur need not die. Possibly he shall return to rule again as the once and future king. I had forgotten that, somehow, and now I hasten to confirm that happier ending to the story. Now the hour is very late. We have had good conversation this evening. I think we should all take our repose now, so we shall be fresh and eager for tomorrow's pageant. I, Arthur, tell you this! Good night."

John Duke of Bedford died in 1435. His successors as governor of England's French Empire were weak and incompetent. Within two decades almost all of the English Empire in France, including Bordeaux, had fallen to the French Crown. The only exception was one French port town that was held by the English for another century. The English aristocracy turned inward, to purely domestic affairs. Never again would the English seek an empire in continental Europe.

Henry VI, John of Bedford's nephew, became steadily more feeble-minded. In 1461, the Lancastrians lost the English Crown during the Wars of the Roses.

Four memorials to the Lancastrians remain: Duke Humphrey's library in Oxford; the chapel of King's College, Cambridge, endowed by Henry VI; Chaucer's poetry; and Hennessey cognac.

CHAPTER NINE
EPILOGUE: MEDIEVAL PEOPLE

I could not know you, medieval people, because you were hidden as hazy, indistinct figures behind layers of screen and scrim, clerical idealizations that congealed into formal typologies. Behind the stiffness of Latin language and classical discourse and the naive fragility of early vernaculars, you became symbolic instruments of pitiless winning forces traversing the past. You were bulky shadows and faceless hulks behind those screens.

I could not love you, medieval people, because I could not perceive your inner selves, your wishes and repulsions, the objects of your joys and hatreds, your hidden consciousness, your gestures and your body language, your breath and fluids.

I could not re-create you, medieval people, because I could not define how your personalities and desires linked with concrete times and places. You were stick figures, totems on a landscape, lines upon the horizon, temporally and spatially floating away.

So I had to imagine you as you really were behind the scrims of clerical formularies, within your inner consciousness, as three-dimensional animations in the context of time and place.

I had to let you speak your voices at moments of estimated crisis, and hope that the passion communicated authentic sounding of your agonies and exaltations, your ideals and repulsions, repression and expression, your prejudice and rationality.

I had to believe I could do this, fix your dialogic voice and not

merely hear my own voice bouncing back in echo function.

My strategy was to attend you in critical moments vocalizing your sense and sensibility, your aspirations and disappointments, and the excavating memory of your life experiences. So that you might be heard precisely, not be merely muffled sound, medieval people, you had to dissolve the bafflement of archaic language and articulate in the language of today, at risk of superficial anachronism.

For economy and dramatic juncture, I had to place you sometime in dialogue with people who were your exact contemporaries but who were not present at the documented moment, although they had the freedom to be there. I had to create some composite and representative secondary characters to read the necessary lines.

Out of the rich compost of scholarship, I tried to grow biographical similitude, imagined character formation, and rounded individuality. I had to compensate for the typology of the sources, the refractory nature of language, and idiosyncratic unconnectedness of known personal feeling with contextual time and place.

If medieval lives will be written at the end of the twentieth century, they can only be written in some risky imaginative projection and some kind of dialogic drama. The writing of medieval lives requires the bold transposition of biographical data, fragmentary and skewered, into accessible and coherent story, interactive with postmodern culture.

If readable narrative of individual consciousness and personality is to be portrayed and communicated, some level of conception beyond the strictest limits of surviving data has to be attempted. The meaningfulness of the resulting narratives to readers and the stories' usefulness in our culture will be the pragmatic test of methodological validity of these tactical transpositions and literary constructions.

I propose we exercise our emancipated option to do what has to be done to repatriate the Middle Ages to our own time and employ accessible medieval lives for whatever joy and illumination they may provide to us.

My narrative through biographical genre began when the Christian Church, abetted by the vehicle of imperial power, prevailed over its long-standing rivals of Judaism, gnosticism, and paganism. This was the advent of the Middle Ages. The narrative then sought the hardening of the medieval ethos under the African sun where classi-

cal structures and biblical messages were rebuilt into Christian doctrine and institutions by the fierce efforts of visionary, uncompromising persons. In the time of barbarism that followed, progress was signified and great expectations heralded by literate intelligence that was delicately cultivated by peaceful people who were frustrated by the greed and power of the great families and the rolling interim of conquest and booty-seeking.

The clerical standard of moral revolution was raised against the empowered and enriched social structure by alienated strong personalities, to be turned back in its frontal assault. A party of humanity arose among the other gender, demanding emancipation and cultural integration, and bold visions were declared and beautiful things known and done by aristocratic women, only to be closed down by resurgent male power within the engine of law and bureaucracy. A final effort was made to declare a party of humanity committed to learning and love, to freedom and honesty, expressed through charisma, to be overborne by power at the center of institutional faith and betrayed by academia and the learned professions it spawned.

My narrative ended in the winter of the Middle Ages, when the culture was irreparably fractured and ideas were running off the edges of society, but there still was faith in the mind and body of the charismatic lord.

This is the outline of the story I have told through the lives of eight medieval women and men in their times and places.

Biography needs no justification. It makes the past immediately accessible to us. The sequential life experiences of vigorous and creative people, the dramatic crises they endure and their interaction with and impact upon contemporaries, both friends and enemies, shapes a narration that is naturally attractive to us. The enjoyment which this literary genre offers is perennially spontaneous and immediately meaningful. It resonates against one's own memory and schematic ordering of one's own life experiences.

Biography signifies individuation and stands at the opposite intellectual pole from group or sociological history. Each of the eight medieval women and men whose story I have sought to tell is a unique individual, memorably distinguished from any other single person. It is this individuated character, behavior, and consciousness

that intrigues the reader most and holds attention. A person's speech refers to social contexts and communal issues, but it is how the individual perceives the context and relates to it, and defines the issues, and acts upon them that we want to know about and which therefore becomes the burden of the story.

Yet collective patterns do arise from individual biographies. Unique sensibility and individual character do not preclude approximate grouping according to repeated phenomena. These eight people of the Middle Ages had three things in common beyond their obvious participation in a wide-ranging, quite amorphous Latin Christian culture.

First, they all exceeded the normal medieval life expectancy of less than forty years of age. Did this long life span produce a stirring impact on their times and places? It helped. There is a Darwinian, eugenic effect at work here. At a time when there was very little medical or pharmacological capacity to prolong life, or alleviate illness, these people lived beyond normal life expectancy, six close to or exceeding the doubling of it. So these were very strong, hardy people; their bodies were extraordinarily strong specimens, and that contributed to their energetic involvement in their societies and cultures and their visibility and legacies. Each of these people was aggressive and self-assertive, a function of their physical strengths and good health.

Second, they were people of the dominant class, either born or promoted into it. One was a member of the most celebrated imperial family of late antiquity. Two came from among the great landed families, the one hundred to two hundred families that dominated European life after 900. Two more were also nobly born although in less exalted strata. Two were of middle-class gentry or bourgeois stock in provenance. One was very humbly born; he was probably of peasant origin. Yet the three of middle and peasant class in origin rose to high status through the Church and state and for several decades moved on familiar terms among the nobility. These were thus all people of the social establishment.

Third, they were all idealists, although the content of their idealism varied significantly among them, aside from a baseline Latin Christian culture. Each believed passionately in something important and they advocated their ideals by didactic discourse and/or by

the thrust of their exemplary lives and leadership roles in society.

Longevity and physical hardiness; well-born or at least high-positioned status; idealism—these are the threefold components of medieval charisma.

The three women stand fully within the threefold pattern. Categorically they were not others. Yet two of them impatiently differed by adhesion to ideals we recognize as feminist in a society of masculine domination and clerical hostility to, and aristocratic disdain for, women's equality.

What is the significance of these eight lives for us? For me, their special character is their idealism. Each wanted to achieve some grandly conceived program, and it was not pursuit of wealth or consumption. I think it can be designated as a moral goal in each case that galvanized their energies and dominated their minds.

The goals, however, do not coincide by a large margin. Put over each other, there is a degree of formal compatibility because of their Latin Christian culture and idealism. But the goals were in conflict with one another, and ambitions to realize them severally then canceled each other out. That is one reason that medieval civilization eroded and fractured, although not the only reason.

To take just one overarching issue that arose consistently in the medieval world: Should the Church determine the moral order of society? If the only allowable answer were a simple yes or no, three of the eight medieval people I have discussed would say yes; three would say no. The two others would say: Which Church? The visible Church or the true Church? If the issue were more complicated, such as does human love imitate or counter divine love, it would be necessary to plot the answers along a broad spectrum.

In the lives of at least seven of these eight people there appears to be a common pattern of failures to achieve the heartfelt goals envisioned by each of these people. In some of the seven it is a shortcoming; in others a calamity. In all instances there is frustration and disappointment.

Yet I see this quality of failure not as distinctly medieval but as characteristic of idealists in any society and culture, the dues paid for membership in humanity.

SELECT BIBLIOGRAPHY

The date given in parentheses at the end of the bibliographic entry is the date of original publication in the case of a work that has been translated into English or has gone through two or more editions.

CHAPTER ONE: THE ADVENT OF THE MIDDLE AGES. HELENA AUGUSTA

Jan W. Drijvers, *Helena Augusta*. New York: Brill, 1992.
Robin Lane Fox, *Pagans and Christians*. New York: Knopf, 1987.
Ramsay MacMullen, *Constantine*. New York: Dial, 1969.
A. H. M. Jones, *Constantine and the Conversion of Europe*. Toronto: University of Toronto Press, 1978 (1948).
Elaine Pagels, *The Gnostic Gospels*. New York: Random House, 1979.

CHAPTER TWO: AFRICAN HORIZONS. AUGUSTINE OF HIPPO

Peter Brown, *Augustine of Hippo*. New York: Dorset, 1986 (1967).
John J. O'Meara, *The Young Augustine*. London: Longman, 1954.
Karl F. Morrison, *Conversion and Text*. Charlottesville, VA: University of Virginia Press, 1992.
Frederick van der Meer, *Augustine the Bishop*. New York: Sheed and Ward, 1961.
W. H. C. Frend, *The Rise of Christianity*. Philadelphia: Fortress, 1984.

CHAPTER THREE: NORTHERNERS. ALCUIN OF YORK

Stephen Allott, *Alcuin of York*. York, England: William Sessions, 1987 (1974).

Wilhelm Levison, *England and the Continent in the Eighth Century*. New York: Oxford University Press, 1946.

Pierre Riché, *Daily Life in the World of Charlemagne*. Philadelphia: University of Pennsylvania Press, 1988 (1978).

Louis Halphen, *Charlemagne and the Carolingian Empire*. New York: North Holland, 1977 (1949).

Roasmund McKittrick, *The Frankish Church Under the Carolingians*. New York: Longman, 1983.

CHAPTER FOUR: REVOLUTION. HUMBERT OF LORRAINE

Gerd Tellenbach, *Church, State, and Christian Society at the Time of the Investiture Contest*. Oxford: Blackwell, 1959 (1936).

Uta-Renate Blumenthal, *The Investiture Controversy*. Philadelphia: University of Pennsylvania Press, 1988.

J. P. Whitney, *Hildebrandine Essays*. Cambridge, England: Cambridge University Press, 1932.

Richard Krautheimer, *Rome. Portrait of a City, 312–1308*. Princeton: Princeton University Press, 1980.

Noreen Hunt, *Cluny Under Saint Hugh*. London: Arnold, 1967.

CHAPTER FIVE: THE FORM OF WOMAN.
HILDEGARD OF BINGEN

Peter Dronke, *Women Writers of the Middle Ages*. New York: Cambridge University Press, 1984.

Sabina Flanagan, *Hildegard of Bingen*. New York: Routledge, 1989.

Barbara Newman, *Sister of Wisdom*. Berkeley: University of California Press, 1987.

R. Howard Bloch, *Medieval Misogyny and the Invention of Western Romantic Love*. Chicago: University of Chicago Press, 1991.

Frances Beer, *Women and Mystical Experience in the Middle Ages*. Rochester, NY: Boydell, 1992.

CHAPTER SIX: THE GLORY OF IT ALL. ELEANOR OF AQUITAINE

Amy R. Kelly, *Eleanor of Aquitaine and the Four Kings*. Cambridge, MA: Harvard University Press, 1978 (1950).

William W. Kleber, ed., *Eleanor of Aquitaine*. Austin, TX: University of Texas Press, 1976.

Michael T. Clanchy, *From Memory to Written Record*, 2nd ed. Cambridge, MA: Blackwell, 1992 (1977).

Frank Barlow, *Thomas Becket*. Berkeley: University of California Press, 1986.

H. G. Richardson, *The English Jewry and Angevin Kings*. London: Methuen, 1960.

CHAPTER SEVEN: THE PARTING OF THE WAYS. ROBERT GROSSETESTE

R. W. Southern, *Robert Grosseteste*. Oxford: Clarendon Press, 1986.

James McEvoy, *The Philosophy of Robert Grosseteste*. New York: Oxford University Press, 1986 (1982).

A. C. Crombie, *Robert Grosseteste and the Origins of Experimental Science*. Oxford: Clarendon Press, 1953.

David Knowles, *The Religious Orders in England*, vol. I. Cambridge, England: Cambridge University Press, 1948.

F. Pollock and F. W. Maitland, *History of English Law Before the Time of Edward I*, 2nd ed., 2 vols. Cambridge, England: Cambridge University Press, 1968 (1898).

CHAPTER EIGHT: THE WINTER OF THE MIDDLE AGES. JOHN DUKE OF BEDFORD

R. L. Storey, *The End of the House of Lancaster*. London: Barrie and Rockliffe, 1966.

E. Carleton Williams, *My Lord of Bedford*. London: Longmans, 1963.

G. L. Harris, *Cardinal Beaufort*. Oxford: Clarendon Press, 1988.

Donald R. Howard, *Chaucer*. New York: Dutton, 1989 (1987).

Charity C. Willard, *Christine de Pisan*. New York: Persea, 1984.

CHAPTER NINE: EPILOGUE: MEDIEVAL PEOPLE

Robert W. Hanning, *The Individual in Twelfth Century Romance*. New Haven, CT: Yale University Press, 1977.

Lee Patterson, *Negotiating the Past. The Historical Understanding of Medieval Literature*. Madison, WI: University of Wisconsin Press, 1987.

Stephen G. Nichols et al., eds., *The New Medievalism*. Baltimore, MD: Johns Hopkins University Press, 1991.

Ernst Robert Curtius, *European Literature and the Latin Middle Ages*. Princeton: Princeton University Press, 1973 (1953).

Norman F. Cantor, *The Civilization of the Middle Ages*. New York: HarperCollins Publishers, 1993.